THE APPRECIATION OF THE ARTS 8

General Editor: Harold Osborne

Relief Sculpture

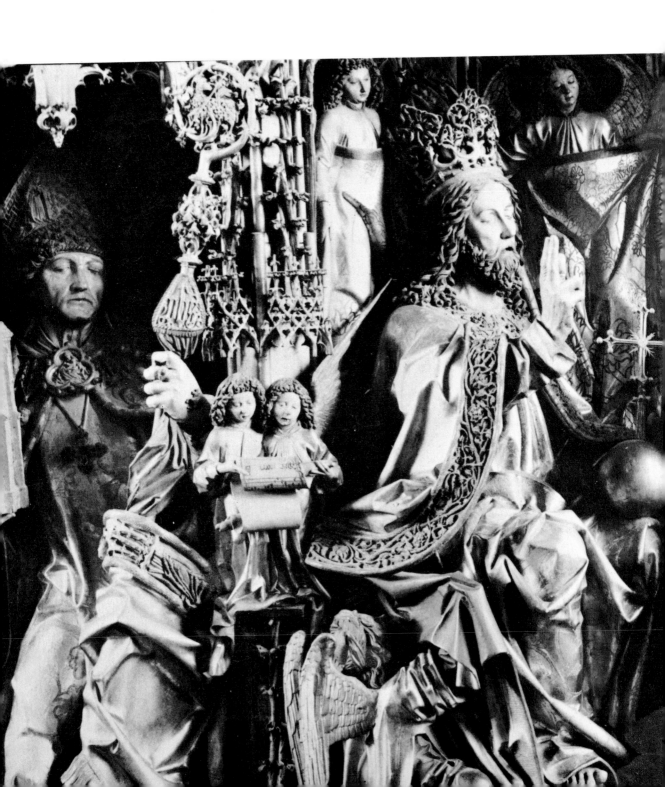

RELIEF SCULPTURE *L. R. Rogers*

London *Oxford University Press* New York Toronto 1974

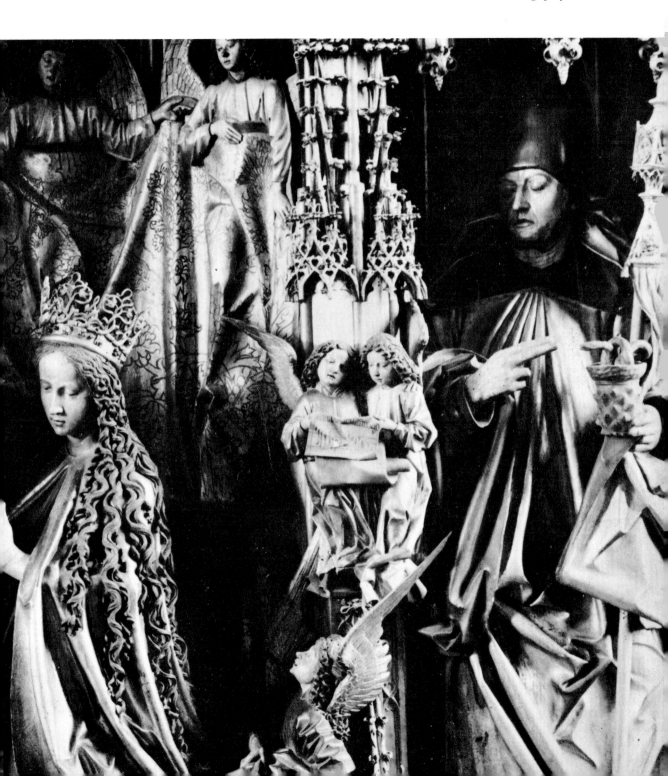

Oxford University Press, Ely House, London W. 1

GLASGOW NEW YORK TORONTO MELBOURNE WELLINGTON
CAPE TOWN IBADAN NAIROBI DAR ES SALAAM LUSAKA ADDIS ABABA
DELHI BOMBAY CALCUTTA MADRAS KARACHI LAHORE
DACCA KUALA LUMPUR SINGAPORE HONG KONG TOKYO

ISBN 0 19 211920 6

PRINTED IN GREAT BRITAIN
AT THE UNIVERSITY PRESS, OXFORD
BY VIVIAN RIDLER
PRINTER TO THE UNIVERSITY

Contents

List of Illustrations

Introduction

THE CONCEPT OF
RELIEF

Apart from a few hybrids and border-line cases, which we shall discuss in due course, most sculptures may be readily classified as either in relief or in the round. These two traditional main branches of the art of sculpture were being practised side by side about 20,000 years ago but they do not appear to have originated at the same time. The evidence that has been discovered so far points to the conclusion that relief did not, and perhaps could not, emerge until the arts of sculpture in the round and drawing were both well established. The reasons which have been suggested for this later development of relief throw an interesting light on its fundamental nature as an art form:

Theoretically, the art of relief might be expected to appear between sculpture in three dimensions and drawing or engraving; but in fact a mastery of naturalistic representation in relief entails mastering almost all the problems that confront the draughtsman. In his tools and manner of working this artist may be closer to a sculptor in the round, but he must also have resolved the intellectual problems of drawing. A two-dimensional pattern lies embedded in the two and a half dimensions of the relief. The first steps towards relief were taken at much the same time that engraving was gaining in assurance. . . .[1]

The evidence of prehistory thus seems to confirm what every practitioner of the art of relief knows to be true: that it is a synthesis of two-dimensional and three-dimensional art forms and that a relief artist must to some extent be both sculptor and draughtsman. This is something which we shall return to later.

During the long history of sculpture some societies, for either the whole or part of their time, have preferred one branch to the other – African tribal sculpture, for example, is almost all in the round, while Romanesque sculpture is almost all in relief – but in most parts of the world both branches have coexisted on more or less equal terms, and in an over-all view of history it would be difficult to say that either has dominated. Certainly each has produced its share of supreme masterpieces.

If there is one feature which above all others distinguishes sculpture in relief from sculpture in the round it is its physical dependence on some kind of background or matrix. A sculpture in the round may be designed to stand in open space, where it can be viewed from all directions, or it may be intended to be placed against a wall or in a niche, so that it can be viewed from only a limited range of frontal positions, but in either case it is a separate, detached object in its own right, leading the same kind of independent, self-contained existence in space as a human body or a

[1] N. K. Sanders, *Prehistoric Art in Europe*, Harmondsworth, 1968, p. 19.

chair. A relief sculpture, on the other hand, is not a separate, independent object. It projects from and is attached to, or is an integral part of, something else which serves it either as a background against which it is set or as a matrix from which it emerges. It is essentially a form of sculpture which is created on some underlying object, even if that object is merely a small slab of ivory or a crude, natural rock face at the entrance of a cave.

Reliefs are one of three fundamentally different kinds of art works which are concerned with relating an image or decoration to a surface or ground. The others are intaglios and pictures.

An intaglio is an image or decoration which is incised into or hollowed out of a matrix so that it lies below the surface. It is thus the opposite of a relief. Strictly speaking, an intaglio is a negative form, and its main use has been for seals and dyes which are intended to be impressed on such plastic materials as clay, wax, or hot metal in order to produce a positive relief image. The uses of intaglios are, however, extremely limited in comparison with those of direct reliefs and pictures.

Intaglios and reliefs both modify the actual form of a surface, causing it either to recede or to project, and they are therefore always in some degree three-dimensional. In this respect they differ fundamentally from paintings, drawings, prints, and other forms of pictorial art. In a picture it is only the colour or texture of a surface that is modified, not its actual form.

As a means of enlivening the surfaces of objects, especially those which are liable to wear because they are handled a great deal or, like the exterior surfaces of buildings, are exposed to the weather, reliefs have one great advantage over pictures: they are much more permanent. In fact, in some civilizations — ancient Egyptian, for instance — one of the principal functions of relief seems to have been to guarantee the permanence of an image by providing it with outlines which were highly durable and which could also, if the need arose, facilitate the repainting of the images when their colours had worn away or faded.

Some forms of art do not fit neatly into any of the main broad categories of sculpture in the round, relief, intaglio, or pictorial art. There are, for example, numerous sculptures which are made up of both figures in the round and figures in relief. There are others, like the column figures of Chartres, which are in effect complete statues although they are connected to a background. One of the main art forms of ancient Egypt is sometimes known as *intaglio* 4 *relief*; and although this appears to be a self-contradictory term it is, as we shall see (p. 95), a quite appropriate descriptive title for what is in fact a hybrid art form. Other somewhat ambiguous forms of art exist on the border line between relief and painting. The arts of collage and assemblage, for instance, which have figured prominently in the development of twentieth-century art,

are usually regarded as offshoots of painting, probably because they were invented by painters; but they could equally well be regarded as types of relief. A recent writer has suggested that 'if the total perception of such a work may be accomplished from a frontal vantage point, and this perception leads to the comprehension of the work as a two-dimensional pattern underlying and controlling any projections or extensions into space, the work is in the domain of painting.'[1] This seems to be a reasonable suggestion for drawing a line between what is primarily pictorial or primarily sculptural. But we need not take these problems of definition too seriously. It is unlikely that we shall find complete sets of defining characteristics which will clearly and finally separate all works of art into one or another category. Nor is this necessary. Our inability to formulate a hard and fast and all-inclusive definition of relief sculpture, or of any other art form for that matter, does not imply that we do not know clearly what we are talking about. The concept of relief may have fluid boundaries with the concepts of other art forms but at its centre it is clear enough.

At the present day as a visit to any leading museum or gallery of modern art will confirm, the traditional boundaries between the visual arts themselves and between the visual arts and the arts of sound, movement, film, and theatre are in a state of flux. Nevertheless, relief sculpture of a more or less traditional kind is still widely practised and there are many new types of art work which still undoubtedly fall into the category of relief even though they may be different from anything which has been produced in the past. It is in fact pretty well inevitable that in any age there will be an art form which exists, so to speak, between two and three dimensions — between the pictorial and sculptural. Relief is one of the fundamental spatial modes of art and it is likely to persist in some form through all revolutions and transformations.

THE SCOPE OF RELIEFS The kinds of objects that have served as hosts or vehicles for relief sculptures are extremely varied. Perhaps the first to come to the minds of most people, and certainly the most impressive, are those which are generally grouped together under the term 'monuments'. This somewhat abused but useful word has three related meanings which are relevant to the purposes of the present book. It denotes, first, buildings such as the Temple of Luxor, Chartres Cathedral, and the Parthenon, which have survived from the past and are of some archaeological or historical importance; second, structures such as Trajan's Column, the Arc de Triomphe, and the Monument in London, which were erected to commemorate

[1] E. Fry, *Sculpture from Twenty Nations*, Guggenheim International Exhibition, 1967, Princeton, 1967, p. 12.

3

important persons or events; and third, funerary structures such as tombs, gravestones, and sarcophagi.

There are so many masterpieces of relief sculpture on a grand scale associated with some of the more celebrated great monuments of past ages in the Near and Far East, the Classical world, pre-Columbian America, medieval Christendom, and post-medieval Western civilization that they tend to divert attention from the wealth of smaller scale, more intimate works which also exist. But our knowledge and enjoyment of relief sculpture would be lamentably one-sided if we limited our attention to these monumental works and ignored the others.

Many relief sculptures of the highest artistic quality lie altogether outside the field of monumental sculpture and are not connected in any way with architecture. In fact images and decorations in relief have been created at one time or another on almost every kind of artifact which affords an opportunity for doing so — on jewellery, furniture, musical instruments, ceramic and metal vessels, boxes and caskets of all kinds, coins and medallions, cutlery, weapons, mirrors, candelabra, fireplaces, fountains, garden ornaments, and a host of other things.

Much of this work is, of course, trivial and merely decorative, but the custom of listing many of these artifacts under the general heading of 'minor arts' should not mislead us into thinking that

Procession of Prisoners, from Tomb of Haremhab, near Saqqara, eighteenth dynasty. Stone, 31in. Rijksmuseum van Oudheden, Leiden. *Hirmer Fotoarchiv München*

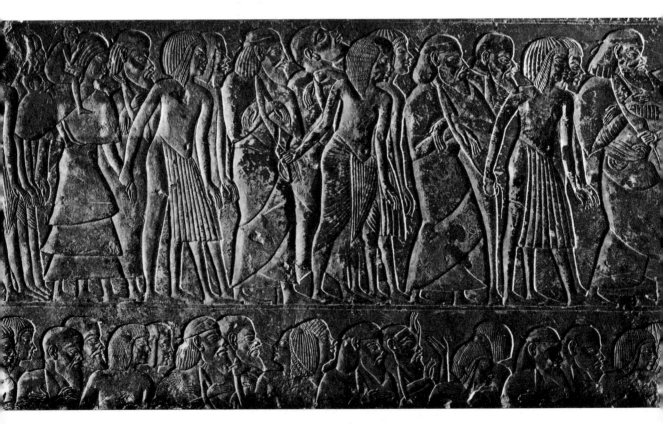

they are all necessarily inferior to work on a grander scale. A small Byzantine ivory tablet or a medallion by Pisanello can achieve a degree of perfection which is comparable with that of a superb sonnet or short lyric. There are vast programmes of architectural relief sculpture such as those of Chartres and the Parthenon which have the epic scope and scale of an *Iliad* or a *Divine Comedy*, and there are small individual works which have the elegance and lightness of a lyric by Herrick, the pastoral charm of a Virgilian *Eclogue*, or the compressed intensity of religious feeling of some of Donne's *Holy Sonnets*. Different *kinds* of excellence are attainable in different scales of work, but the *degree* of excellence has nothing to do with scale.

The range of different kinds of work which are covered by the term 'relief' is vast. Many of these differences will be discussed at some length in subsequent chapters but I shall mention some of the more important ones here in order to give a brief preview of the scope of what we are taking as our subject. We have just referred in general terms to the variety of scale of reliefs. In more precise terms, they range in size from the frieze of the great Altar of Pergamon, which is nearly 400 feet long and $7\frac{1}{2}$ feet high and contains figures which occupy its full height, to the smallest coins and cameos, which are less than half an inch in diameter. The numerous crafts employed in the production of reliefs include goldsmithing and silversmithing, bronze-founding and other metalwork, pottery and various kinds of modelling with plastic materials, gem-cutting, die-cutting, and carving in ivory, bone, wood, and stone. The three-dimensionality of reliefs varies from that of some repoussé work which is little more than faintly embossed drawing to that of some of the figures on Indian temples, which have more than the depth of a natural figure and are almost completely detached from their background. The styles of relief include some which are almost entirely linear, some which are painterly in both their composition and their surface treatments, some which are purely ornamental and in which everything is subordinate to their quality as over-all patterns, and some in which the forms are fully plastic and the subject is treated in a sculptural, statuesque manner. The purposes for which reliefs have been made are also extremely diverse. On the one hand they may serve important social and religious purposes, functioning, for example, as symbols for, or even as embodiments of, a society's gods and rulers. On the other hand their purpose may be a comparatively trivial one such as decorating a comb or the lid of a jewel box. The subject-matter of reliefs varies in scope from a single human head or figure to vast panoramas with landscapes, skies, buildings, and armies in conflict. And the manner of treating the subject-matter ranges from the nearly abstract through various degrees of simplification and stylization to an extreme naturalism.

Some reliefs, especially recent ones, have no subject-matter at all, in the ordinary sense of the term, and are completely non-representational.

ATTITUDES TO APPRECIATION
In all these varied kinds of relief there is no single quality or group of qualities that may be looked for. They fall into many different styles and aesthetic categories and embody widely different formal and expressive qualities. What is required of the spectator is a readiness to perceive and respond to a great many different kinds of form and expression, each of which makes its own special demands on him.

Such open-mindedness and breadth of appreciation are often difficult to achieve. There are habits of seeing and thinking, prejudices of many kinds, and other mental obstacles that hinder us. Some of these are acquired; others are innate.

By far the most powerful of the acquired obstacles are certain prejudiced views which we may hold about what is and what is not really art. These may be definite theories which are consciously held and applied to works of art. We may, for example, hold the view that before we are prepared to grant that something is a work of art and to look at it as such it must satisfy certain specific moral or social criteria, or be concerned with a certain kind of subject-matter or treat its subject in a certain way. On the other hand, our difficulties may be due not to considered opinions which we have arrived at as a result of thinking but to the conditioning we may have undergone in the process of being educated – a conditioning which predisposes us to favour some kinds of work and to reject others, probably without really looking at them.

Prejudice against highly abstract, stylized, expressionistic, and other non-naturalistic styles of art still exists but is happily nothing like as common as it was at the turn of the twentieth century. Romanesque, Byzantine, Mexican, and African art, which, when known, was largely ignored or despised in previous centuries, is now widely appreciated. Moreover, the main battles for modern art have been won; even completely non-representational art is now rapidly penetrating to the level of popular taste. There is still, understandably, a fair amount of resistance on the part of the public to each of the new trends in art which is brought to its notice, usually in a sensational manner through the mass media. But such artists as Picasso, Mondrian, Brancusi, Gonzalez, and Moore have now achieved the status of old masters, and most of the significant innovations of the pioneer days of modern art have passed into general currency and become a familiar part of our everyday visual imagery and surroundings.

In fact the revolution in taste has now reached a point at which we are beginning to see not so much a broadening of appreciation,

as the substitution of one kind of narrowness for another. A new kind of academic stereotype, the anti-traditionalist, is becoming as common and as boringly predictable as his predecessor, the anti-modernist. Over the past thirty or so years there has been a widespread growth of prejudice against styles of art in which the forms are closely related to the forms of nature. Many influential teachers, artists, and critics who were trained at a time when modern artists were vigorously pressing their claims against the inertia of a narrow traditionalism have not outgrown the one-sided attitudes and opinions which they acquired at that time and are still passing them on long after they have lost all polemical justification or value. In numerous books which set out to explain the art of the twentieth century to laymen and students, the aesthetic virtues of modern painting and sculpture are contrasted with the aesthetic vices of the so-called imitative mainstream of the Western tradition. There are even some people who express the view that the art of Classical, Renaissance, and post-Renaissance Europe down to the present century has almost all been a terrible mistake, a vast heresy in the history of world art, which has resulted from following the false doctrine that the purpose of art is to imitate nature. In support of their view such people often quote a highly slanted selection of passages from the writings of Plato, Aristotle, Leonardo, Rodin, and other writers and artists who appear to have believed that the artist's main function was to produce an accurate copy of nature. Such absurd views about Western art could be held today only by those who spend more time reading art theories than looking at works of art and who pay more attention to what artists have said they were trying to do than to what they actually did. Unfortunately, the dissemination of these views sometimes has the effect of deterring people, especially those who wish to be up-to-date in their taste — and this includes most young people — from ever looking seriously at some of the greatest works of art of the past.

The main innate obstacle to our appreciation of a wide range of styles of art is the bias of our own temperament. A great deal has been written by psychologists and others about the varieties of human temperament and personality. We have been classified by ancient physiologists according to our predominant humours as choleric, melancholic, sanguine, or phlegmatic. Jung has divided us into extroverts and introverts, who may also be predominantly thinking, feeling, intuitive, or sensation types. Joan Evans has developed Jung's classification with special reference to the styles of artists and to other people's tastes in art. Victor Lowenfeld has claimed that the nature of our responses to the plastic arts depends largely on whether we are haptic or visual types, that is on whether our imagery is primarily derived from tactual experience and bodily sensations or from visual experience. Whatever we feel

about the merits of these and other more recent methods of classification there can be no doubt that there are a great many different types of human temperament and that the kind of temperament we possess causes us to respond more readily and powerfully to certain kinds of art than to others.

Nevertheless no normal person is so temperamentally one-sided that his tastes are necessarily confined to a small sector of the spectrum of styles. Extending the range of our appreciation is mainly a matter of attitude, or mental set. It requires willingness to extend ourselves and to adapt our approach to different kinds of work. What we should aim above all to avoid is grossly over-rating works in styles for which we have a temperamental affinity and underrating works in other styles simply because they do not immediately appeal to us.

There have been, and still are, many conflicts in the realm of art which are due primarily to differences of temperament. One of the most long-standing, fundamental, and pointless of these is the conflict between the two polar groups of attitudes which are most clearly revealed in the Romantic and Classical outlooks. Works which the Romantic artist or critic describes in complimentary terms as expressive, spontaneous, and dynamic the Classicist tends to see as over-emotional, structurally loose, and lacking in balance. Conversely, what the Classicist admires for its restraint and unity of composition a Romantic tends to see as cold and over-organized. Similar fundamental differences of attitude exist in the realms of music and literature, and they are present to some extent even in philosophy. The phraseology of critical and artistic quarrels differs from generation to generation and not many people today would confess to being Romantics or Classicists, but the fundamental issues which underlie many of the quarrels remain the same. They do so largely because the same types of opposing human temperaments recur in each generation.

Through the variety of expressive form and content in the world's art we are able to learn something of the ways in which other societies and individuals have seen and felt. Works of art can mediate new kinds of experience to us and thus enable us to extend the range of our own sensibilities and feelings. To confine our attention to those styles and periods of art for which we have a special affinity and to deny ourselves access to the others would mean locking ourselves up in our own temperaments and forgoing the expansion of experience and escape from individual isolation which art can provide. We are not enriched by art if we merely use it to confirm and strengthen our own tastes, feelings, and ways of looking at things. Such aesthetic narcissism is not to be confused with appreciation.

Most reliefs, like most other works of art, are so deeply and intimately expressive of the times in which they were produced that their full significance as human products can be understood

only if we can place them in their cultural context. Should we then begin by devoting our time to studying the history of relief sculpture – to finding out why, when, by whom, and how the works were produced, and what their significance was for the people who made and used them? In order to do this for a broad selection of reliefs we would have to study the religions, mythologies, social customs, political and military histories, technologies, and other arts of several major and minor cultures. This would certainly lead to a greater understanding of the works as human products; we should know a great deal more *about* them. But it would not necessarily help us to appreciate them more as works of art. We may know every historical, archaeological, iconological, etc., fact that is available about a relief sculpture or other work of art and yet be no nearer appreciating it as a work of art than a person who does not even know which culture it comes from or what it represents.

In order to appreciate a relief sculpture, or any other work of visual art, as a work of art, the most important thing we must do is to get to know it – which is different from getting to know *about* it – as it is presented to vision. Its visual properties, its visual form and expressiveness, are what give it aesthetic value. It is a central paradox of the visual arts that whatever matters in them aesthetically is fully in view but that only those who are prepared to see it can do so. This preparation is primarily a matter of acquiring the appropriate attitudes, visual skills, visual sensibility, and visual knowledge. This does not mean that the history, iconology, etc., are irrelevant, but that they are relevant only in so far as they contribute to this central process of visual apprehension. Given the ability to apprehend the expressive forms of works of art we may deepen our appreciation by learning other things about them. But if we do not possess this ability, all the rest, so far as appreciation goes, is of no value whatever.

Many people whose education has been primarily literary or scientific find this situation frustrating and distressing. The knowledge and skills which they have acquired through considerable effort are not merely unhelpful but may be an actual hindrance to them. They may begin by wishing to learn what to look at in the works of art themselves but they are easily lured into the trap of applying their own ways of thinking and learning in a realm where they are inappropriate. The result is that they often become extremely well informed about the history of art, the lives of artists, the psychology of art, and so on, but get no further with appreciating the works as works of art.

It is for these reasons that I have concentrated in this book on trying to show what kinds of formal and expressive qualities there are to be looked for in different kinds of relief sculpture. Ideally we should be looking together at the works themselves and discussing

them in a church, a museum, or a gallery. Since this is not possible, the book should be used as an aid to looking at the reliefs themselves. Photographs are useful but they are no substitute for the real thing. It is through constant contact with the visible, tangible works themselves that we grow to know and love them.

CHAPTER 2 Space (1): Between Two and Three Dimensions

The principal aim of this and the next chapter is to discuss the treatment of space in many different kinds of reliefs, but before we do this I shall try to place the spatial aspects of reliefs in some relation to those of the other main visual arts. By doing this we should gain a deeper appreciation of the special character of relief as a spatial art.

When we speak about the three-dimensional space or form of sculpture which is free-standing and in the round we are referring to something which actually exists in a straightforward, unambiguous way. The sculptures are real three-dimensional objects inhabiting actual three-dimensional everyday space. We can walk round them and in some cases we can pick them up and turn them round in our hands. They may not look like any objects which are known to us but fundamentally they lead the same kind of spatial existence as natural objects and ordinary artifacts. And although their solid form and spatial design may be extremely complex and subtle and make the greatest possible demands on our powers of perception, we nevertheless perceive them in essentially the same way as we perceive the three-dimensional properties of the ordinary furniture of the world.

But when we speak of the three-dimensional space or form of pictures we are referring to something much less straightforward. A picture has no real three-dimensional properties. A landscape drawing or a figure painting does not actually possess any of the qualities of space and form, of depth, distance, and solidity, which we attribute to it. It actually exists in two dimensions, as a configuration of lines and expanses of tone or colour. It is, however, a familiar fact of human experience, which we need not attempt to explain here, that lines and other two-dimensional pictorial elements may be arranged so that they convey an impression or semblance of three-dimensional space and form.

We could say that the elements of a picture exist spatially on two levels. On one level they have their own actual two-dimensional properties and on the other they have the spatial properties of whatever they represent. Consider as a simple example the lines in Fig. 1. We could describe these either as a drawing of two different sized trapeziums which are side by side and joined by a horizontal line, or as a drawing of two similar sized rectangles standing one behind the other on a horizontal plane and receding into space in the direction of our line of vision. The first would be a description of them as they exist on the flat surface of the picture, that is, in what is usually called the *picture plane*. The second would be a description of them as they exist within the familiar but

Fig. 1

logically puzzling realm of three-dimensional space which pictures are able to represent and which is usually known as the *picture space*.

Attempts to discuss the nature of pictorial space seem almost always to end in hopeless conceptual confusion. It is a problem which perplexes us in the way that the question, What is time? perplexed St. Augustine: 'If no one asks of me, I know; if I wish to explain to him who asks, I know not.' There is no term in common use which will adequately express the nature of pictorial space without giving rise to false analogies. It is often called 'illusory' space, with inverted commas signifying that no illusion in the generally accepted sense of the word is involved, for we are never, except in a few special trick instances, under any actual illusion that the three-dimensional space and form of pictures are real. The terms 'illusory' and 'illusion' should be used with caution, however, since they have led to a great deal of confused thinking about the nature of pictorial space. They have even been used without inverted commas by some muddle-headed artists and critics to suggest that Greek, Roman, and Renaissance artists were performing some kind of facile optical conjuring trick. Other terms such as 'notional', 'imaginary', and 'ideal' (as opposed to 'real') are also sometimes used. Susanne Langer favours the term 'virtual', which she has adopted from the science of optics, where it is used to distinguish the realm of reflected mirror images from the real world of space and form.

We shall try wherever possible to avoid using any of these terms and will call the three-dimensional space and form of pictures simply *represented* space and form, but where it is necessary to employ another term we shall use 'notional' since this seems to be the least confusing choice open to us. All the three-dimensional properties which we attribute to pictures are in fact represented by properties of the actual two-dimensional elements of the pictures — by the directions and lengths of lines, the relative positions of elements on the picture surface, the shapes and sizes of areas, and so on. There are many different ways of translating the three-dimensional properties of the world into two-dimensional terms. Some of them are systematic, some are not; some are fairly like mirror images, some are nothing like them; some set out to give us an accurate *view* of the world from a single viewpoint, and some set out to convey the kind of complete and accurate specifications of the structure and dimensions of objects which are contained in engineers' working drawings.

The relations between the actual two dimensions of the picture surface and the represented three dimensions of the picture space are an important aspect of the pictorial arts. In some kinds of pictures the artist has been primarily concerned with organizing the elements of his picture within the area of the picture surface or

picture plane in order to produce an expressive and well designed two-dimensional composition or pattern. This is particularly characteristic of Byzantine and most medieval art and, in a different way, of Egyptian art. In other kinds of pictures the artist has concentrated most of his attention on the organization of the elements within the picture space and with making of them a well designed spatial composition. Some of the great painters of the Italian Renaissance excel in this. Raphael, according to Bernard Berenson, was the greatest master of spatial composition of all time. In others, again, the artist has attempted to do both, that is, to create a picture which is equally satisfactory as a two-dimensional composition and as a composition in depth. One of the main sources of aesthetic interest in the pictures of Cézanne and the early Cubists is their attempt at a completely satisfactory interlocking, so to speak, of these two spaces, so that each element in the picture has two equally important kinds of compositional function.

The three-dimensional properties of free-standing sculpture in the round are not represented properties. The sculptures exist spatially on only one level. They may represent objects such as a man or a horse, but they cannot, as a picture can, represent three-dimensional space and form. This is not due to any deficiency in the medium; it is a logical impossibility. To be fully in the round *means* to have a full quota of three-dimensional form and to be free-standing *means* to be in three-dimensional space. We can say, for example, that certain lines on a surface *represent* a cube but we cannot say that this solid piece of stone with six equal square faces and so many right angles *represents* a cube. It *is* a cube. It may well represent a throne or a box, but that is a different matter. An element of represented, pictorial space can be introduced into sculpture only when the sculptor is able to control the conditions under which it will be seen. There are countless sculptures which are placed in a niche or backed against a wall, with the result that the spectator cannot see all round them and is restricted to a narrow range of frontal views. Under these circumstances it is possible to introduce an element of represented space and other pictorial features. But with sculpture of this type we are beginning to approach the conditions of relief sculpture.

The three-dimensional properties which we attribute to reliefs are more varied and in some ways more complex than those of pictures and free-standing sculpture in the round. Reliefs occupy a whole range of intermediary positions between the complete flatness of pictures and the full three-dimensionality of sculpture in the round. Some of them have hardly any actual three-dimensional properties and depend very largely on methods similar to those used for representing space and form in the pictorial arts. Others are made up of forms which are fully

three-dimensional; they are almost sculpture in the round and are classified as reliefs only because they are related to and partially attached to some kind of ground. The vast majority of reliefs, however, depend for their qualities of space and form on a great many different kinds of subtle fusion of pictorial and sculptural techniques and conceptions, so that they are in effect a synthesis of two-dimensional and three-dimensional art forms. Like pictures, they are designed to be seen from one aspect and are extended across our line of vision in a visual plane which may be regarded as a picture plane, and we may look at them much as we would look at a picture. But like sculpture in the round and unlike pictures, they do have actual depth and three-dimensional form, so we may also look at them much as we would look at pieces of sculpture.

It is typical of reliefs, however, that their actual extension in depth, in comparison with their extension in the other two dimensions, is restricted to a more or less shallow layer and that within this shallow layer the forms of the relief and their relations in depth are, so to speak, compressed or condensed so that they convey an impression of a greater degree of depth of form and space than is actually present. We shall see when we look more closely at the form and spatial design of reliefs that this contraction of the depth dimension is not a uniform one in which, say, one inch of depth in the relief is made to represent one foot of real depth. It is much more subtle than that. The forms and spatial relations of reliefs, as of the visual arts in general, are designed for presentation to a viewer; they are intended to be looked at. It is not their actual measurements or their objectively considered relations in space which the artist is primarily concerned with, but the dimensions and relations which they appear to have or may be accepted as having in the perceptual experience of a viewer. The condensation of form and space is accommodated to human visual perception and it is the way the forms *look* that counts, not the way they *are*.

Most reliefs, then, inhabit a spatial realm which may be regarded as lying somewhere between the completely notional space of pictures and the completely actual space of free sculptural volumes. Relief has been aptly described as 'a subtly protean form of art'[1] and there is no doubt that the enormous variety and richness of form and expression which it displays are to a great extent due to the fact that the relief sculptor can draw upon and combine in his work many of the qualities of both the pictorial and the sculptural arts. For this reason it is important that we as viewers should take into account both these aspects of relief. Throughout this book, therefore, we shall be switching our attention between these two aspects, concerning ourselves sometimes with such primarily pictorial matters as pattern, linear design, composition in the picture plane, and the use of perspective,

[1] Rhys Carpenter, *Greek Sculpture*, Chicago, 1960, p. 32.

and at other times with such primarily sculptural matters as the actual projection of the relief, and the volume and other three-dimensional qualities of its forms.

This division into pictorial and sculptural aspects is a convenient way of grouping the features of relief sculpture which we are attempting to elucidate, but it should be borne in mind that in the works themselves these two aspects are interdependent. I said a moment ago that relief sculpture is a synthesis of two-dimensional and three-dimensional art forms. I should perhaps stress that it is a genuine synthesis which cannot be created by the sculptor or fully appreciated by the viewer through the principles of either of the other art forms. We may direct our attention to the pictorial aspects or the sculptural aspects of a relief but a relief is not a picture or a sculpture in the round. Relief sculpture makes its own special demands on both the artist and the viewer and is perhaps best regarded as an art form in its own right.

APPROACHES TO THE REPRESENTATION OF SPACE IN RELIEFS

There are a number of fundamentally different approaches to the treatment of three-dimensional space in reliefs. First there is the approach of those styles which attach so much importance to the three-dimensional spatial aspects of reality that they convert the field of the relief into a picture space which serves as a notional spatial environment for the objects and events depicted in the relief. At their most naturalistic these styles present us with a view of objects and events which approaches the view we might get of them if we observed them in real life through a window or the viewfinder of a camera. The whole composition is presented from a single viewpoint and everything in it is located within a consistent three-dimensional picture space which is a microcosm of the space we actually perceive in a single view of a segment of reality.

Next there are those styles which do not represent the three-dimensional aspects of reality as such but translate them into planar equivalents which do not suggest or require any kind of recession into a picture space. The type of imagery used in these essentially planar styles preserves the two-dimensional nature of the field of the relief, that is of the area of the wall or other surface which the relief occupies. In reliefs of this kind different parts of the composition, even parts of the same object, may be represented from different points of view, and there may be no attempt to link them spatially into a coherent scene or to provide them with any spatial setting at all.

The extremes of these two fundamentally different pictorial approaches to the treatment of three-dimensional space are found respectively in post-Renaissance European reliefs which make use of systematic perspective, and in ancient Egyptian and Mesopotamian reliefs. We could, without too grossly oversimplifying the

facts, say that with regard to the pictorial treatment of space in reliefs there are two stylistic poles; one which sacrifices the planarity of the field of the relief in order to preserve the three-dimensionality of the subject, and one which sacrifices the three-dimensionality of the subject in order to preserve the planarity of the field.

The third approach is essentially a sculptural one. It does not conceive the field of the relief as a material surface *upon which* the forms exist, nor as a window looking through to a picture space *within which* the forms exist, but as a solid background *against which* they exist. The only kind of space these forms inhabit is the space actually occupied by or implied by their own volume, that is the space they actually project into in front of the background. The only notional element attributable to the space of these reliefs is that which arises from the contraction of the depth dimension of the solid forms themselves. The space of these reliefs could not exist without the solid forms, it is defined by them and comes into being only as a by-product, so to speak, of the creation of solid forms. This approach is most clearly exhibited in Classical Greek and related styles of relief.

These are three extreme and fairly consistent approaches to the problems of representing the three-dimensional aspects of reality in reliefs. There is also a whole range of styles which are not wholly planar or systematically perspectival or completely sculptural. Their subjects do not exist in the infinitely receding and ordered notional spatial world of Renaissance perspective, or in the depthless realms of Egyptian reliefs, or in the limited actual space of Classical reliefs. The approach of many of these styles to the representation of space is empirical. The artists have no one method which will solve all their problems in advance; they solve them as they arise or by rule of thumb. Usually, they reach some kind of a compromise between the demands of the plane and their desire to represent depth. The methods they use may not give rise to a unified and consistent realm of space and are, in fact, often mutually contradictory and ambiguous, but aesthetically, as compositions of expressive forms, the reliefs may gain from this.

In the following pages we shall consider a number of fundamental aspects of the spatial composition of reliefs in general terms. After this we shall discuss the special qualities of the main approaches to relief space. None of the ways of treating space which we shall be discussing is of necessity aesthetically better than the others. In particular we should not think of the space of pre-Renaissance reliefs (and pictorial art) as a more or less clumsy attempt to achieve something which reached perfection in systematic perspective. The degree of naturalism in the representation of space may be indicative of progress in the *science* of representation but such scientific advances are of aesthetic

significance only because they open up possibilities of new *kinds*, not new *degrees*, of artistic excellence.

PRESENTATION IN THE PLANE

When we look at an object or witness an event in real life we usually move in relation to it and thus see it from a number of different points of view. Our ability to understand what things are and what is happening in the world depends to a great extent on this shifting viewpoint, since objects and events are seldom revealed with complete clarity in any one view. It is in the nature of pictures and reliefs, however, that they can present us with only one view of their subject. This is one of the most fundamentally artificial (in a non-pejorative sense) aspects of representational reliefs and pictures and its effect on their composition is profound and far-reaching. In particular it gives rise to one of the relief sculptor's main problems, namely that of arranging the parts of his subject in such a way that the content of the relief and its significance may be apprehended in one view. In a simple single-figure relief this may entail nothing more than merely posing the figure in such a way that its actions or significance are clearly visible to the viewer. The action of an archer firing a bow, for example, is more clearly shown in a profile than in a front view, while the significance of the Crucifixion is obviously more apparent from a front view. But in a narrative or dramatic composition involving numerous figures and a variety of actions, the problem is more complex. It is, of course, essentially a *pictorial* problem, perhaps the most fundamental of all pictorial problems.

Fig. 2

The various ways in which artists have responded to this problem are among the most distinctive characteristics of style and many of the features which we find most aesthetically interesting in different styles of pictures and reliefs originate in the artist's search for a solution to it. In fact the solutions are so diverse and ingenious and so rich a source of aesthetic interest and enjoyment that it should perhaps be regarded more as an opportunity to be exploited than as a problem to be solved. Like many such problems in art it has acted more as a stimulus to the artist's imagination than as a constraint upon it.

If the significant parts of the subject of a relief are to be brought into view they must be spread out over the two dimensions of the field of the relief. There are, of course, many ways of doing this. One of the most common is to spread them out mainly in a horizontal direction so that the action of the composition and the relations between its parts are unfolded, so to speak, across the width of the relief. Another way is to distribute them up and down the field, so that we read the composition mainly in a vertical direction. Of course, the way in which a sculptor arranges his subject-matter depends to a considerable extent on the shape of the field it has

to occupy. A frieze naturally demands a mainly horizontal composition, while a tall panel or a door jamb calls for a vertical one. But there is more to it than that. The way in which the horizontal and vertical dimensions are used contributes to the expressive character of the composition and may be intimately connected with the sculptor's approach to the problems of representing three-dimensional space. It is much more than a simple matter of space-filling, as we shall see later.

We shall now turn our attention from general problems and consider one or two examples, but in fact almost every relief illustrated in this book could serve as an example, since the need to present a subject clearly in the plane is pretty well universal. As we take note of the various aspects of relief in the chapters which follow we shall see how all-pervasive this need is and how many aspects of the art of relief sculpture it affects. We shall see, for example, how Egyptian relief sculpture is dominated by a desire to present its subject so that it can be apprehended with the utmost clarity, and we shall see how powerful an effect a similar need for clear presentation in the picture plane has in the vastly different reliefs of Donatello.

In the Greek votive relief *The Abduction of Basile by Echelos* the action has been clearly spread out across the field. Both Basile and Echelos are turned towards the viewer – an unlikely position since the chariot is moving to the left – and Echelos's hands have been arranged so that they can both be seen, the left holding Basile and the right holding the reins. The four horses are not represented in a complete side view, which would be consistent with the position of the chariot. Only the first horse is shown in this way; the others are staggered in such a way that their heads and forequarters come into view and an opportunity arises for creating a lively pattern of movement with their legs. Hermes, who is holding a torch (a detail which was painted) in his left hand and showing the way up the slope out of the darkness of the underworld, is also turned towards the viewer and is brought in closer to the horses than he would be in reality.

Although, possibly as a result of centuries of paying too much attention to the writings of Plato and Aristotle, we have become accustomed to thinking of the style of Greek sculpture as one which 'imitates nature', we should bear in mind that, as in this example, the naturalism is almost always subordinated to the interests of visual clarity and composition. The modern viewer's ideas of pictorial space receive a considerable shock when he notices that while Hermes's feet are in line with the hoofs of the nearest horse, his left arm is behind the head of the furthest horse.

The Abduction of Basile by Echelos is not a reproduction of a segment of reality but a carefully constructed composition in which the forms and spatial relations of objects and events belonging in

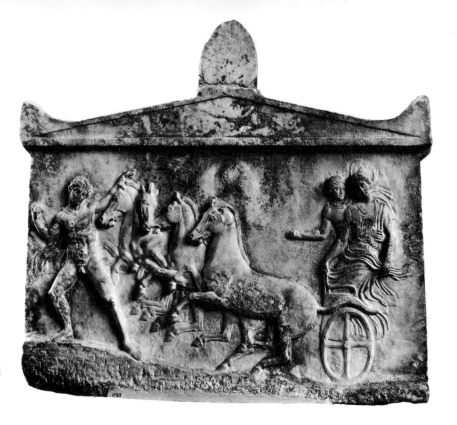

The Abduction of Basile by Echelos, Greek, c. 400 B.C. Marble, 88 × 76cm. National Museum, Athens. *Hirmer Fotoarchiv München*

three-dimensional space are radically transformed in order to accommodate them to an entirely different mode of existence. The relief is a product not of a mindless copyist but of a sophisticated visual intelligence and sensibility. It is not one of the greatest of Classical reliefs but it does show admirably the principles of composition which underlie most of them. The subject-matter in almost all Greek reliefs is spread across the field in this way and the action or movement is transmitted from figure to figure in a horizontal direction.

The Flight into Egypt, a Romanesque carving by Gislebertus, the master sculptor of Autun Cathedral, is also presented in a way that enables us to grasp the essentials of its significance and design immediately. The whole composition is spread horizontally in a shallow layer of space parallel with the face of the capital which it decorates. Gislebertus has used the side-saddle riding position as an opportunity for showing Mary, the infant Jesus, and their actions and relationship clearly in the frontal plane, while at the same time showing the ass in its more visually characteristic side view. Mary's frontal position also has great psychological advantages. It has enabled Gislebertus to treat her body and limbs as a hollowed-out niche into which the Child is fitted, and to give the impression that he is looking out towards and being presented to the congregation. Joseph occupies a corner of the capital and he has therefore been designed to be seen from both the side and the front. All the parts of this small carving are

20

19

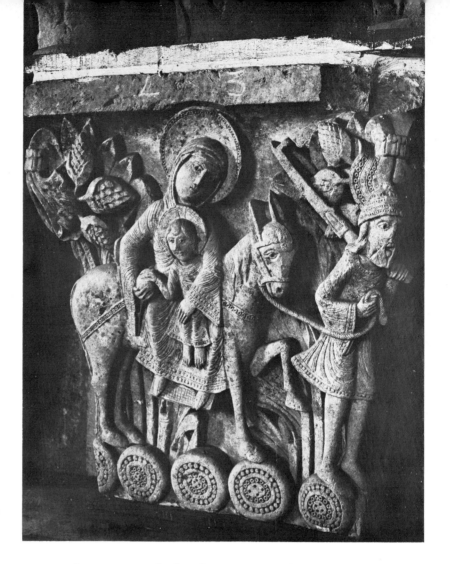

The Flight into Egypt, by
Gislebertus, *c.* 1130. Capital
from Autun Cathedral. Stone,
H. 75cm. *Archives
Photographiques*

*The Meeting of Pope Leo I and
Attila,* by A. Algardi,
1646–53. Marble, H. 25ft.
St. Peter's, Rome. *Mansell
Collection*

presented in a view which takes account of the way they will be
seen by the spectator and which clearly expresses their narrative
and more deeply religious significance.

It would be difficult to find a greater contrast to the small quiet
capital of Gislebertus than Algardi's enormous dynamic relief *The
Meeting of Pope Leo I and Attila.* But however different in expression
Algardi's relief may be, the sculptor has still had to find a way of
arranging his subject in the plane so that its significance may be
grasped in one view. His two protagonists are brought clearly into
view, full-length and in the foreground, and they are arranged in
a way that brings out the full dramatic significance of the encounter.
Their gestures, bodily attitudes, and facial expressions are emphatic
and clearly in view, like those of actors who want to make quite
sure that their audience will see and understand all that is
happening on the stage. The apostles miraculously appearing in
the sky are staggered so that they also are brought clearly into
view. They make a strong diagonal which dominates the scene

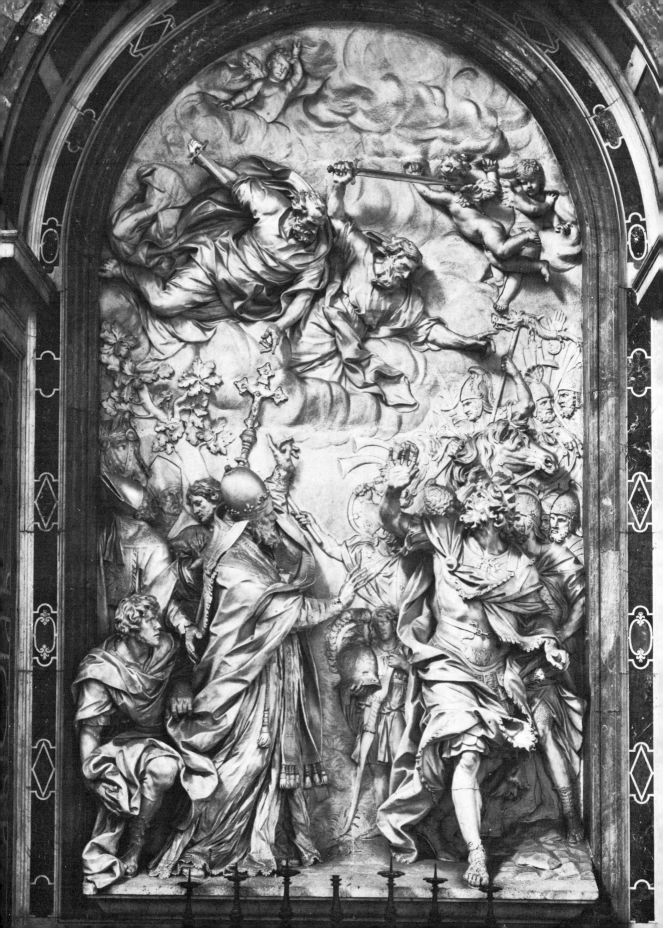

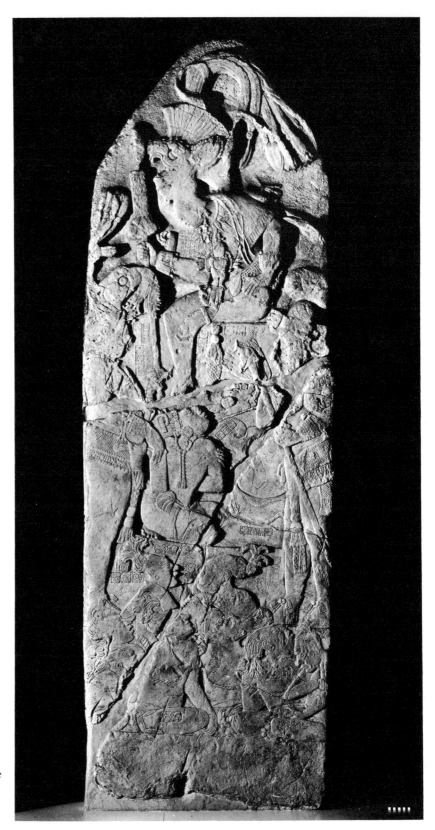

Stele No. 12 from Piedras
Negras, *c.* 510. Stone,
H. 313cm. Museo Nacional de
Arqueologia, Guatemala.
*The University Museum,
Philadelphia*

both in depth and across the picture plane, and their relations with the group below are unmistakable. The expressiveness of the design, in addition to its narrative significance, is clear in pictorial terms. The strong forward-leaning lines of the Pope's body and upstretched arm, reinforced by the line of the cross, are connected with the arm of one apostle and the body of the other to suggest an invincible force which resists and dominates the confused and broken forms of Attila and his army, who are being pushed, as it were, towards the edge of the composition and out of the picture.

A refined and complex example of relief composition in which the subject-matter is spread out vertically is the Classic Mayan Stele no. 12 from Piedras Negras. In their exploitation of the spatial and formal possibilities of the relief medium the sculptors of Piedras Negras are both adventurous and subtle, as this and other reliefs show. The military chief at the top of the Stele is represented in a remarkably expressive relaxed pose. His head-dress is spread out to fill the top of the Stele and his ceremonial spear is held out to one side, where it is clearly in view. He is shown looking down at the prisoners, who are arranged in two tiers beneath his throne or platform. The tiers are precisely separated and the heads of all the prisoners are clearly in view, as are the ropes which bind those in the foreground. The two guards standing in profile on either side of the Stele are in full view and are standing on yet another level. They unite the top and bottom halves of the composition. The whole complex scene is spread out vertically in the field of the Stele in such a way that all the figures and their relations are clearly visible. It is not fanciful to see more in this arrangement of the figures than a mere description of their spatial relations. It seems also to express the human situation. The chief dominates the scene from above and the two guards, massive, straight, and implacable, hem in and seem to crush the crowded, pathetic prisoners.

THE GROUND PLANE It is common visual knowledge that movement or position in depth may be represented pictorially by movement or position up and down a picture plane. This fundamental pictorial method of representing spatial recession is not an arbitrary convention but is based on familiar visual experience. When we look at a number of objects standing at various distances from us on level ground — a row of posts, for example — we notice that the more distant objects are higher in our visual field. Another example is the way in which a ship sailing away from us moves upwards in our visual field towards the horizon. Professor Rhys Carpenter points out the interesting fact that the Greeks had an idiom which 'refers to a ship putting out from the shore as sailing "up the sea"'. Even when there are no other indications of the existence of a picture

23

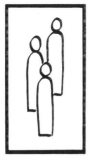

Fig. 3

space, we tend to interpret arrangements like those in Fig. 3 as arrangements in depth. The positions of the figures give us the impression that they are standing at various distances on a receding ground plane. The impression is of course enhanced if other indications of depth, such as overlapping, are also present. This is one of the most widespread methods of representing recession. It is used in Indian, Chinese, Greek, Roman, and medieval art and is of course a fundamental feature of systematic perspective.

BIRD'S EYE PERSPECTIVE

Vertical arrangements of the kind we have just described tend to be interpreted by modern viewers, who are familiar with systematic perspective, as a view from above. It is an optical fact that we see more of a ground plane, in the sense that it is less foreshortened and thus extends further up our visual field, when we view it from an elevated position. The vertical arrangement of the composition of many Roman and other pre-Renaissance reliefs suggests to the modern viewer that the artists have represented their subject from a great height. The terms 'bird's eye perspective' and 'cartographic perspective', which are frequently used in connection with this method of representing space, imply this. It is not at all likely, however, that Roman, Indian, and Gothic artists deliberately set out with the intention of representing their subject as though they were looking down on it from a high viewpoint. If the sculptors did realize that their scheme could be interpreted in this way, they no doubt accepted this as a minor disadvantage which was outweighed by its great compositional advantages.

Briefly stated, its advantages are these. First, it tends to produce over-all compositions which often have considerable decorative value since they spread vertically as well as horizontally and thus occupy the whole field of the relief. Second, by separating and spreading out the parts of a composition vertically it avoids the confusion that would result if they were arranged one behind the other on the same level. Thus the method helps the artist to present his subject more clearly in the plane. Third, while suggesting a certain degree of recession in space, it also preserves much of the plane character of the field or background. It is in effect a method which compromises between planarity and depth space. A few examples will make this clearer.

Our first example is a stone carved roundel from a cross bar of the rail surrounding the great stupa (relic mound) at Amaravati, 'which in the 2nd century A.D. was by far the finest monument in the Buddhist world. It is now a circle of debris enclosing a few broken pillars and the course of a small stream.'[1] The roundel,

[1] Douglas Barrett, *Sculptures from Amaravati in the British Museum,* London, 1954, p. 21.

along with many other sculptures from Amaravati, is now in the British Museum. These great works of art, which were formerly on display in the entrance hall of the Museum, have unfortunately not been on view to the public for some time.

The scene depicted in the roundel shows Buddha in one of his incarnations seated as a young prince on a couch beside his father. In spite of the seductive charms of the female dancers, musicians, and other attendants who surround him the prince remains firm in his resolve to renounce the world. In a small inset at the top left he is shown taking leave of his mother on the day of his final departure from the palace.

The composition of this relief is a good example of the way in which the demands of the picture plane and the picture space may be reconciled. The scene is certainly represented as having considerable depth. Between the figures at the very bottom of the roundel and those leaning over the back of the couch several layers of depth space are implied, and the background of the relief may be seen as a ground plane extending considerably in depth. At the same time, however, the relief has been carefully designed as a flat composition within the circular picture plane, and the depth suggested by the vertically arranged sequence of overlapping layers is partly cancelled out by the similarity of scale in the foreground and background. The result of selecting such a view and arranging the composition in this way is to create an ambiguous space which manages to suggest depth without giving

Mandhata Sharing Sakka's Throne, from Amaravati, India, middle or second half of 2nd century. Stone, DIAM. 2ft. 8in. *The Trustees of the British Museum, London*

the impression that the integrity of the picture plane has been destroyed. Such an arrangement has architectural value because it visually enhances the building surfaces without suggesting any penetration of them. We are aware of the depth of the composition but our eye is not drawn into a receding picture space.

The shaft of Trajan's Column, one of the greatest sculptured monuments of the ancient world, is covered by a spiralling band of relief carving some 625 feet long which recounts the story of the emperor's Dacian wars. The military events and episodes are fused into a continuous sequence which unfolds as the spiral winds upwards. Vertical, bird's eye perspective is used throughout partly because it lends itself to the creation of an over-all pattern on an appropriate scale, but also, no doubt, because it provides opportunities for including a wealth of incident and detail. Some such method of representing depth without seriously detracting from the planar quality of the field of the relief is even more important architecturally in this instance than in the Amaravati roundel. Any strong suggestion of a receding depth space entwining the shaft of a huge column would be absurd.

Trajan's Column, with details of lower windings. Roman, *c.* 113. Marble, H. *c.* 100ft. Rome. *Mansell Collection*

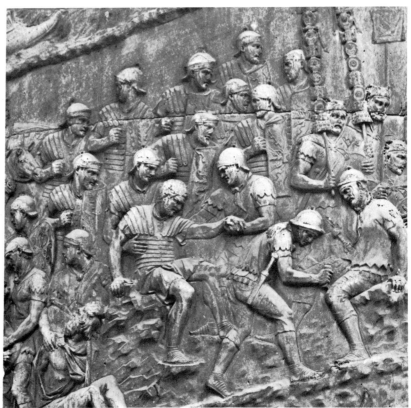

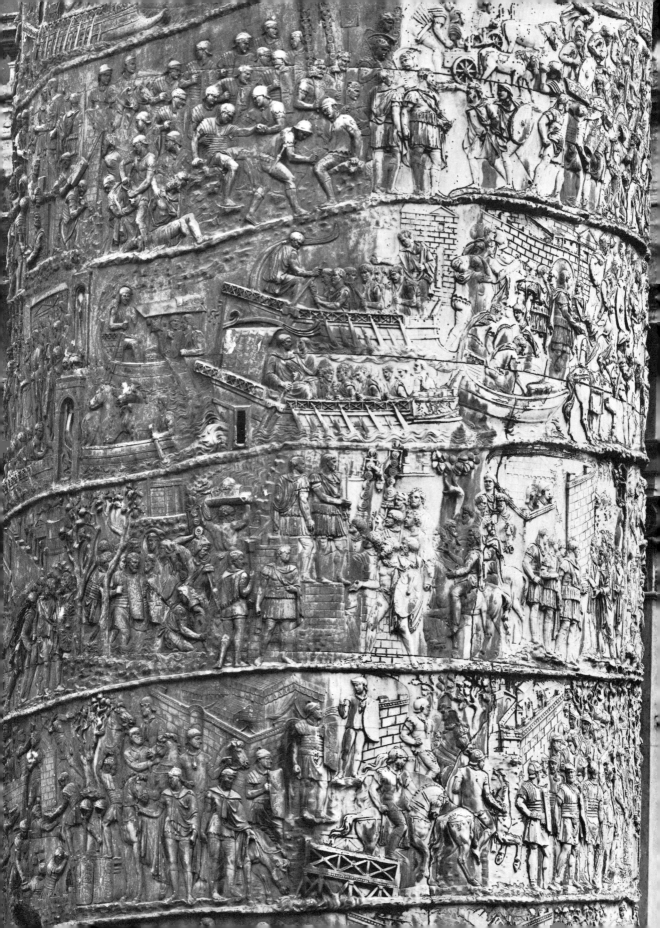

In Giovanni Pisano's *Annunciation, Nativity, and Annunciation to the Shepherds* a number of separate events and different angles of viewing are combined in one crowded composition. No attempt is made to create a consistent space. The Annunciation scene on the left, the two women washing the Child with Joseph (in the bottom left corner) watching them, and the shepherd on the right are all shown more or less from normal eye level; the reclining figure of Mary and the Child in the crib are seen from a more elevated position, while some of the sheep at the bottom of the relief are almost in plan view. The parts of the composition are arranged for clear and dramatic presentation in the frontal view and for the creation of an all-over pattern of boldly projecting forms with strong shadows and highlights. Yet although there is no coherent picture space and an apparently arbitrary use of scale for the figures, we still tend to read the bottom of the relief as a foreground and to equate height in the picture plane with depth in the picture space. The main reason for this is that the effect of the vertical arrangement of the parts of the relief is reinforced by a considerable degree of overlapping. We must now turn our attention to this.

Annunciation, Nativity, and Annunciation to the Shepherds, by Giovanni Pisano, 1301. Marble, 84 × 102cm. S. Andrea, Pistoia. *Mansell Collection*

Massacre of the Innocents, by Giovanni Pisano. Details as above

OVERLAPPING It is an obvious visual fact that distant objects or parts of objects are hidden behind others which are in the same line of vision. This overlapping, or superposition, of forms is one of the most powerful of all visual clues to the relative positions of things in depth and it is used a great deal in the pictorial arts for this and other purposes. We have only to draw two or three overlapping shapes to evoke immediately a rudimentary impression of three-dimensionality.

In a picture the overlapping of forms, like all other 'three-dimensional' features, is represented by the arrangement of shapes and lines which are all actually in the same plane. In reliefs, however, there is the added possibility of making one form actually project in front of another, so that they are to some extent superimposed in fact and not merely in appearance.

Because overlapping involves the partial concealment of the objects and events which are represented in a picture or relief it is usually treated with great care. It is possible to make forms

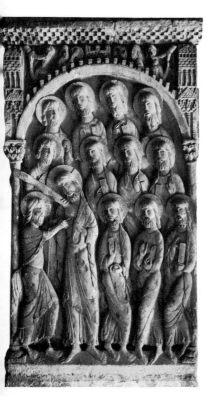

Doubting Thomas, 1085–1100.
Stone, approx. 2 × 1m.
Santo Domingo de Silos, Spain.
Photo Mas

overlap in such a way that they become unrecognizable or clumsy. Many primitive and archaic forms of pictorial art avoid or minimize overlapping and show each component as a complete object, isolated and completely contained within its own unbroken contour. Egyptian artists never overlap objects in a way that conceals any important contours, and in many works they go to considerable lengths to avoid overlapping altogether.

The overlapping of forms in a relief does not necessarily imply the existence of a consistent picture space for the whole relief. It may be simply a way of stating that one object is behind another without any attempt to represent depth space as such. When donkeys or cattle in Egyptian reliefs and soldiers in Assyrian reliefs are shown in echelon, any tendency of the viewer to see an indication of a picture space is immediately checked by the observation that all their feet are on the same horizontal ground line. Again, in the Romanesque relief from San Domingo there are three layers of overlapping figures, which would normally imply a considerable recession, but against this there is no diminution in the size of the figures, and the haloes of the hindmost (and highest) layer overlap the arch in the same way and presumably in the same plane as the two front figures on the extreme left and right. They are, as it were, placed one behind the other but are also in the same plane.

The compositional effect of overlapping depends very much on the point of view chosen for the relief as a whole. The elevated viewpoint of the Amaravati roundel makes possible the inclusion of a great number of overlapping layers of figures. If the viewpoint were lowered and the whole scene put into a more consistent picture space, the successive layers of the composition would become more and more completely eclipsed until the whole effect became chaotic and visually unintelligible.

In a similar manner the amount of overlapping in the Parthenon Horsemen frieze is carefully calculated to achieve a high degree of clarity – we can see perfectly well what is going on – and to provide a horizontally linked pattern of line and form. It achieves a balanced degree of visual complexity, avoiding both the dullness of a mere progression of separate events and the visual chaos that would follow from sandwiching together too many overlapping layers. The result is a lively impression of movement and conflict.

In the case of the Piedras Negras Stele the background clearly 22 does not represent a continuous ground plane, as in the Amaravati 25 roundel, but a series of raised platforms or steps. It is difficult to determine to what extent the vertical arrangement is intended to represent depth or to represent the different heights of the platforms on which the figures are placed. It is clear, however, that depth *is* represented and that there is some consistency

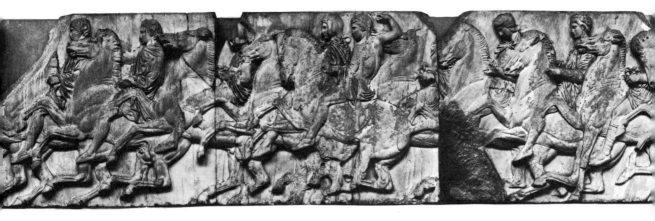

Procession of Horsemen, from
the north frieze of the
Parthenon. *c.* 432 B.C.
Marble. British Museum,
London. *Hirmer
Fotoarchiv München*

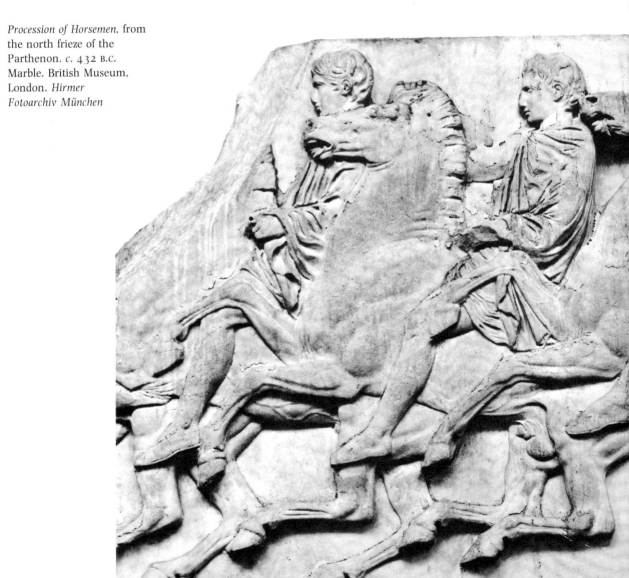

in the sequence of overlapping planes and in the positions of the figures in depth space. There are four overlapping layers of figures in the foreground at the bottom of the relief, and the hindmost layer of these clearly overlaps the guards. The guard on the left is unmistakably in front of the prisoner on the second tier and his head-dress overlaps the spear of the warrior chief above and behind him. If we see this scene as taking place on a series of steps or platforms which as well as ascending are also receding in bird's eye perspective, it appears to be perfectly coherent spatially and, in comparison with any pre-Greek old world sculpture, to be astonishingly sophisticated. It is an interesting and highly successful solution to the problems of spatial representation, space-filling, and clarity of narrative.

As an example of a relief in which overlapping is used within a coherent perspective space we may take one of Donatello's four bronze panels of the *Miracles of St. Anthony* from the Paduan Altar, *The Heart of the Miser*. The viewpoint from which the subject of this relief is represented is on a level with the eyes of the standing figures in the relief. The heads of all the figures, whether standing in the foreground or in the background, are therefore shown on the same horizontal line. Some of the background figures are almost completely obscured and all that we can see of them is a part of their heads. The effect is very like that of being in a crowd and would be completely chaotic visually if Donatello had not taken great care to arrange the parts of his composition in a way that makes the narrative clear. He has placed the important figures in clear view in the foreground so that the body of the miser, the figure leaning over the body displaying the cavity in its side, and the figure of St. Anthony are plainly visible. In a similar way the miser's money chest, in which his heart was

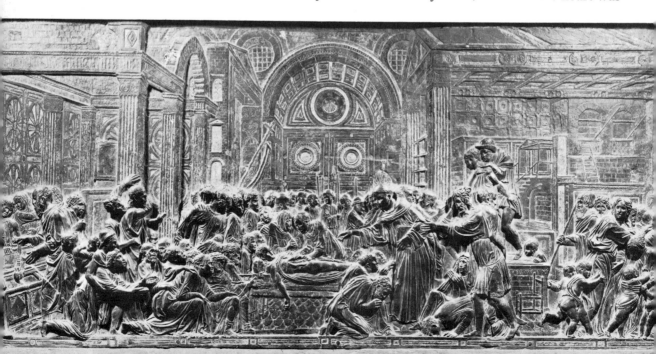

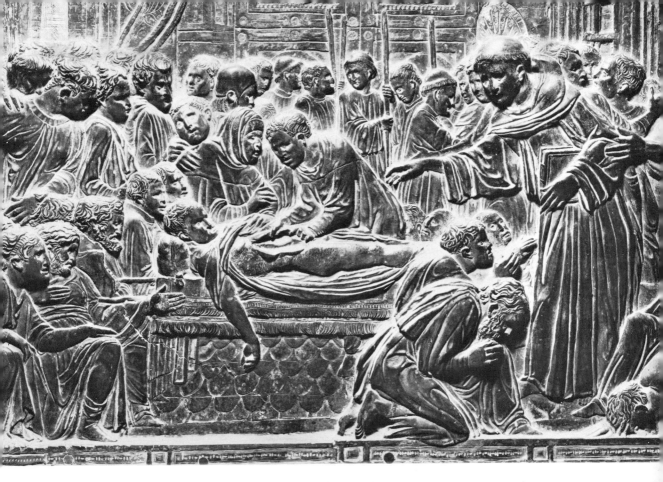

The Heart of the Miser, by
Donatello, from the High
Altar, S. Antonio, Padua,
1449. Bronze,
57 × 123cm.
Mansell Collection

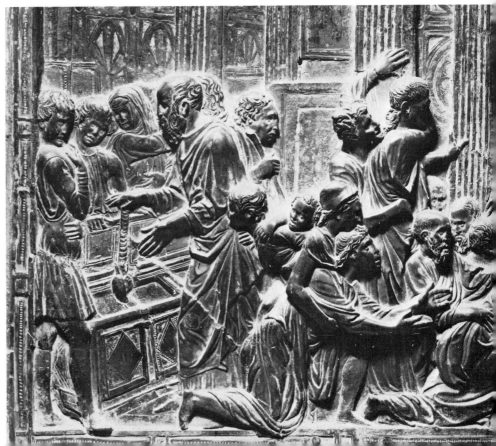

found, is brought clearly into view on the extreme left of the composition. The extremes of overlapping are confined to the relatively unimportant parts of the composition. The figures that are barely visible serve mainly to provide a busy crowded setting for the dramatic chief event and, by leading towards it, to focus attention on it as a centre of interest.

The overlapping of forms serves a variety of decorative and expressive purposes. In the Donatello it assists the general impression of agitation and drama. In the Parthenon frieze it contributes to the movement and links the succession of horizontal parts of the frieze into a continuous band. In the San Domingo relief it enables the sculptor to create a formal decorative repeating pattern of heads and haloes which occupies the whole field of the relief. In the Amaravati roundel it contributes to the richly varied organic pattern of the whole relief, heightening the feeling of sensuousness with its contrast of deep shadows and layers of full, convex, boss-like forms.

PHYSICAL PROBLEMS OF OVERLAPPING

As we have already remarked, the overlapping of forms in reliefs involves some degree of actual physical superposition. In pictures the overlapping of any number of layers of forms raises no special problems, since no actual projection is involved, but in reliefs the overlapping forms do have some degree of actual thickness and this raises a number of interesting problems which have acted as a stimulus to the imagination of sculptors. The main problem from the sculptor's point of view is that he has to create these superimposed layers within a limited depth space. There are many methods by which sculptors of different periods and styles have overcome this problem, and there are many different types of composition which owe their origin to the sculptors' attempts to overcome it.

Perhaps the most obvious and straightforward method of overlapping a number of forms in a limited space is to put all the forms into different planes of relief, so that the foremost layer constitutes the front plane and the other layers lie in a series of receding planes between this front plane and the background. This is tantamount to arranging the forms so that their relative positions in the condensed space of the relief correspond with the relative positions they are represented as having in natural space. This has been done, up to a point, in some reliefs; but in practice such an apparently logical procedure imposes severe restrictions on the composition as a whole, although it may work satisfactorily in parts. The important point to grasp here is that it is the visual effect of superposition which counts in a relief, and that what is found by experience to be visually effective has no necessary connection with an abstract scheme which satisfies an intellectual desire for order and logical procedure.

The designer of the Horsemen frieze from the Parthenon —

34

presumably Phidias — could not possibly have placed all his forms in planes of relief which corresponded with their represented depths. He has made use of the horizontal extension of the field of the frieze to create a complex cavalcade of overlapping horses and riders, and in places it is possible to trace some dozen or so overlapping layers of form, all apparently in different planes. And all this is achieved within a depth of some three or so inches. Obviously no kind of exact mathematics of recession could possibly apply here. What the designer has done, with extraordinary subtlety, is to combine spatial fact and optical deception. Some of the horses and riders do actually lie in different planes of relief, but there is no consistency in this. It is not so much the degrees of projection of the forms from the background plane which indicates their represented depth. It is rather the behaviour of the contours which provides us with the strongest clues. As in many types of drawing, it is the contours which define the forms and tell us which forms are in front of which. The plastic surfaces within the contours are modelled with great subtlety, but where necessary

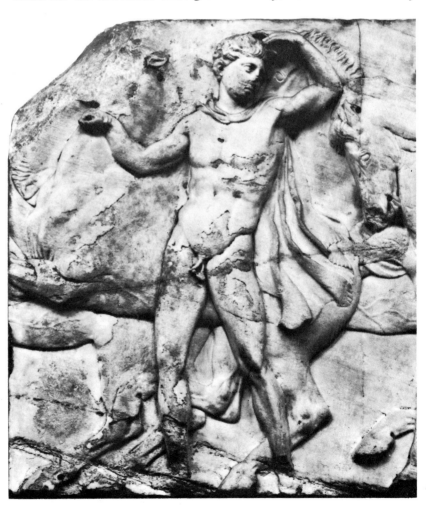

Youth Standing by a Horse, from the north frieze of the Parthenon, *c.* 432 B.C. Marble, 3ft. 7in. British Museum, London. *Hirmer Fotoarchiv München*

they are hollowed out or cut back to provide enough stone for a superimposed form and to give the necessary thickness for a contour. Thus a horse's flank is cut back to make room for a rider's leg or for a standing figure, and the hindquarters of one horse are cut back to make room for the overlapping forequarters of another. The thickness of the forms is varied so that they may be superimposed and still fit into the available depth. The actual physical substance of the whole relief is treated as a constantly varying plastic layer, not as a series of superimposed layers at regular intervals of depth. But the effect of all this when it is seen by a viewer is to convey just the right impression of overlapping and relative depth. In this subtle and difficult process there are few rules; the sculptor can rely only on his experience and visual sensibility. As Edouard Lanteri remarks in his well known manual *Modelling and Sculpture,* 'beyond the outline of the figure, which remains the same as in the model, all the rest is artifice.'[1]

The methods of overlapping which are used in the Horsemen frieze are common in low reliefs, especially horizontally composed ones. Attempts to solve the problems of overlapping in higher reliefs, especially those in which the forms overlap vertically, have led to some extremely interesting types of composition. The principles involved in this are best illustrated by a series of examples. These have been chosen because they form a series for the purposes of explanation. They do not illustrate any kind of actual historical development.

Let us consider first how two rows of overlapping figures might be presented in a relief. It would be an easy matter in a simple regular arrangement of this kind to carve the more advanced figures in high relief and the deeper-lying figures in low relief and to keep them both in separate planes. Obviously the individual figures in the back row must be carefully placed in relation to those in the front row or they would be hidden. If the figures are all on the same level, the heads and shoulders of the figures in each row are usually alternated so that the heads of the figures in the back row can be seen looking over the shoulders of the figures in the front row. This basically is the method of composition used in such famous Roman processional and group reliefs as the friezes on the Ara Pacis and the Cancellaria reliefs. In these works the compositional scheme is not rigidly applied. The spacing and poses of the rows of figures and the relationships between them are varied in ways that enliven the composition and maintain our interest.

The back row of figures may be more clearly brought into view if it is raised above the first row, as in the slab of a Roman frieze representing a procession of city magistrates. This combination of vertical perspective and different planes of relief is an important compositional device. It is used in this Roman relief as a scheme for

[1] 1904, new edition, New York, 1965.

Fig. 4

Fig. 5 From a slab of a frieze with a sacrificial procession of the Vicomagistri. Roman

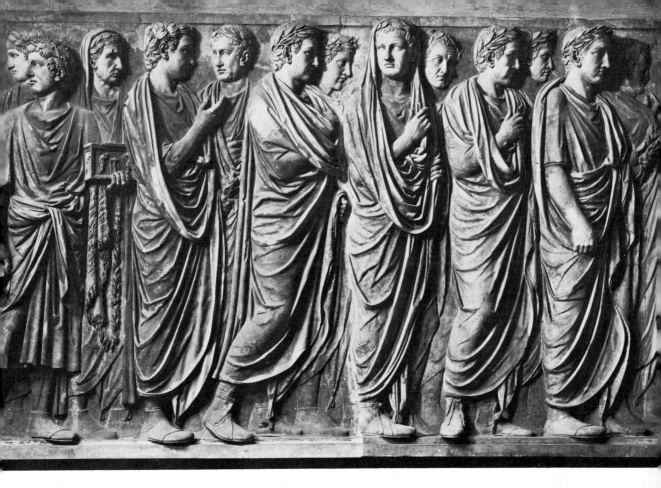

Emperor's Procession, part of
the frieze from the Ara Pacis
Augustae, Rome, 13–9 B.C.
Marble, H. (including dado)
6.30m. *Mansell Collection*

Fig. 6(i)

representing only two rows of figures, so the actual degree of
projection of the whole relief from the background does not raise
any special problems. But when several layers of figures are in-
volved the degree of projection could be considerable and some
kind of projecting platform or framed box-like recess is usually
required in order to support or contain them.

The most extreme types of composition with multiple layers of
overlapping figures are found in Late Gothic altarpieces and screens
in northern Europe. In these the figures are often arranged as
though they are standing at different heights on a sloping floor or
on steps. The effect is somewhat like a traditional school photo-
graph, although the figures are not usually rigidly organized in
rows but are arranged freely. A characteristic feature of these
reliefs is a steeply receding slope into the depths of the relief
across the heads of the figures. A composition of this kind requires a
considerable depth of relief. It may also require a sloping ledge for
the figures to stand on. This kind of recession is readily accommo-
dated in the stage-like compartments of Late Gothic altarpieces
and screens or in specially created hollow spaces within buildings,
but it is not suitable for use on walls or other architectural
members which have a structural function. It tends to destroy the

37

Fig. 6(ii)

Ludovisi Battle sarcophagus,
c. 250. Marble, 5ft. 9in. ×4ft.
Museo Nazionale delle terme,
Rome. *Mansell Collection*

integrity of their surfaces and to negate their character as architectural components. But in the Gothic altarpieces some degree of continuity in a front plane is maintained by the traceried canopies which surmount the figure groups in each of the box-like compartments.

There is one widely used method of composition which does enable the sculptor to represent overlapping layers of figures without destroying the continuity of the front plane. We have already mentioned some examples of this, such as the Amaravati 25 roundel and Giovanni Pisano's *Nativity*, but we have not considered 28 the ingenious ways in which compositions of this type meet the physical problems of overlapping.

These reliefs belong to a family of compositions which are sometimes called front plane reliefs because they are dominated by the foremost plane. The continuity of this plane is preserved by bringing all the main forms of the relief forward into it. Fig. 6(ii) illustrates the basic principles of these compositions. The heads of each layer of figures are brought forward into the front plane and are all actually on the same level, in spite of the fact that they belong to figures which lie one behind the other.

This is achieved by slanting the bodies of one tier of figures back into the relief in order to make room for the figures below. The tiers of figures are thus somewhat like a series of overlapping wedges. This relief system is extremely valuable for architectural and other kinds of reliefs in which it is desirable to preserve a

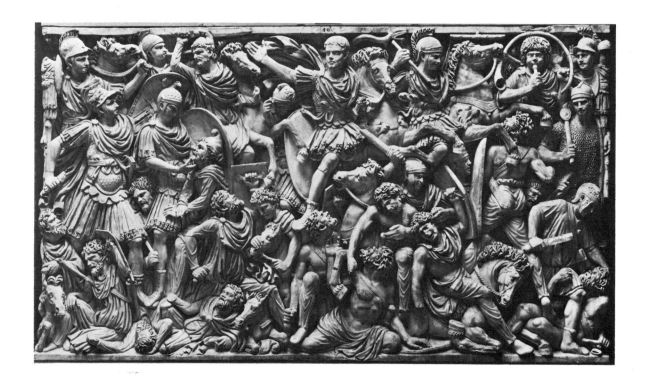

continuity of surface. If the front plane of the relief is the plane of the exterior surface of the original slab, panel or other matrix from which the relief was carved, then by preserving this plane in the finished work the sculptor also preserves the over-all shape of the matrix. The relief therefore does not unduly interfere with any role the matrix may have as an architectural component or with any shape it may have as an object in its own right. Moreover this is achieved without the necessity of sacrificing all attempts to represent depth. The effect might be described as an ambiguous compromise between the demands of the plane and of recession. The forms may be in high relief and they are in part one behind the other but they are also in the same plane.

It is typical of these reliefs that they are crowded with closely packed forms. This gives further emphasis to the continuity of the front plane because it eliminates large hollow space between the forms and leaves little or no room for a background plane to show.

There are abundant superb examples of reliefs which could serve as illustrations for these principles of composition. Panels from the great stupas of Amaravati and Sanchi; numerous early 25 medieval ivories; the panels from the pulpits of Nicola Pisano and his son Giovanni; the astonishing Roman Ludovisi Battle sarco- 28, 29 phagus – all of these are crowded compositions with overlapping figures in vertical perspective and they all preserve the integrity of the front plane.

In some of these front plane reliefs the total effect suggests that the composition has been conceived more as a recession from the front plane than as a projection from the back plane. In fact in many of them the back plane is virtually non-existent. The forms are carved at the front of the relief and the spaces between them are cut back to make a dark shadowed recess without any attempt to create a visible background. The most extreme examples of this kind of composition known to me are found in Gandhara sculpture.

FORESHORTENING

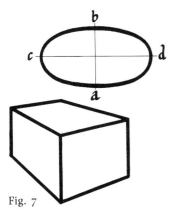

Fig. 7

Foreshortening is a familiar pictorial method of representing the recession of objects. A simple and well known instance is the use of an ellipse to represent a receding circle, that is a circle which is at an angle to the picture plane. If the ellipse in Fig. 7 is taken as a representation of such a circle, then AB and CD are equal since they are both diameters of the circle. In the picture plane, however, AB is considerably shorter than CD, and it is this which, in an appropriate context, gives us the impression that it is receding. This contraction of the depth dimension, or foreshortening, becomes more extreme (and the ellipse grows narrower) as the angle between the circle and the picture plane increases. Another simple example is shown in Fig. 7, where a cube is represented with all its faces at an angle to the picture plane and foreshortened.

This contraction of the depth dimension is also called foreshortening when it occurs naturally, outside the realm of art, in our actual view of objects. In fact, of course, foreshortening is effective in pictures because it is based on certain facts of visual experience. We say when we view a seated figure from the front, for example, that its nose, its lap, and its feet are foreshortened, and we mean by this that their extension in our visual field (which corresponds to a picture plane) is less than their 'true', or actual measured, extension. In fact any surface which is not at right angles to our line of vision will be in some degree naturally foreshortened.

When a draughtsman sets out to represent objects which are at all complex he will almost inevitably be faced with problems of foreshortening which he will have to take into account when deciding on the view from which he is to present them. Consider, for example, the problem of drawing a figure standing to attention. If he draws it from the side, he has a foreshortened view across the shoulders to contend with; if he draws it from the front, he has to find a satisfactory way of dealing with the foreshortening of the feet. But these are relatively simple problems involving no great degree of foreshortening. In fact, a figure standing perfectly upright presents the artist with fewer problems of foreshortening than a figure in any other position. There are some views of the figure, and of other subjects, in which the degree of foreshortening can be extreme, as it is, for example, in a view from the feet or head of a reclining figure.

Extremely foreshortened views are not merely difficult for the artist to represent; they can also be confusing to the viewer. A strongly foreshortened view of an object is not usually a typical or characteristic view and it is not always easily recognizable for what it is. In styles of art where the clear presentation of a subject is an important consideration extreme foreshortening is therefore usually avoided. Severe foreshortening is also extremely aggressive spatially. It totally destroys the plane character of the surface of a picture by giving a powerful impression of recession.

Throughout history artists have experimented and devised many different solutions to the problems posed by foreshortening. In the modern world many of the solutions adumbrated in earlier art have been systematized. This has been done partly as a result of the curiosity of the artists themselves and partly through the pressures on an increasingly technological society to perfect methods of communicating precise technical information in graphic form. Fig. 8 shows some of the methods, systematic and unsystematic, which have been used by artists at different times and in different cultures for representing a simple type of solid.

Foreshortening may be involved in reliefs in two different ways. First, owing to the contraction of the depth dimension in most kinds of reliefs the sculptor is obliged to employ methods of

Fig. 8

40

Tabernacle from the Altar of the Sacrament, by Desiderio da Settignano, 1461. Marble. S. Lorenzo, Florence. *Mansell Collection*

foreshortening which are similar to those employed by painters and draughtsmen. If the forms had their natural depth this would not be necessary, but in a condensed space the desired optical effect must be achieved by a combination of foreshortening with some degree of actual three-dimensional form. This is an extremely subtle process for which the sculptor's only criterion is the optical effect of what he does. The lower the relief is the more its methods of dealing with the problems of foreshortening, and of representing depth in general, tend to approximate to those of the pictorial arts.

There are many clear examples of such foreshortening in the arches and interior spaces which are represented in Italian Renaissance altarpieces and tabernacles such as the Altar of the Sacrament of Desiderio da Settignano in S. Lorenzo, Florence. A more complex example occurs in the wax relief of *Christ Led from Judgement* by that great experimenter with space, Giovanni Bologna. The throne of Pilate is a most effective and bold combination of actual three-dimensional projection and graphic foreshortening. So indeed is the bowl in which Pilate is washing his hands. It is modelled as an ellipse and tilted downwards towards the viewer with the result that it appears from directly in front to be a circular bowl which is naturally foreshortened.

The other kind of foreshortening which is present in some reliefs is natural foreshortening, which, as I have said, is not a feature of the relief itself, but arises in the spectator's view of it. If an arm is projecting straight out of the relief at the spectator or a figure is bending out of it towards him, then, although the forms themselves are not foreshortened but have their natural dimensions, the spectator will have a foreshortened view of them. Extreme natural foreshortening of this kind is not common in reliefs, although it

Christ Led from Judgement, by G. Bologna, *c.* 1580. Wax, 1ft. 7in. × 2ft. 5in. *Victoria and Albert Museum, London: Crown Copyright*

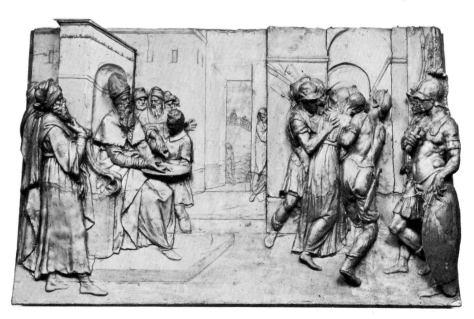

Nativity, fragment from rood screen, Chartres Cathedral, 1230–40. Stone, 0.93 × 1.31m. *Archives Photographiques*

does occur – particularly in Baroque reliefs, where it is mainly used for dramatic effect. An example of this occurs in Algardi's *The Meeting of Pope Leo I and Attila*. 21

Many of the characteristic differences in styles of art are a result of the methods employed by the artists for meeting the problems of foreshortening. The Egyptians apparently avoided foreshortening at all costs and their elaborate system of pictorial conventions seems to have been devised largely for doing just this. Many European artists during and since the Renaissance have been fascinated by the optical puzzles of foreshortening and have devoted their skill to finding ways of representing extremely foreshortened forms in a convincingly naturalistic manner. Mantegna's painting of *The Dead Christ*, the outstretched arms in Caravaggio's *Supper at Emaus*, and the horses in some of Pisanello's medals are well known examples of the deliberate choice of a difficult foreshortened view. Most styles of painting and relief sculpture, however, display an attitude towards foreshortening which falls somewhere between these two extremes. They have not gone to the lengths of the Egyptians but they have tended to avoid extreme foreshortening and to arrange their forms with their

maximum dimensions extended parallel, or more or less so, with the frontal plane. Thus outstretched arms seldom point into or out of the picture but are extended to left or right, and reclining figures are usually represented lying across rather than into the picture plane and are often tilted towards the front in order to avoid a confusing foreshortened view of the width of the body. Both these features of reclining figures occur together in many medieval Nativity scenes and in Indian reliefs representing the sleep of Vishnu. An example of the former is the lovely fragment from a rood scene at Chartres, and of the latter the Vishnu on the south face of the Temple of Vishnu at Deogarh. 71

OBLIQUE VIEWS · One of the most usual ways of avoiding extreme foreshortening while also avoiding the extreme loss of depth which comes from arranging everything parallel with the picture plane, is to represent the forms in a view which is in effect a compromise between extension in the picture plane and extension in depth. Consider again a figure standing to attention. If we view it not in profile or frontally but turned at an angle of about 45° to the picture plane, then neither the shoulders nor the feet are severely foreshortened. Oblique views of this kind often also have the advantage that they can show more of the subject than a straight side or front view. The view across the fronts of the four horses in the Greek relief of *The Abduction of Basile by Echelos* is an example of 19 this, but three-quarter views of heads and figures are the most common types of oblique views in relief sculpture. The unknown master of *The Raising of Lazarus* at Chichester Cathedral has posed

The Raising of Lazarus, 1125–50? Stone, H. 3ft. 8in. Chichester Cathedral. *A. F. Kersting*

his figures in this way on either side of the relief's centre of interest. This is partly responsible for the dramatic concentration of the composition. If the figures had been in profile, the sculptor could not have shown their gestures and facial expressions as clearly as he has; and if they had been shown from the front he would not have been able to concentrate their attention on the figure of Lazarus.

The use of oblique views is of course related to the already mentioned method of avoiding the effects of severe foreshortening across receding horizontal surfaces by taking an elevated view of them or by tilting them forwards.

SIZE In naturalistic Western art the relative size of an object or person represented in a picture or relief is determined objectively by two interdependent criteria. These are, first, its actual measured dimensions in relation to those of other objects in the picture (this is usually called its 'true' size) and, second, its relative distance in the picture space. Thus if two identical figures and a tree are located at equal distances in the picture space, the two figures will be the same size on the picture plane and they will be smaller than the tree. But if one of the figures is moved back some distance, it will become smaller on the picture plane, probably several times smaller than the nearer one, and if the other figure is moved forward it may become larger than the tree.

We have become accustomed to accepting this interplay of true size with perspective diminution as a method of representing certain well known facts of visual experience. But in most styles of art outside the influence of Western naturalism pictorial dimensions are not arrived at by such detached and objectively determinable criteria. In Romanesque, Gothic, Egyptian, Mesopotamian, pre-Columbian American, and most Oriental styles of art the relative sizes of the contents of a picture or relief are usually determined by more subjective or by compositional considerations.

In many styles the size of a figure is determined by its status, its importance in relation to the other figures. The terms 'hierarchic scale', 'hierarchic proportions', and 'psychological perspective' are frequently used to describe this common procedure. Thus a king, a hero, a saint, or a divinity will be given dimensions which are in keeping with his importance. Pharaoh, for example, is usually depicted much larger than his servants or prisoners and the principal figures in pre-Columbian reliefs are usually represented larger than the subordinate ones. In Hindu and Christian art divine figures such as Vishnu, Christ, and the Virgin may be represented on a scale which completely dwarfs the ordinary mortals in the composition. In the reliefs of the great Buddhist Temple of Borobudur ordinary citizens are depicted smaller than the members of the court. In the Amaravati roundel there is no 25

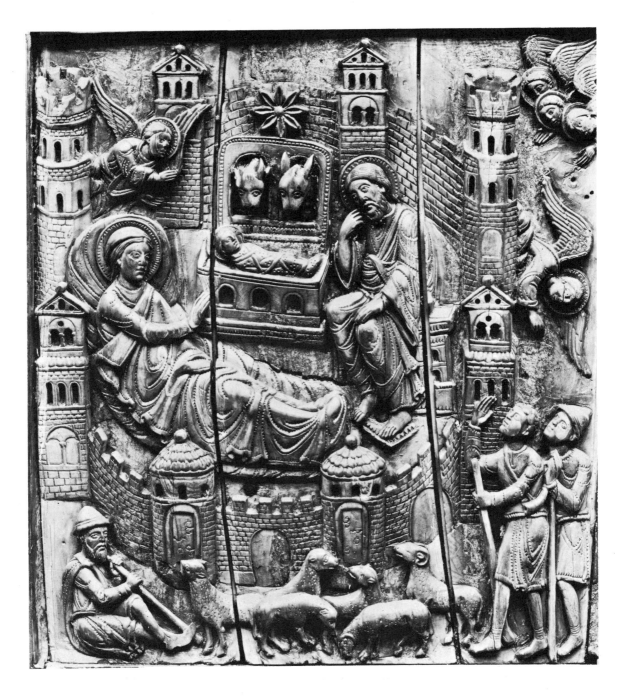

The Nativity, from Cologne,
1225–50. Walrus ivory,
21 × 19cm. *Victoria and
Albert Museum, London:
Crown Copyright*

difference of size between the female figures in the extreme
foreground and those at the back, but the prince and his father are
on a larger scale than all the other figures.

The sculptor of the Nativity scene in the Cologne ivory has
concentrated his attention, very successfully, on presenting his
subject clearly in the plane, and to this end he has spread it out
over the whole field of the relief so that each item in the story is
clearly in view. There was a time when the proportions and

spatial layout of this work would have been thought of as a clumsy attempt by an unskilled or naïve artist to represent a scene which was too complex for him. But of course it is not a piece of failed realism but a composite pictorial symbol which illustrates the Biblical text precisely in its own way. The city wall is a visual symbol which stands for the whole city and its scale in the composition was most probably determined partly by the artist's desire to use the whole working surface available to him and partly by the need to create a space within the city which would be large enough to contain the principal scene. The scale of the figures was almost certainly dictated partly by a hierarchical scale in which the Holy Family is more important than the shepherds and partly by compositional considerations, especially the desire to fit the figures into the available space without any confusing overlapping and without leaving any large vacant spaces. In any case, whatever the artist's reasons were for deciding on the scale of the objects and figures in this bold and delightfully composed panel, it is certain that they had nothing to do with objectively measurable dimensions.

In the Assyrian relief of the fleeing swimmers the size of the buildings in relation to the figures on them and in the water seems to have been determined primarily on compositional grounds. There was a great deal to be put into the composition and the sculptor has adapted the sizes of things in order to show clearly what is happening and in order to fit them into the spaces available in the composition. If the figures were represented in proportion to the buildings, they would be invisible. Again, it is ridiculous to think of objectively accurate proportions in connection with this relief. The overriding consideration was not any kind of 'truth to appearances' as we understand the phrase, but the clear representation of part of a battle. The main parts of this particular incident have been pieced together with remarkable ingenuity to make an extremely direct and clear composition.

Fugitives Crossing a River, from Nimrud, *c.* 9 B.C. Stone, H. 99cm. British Museum, London. *Mansell Collection*

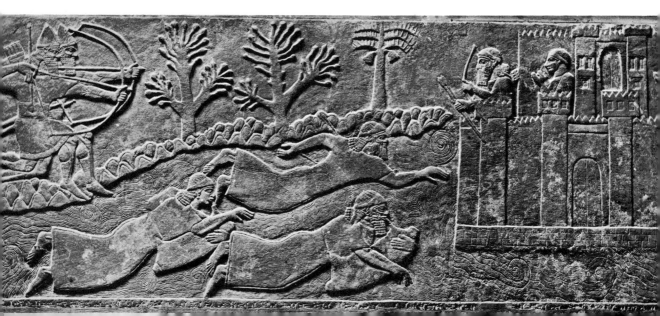

In post-Renaissance Western art a picture or relief usually represents a single scene, a complete incident, or a set of simultaneously occurring events. But this kind of unity of space and time is by no means a universal feature of pictorial art. There are many styles of art in which a single, self-contained, and, from the point of view of its design, completely unified composition may depict a number of separate incidents which must be understood as occurring at different times and in different places. It is quite usual for the same person to be represented several times in what appears at first glance to be a single scene. Obviously there is in such compositions an underlying unity of idea in the sense that the separate incidents are all related to a central incident or theme.

The Amaravati roundel is almost entirely made up of a single 25 scene, but in the inset at the top left Buddha appears for a second time in an entirely different and later incident with his mother, who is distressed at his intention to leave the palace. This incident is obviously related to the main scene but it is not part of it.

In Giovanni Pisano's *Nativity* panel four scenes connected with 28 the birth of Christ are represented in one unified design. These are: the Annunciation, the Nativity, the Annunciation to the Shepherds, and the Washing of the Christ Child. Mary and the Christ Child both appear twice in the panel, and the range of time and space covered by the incidents is considerable. While the small separate scene in the Amaravati roundel is isolated from the main part of the composition by a curtain and wall, the scenes in Giovanni Pisano's panel overlap each other and are fused into a continuous over-all design.

Jacob and Esau is one of ten panels in gilt bronze in the second 48 of two pairs of doors which Ghiberti made for the Baptistery in Florence. They are sometimes known as the *Gates of Paradise*, after 171 a remark attributed to Michelangelo. The *Jacob and Esau* panel takes the fusion of separate incidents into one composition a step further than Giovanni Pisano or any other Gothic sculptor. Several events which occurred at different times and places are represented. In the foreground, from left to right, are: a magnificently composed group of four women, who are usually said to be Rebecca and her companions; Isaac sending Esau and his dogs out hunting; and Isaac blessing Jacob, who is posing as Esau. At the back to the left is Rebecca lying in. In the centre the two brothers are quarrelling, while further back beneath the arches on the right Rebecca is advising Jacob, and on the extreme right Esau is out hunting. On the roof Rebecca appears again talking with God. There is no attempt to arrange these scenes in a sequence corresponding with the Biblical story but they all exist within a continuous coherent picture space and their spatial relations are most precisely determined within the architectural

Jacob and Esau, panel from the *Gates of Paradise* by Ghiberti, finished 1452. Gilt bronze, 79 × 79cm. The Baptistery, Florence. *Mansell Collection*

setting. This kind of coherence does not exist in Giovanni's panel. There is unity of design in it but there is no consistent scheme of spatial relations among the scenes. In fact spatially Giovanni's panel is a jumble, and the scenes have been arranged primarily with an eye to their composition in the plane.

In some narrative reliefs the incidents of the story are presented not simultaneously but in sequence, in a form of composition which is usually known as continuous narrative. This is a particularly common method of composition in friezes and other extended strip-like reliefs. The result is not altogether unlike a modern strip cartoon, although the incidents are not separately framed but are linked into a continuous composition. The Romans did not invent the continuous narrative relief – it was often used by Assyrian sculptors – but they used it a great deal and developed it considerably. The most extensive example is the helical relief band on Trajan's Column. 26

48

Space (2): Four Approaches to Space

PERSPECTIVE SPACE There are only a limited number of ways of directly evoking an impression of depth in a plane. They are based on the facts of ordinary everyday perception and are fundamentally the same in all types of pictures and reliefs. There is no difference in principle between the methods of suggesting depth which are employed in a relief which is composed according to the laws of perspective, say a Ghiberti or a Donatello, and one which suggests depth without using systematic perspective. The methods differ only in the consistency and accuracy with which they are applied. Western perspective is a fully systematic procedure for using methods which were formerly used in a free, unscientific manner. The most important of these methods, leaving aside all those which depend on colour and tone, are those we have described in the previous chapter: the overlapping, or superposition, of forms; foreshortening; the position of objects and events in relation to a ground plane; and the diminution of the apparent size of distant objects.

The system of perspective which was foreshadowed in Classical art and formulated theoretically for the first time in Italy during the early part of the fifteenth century is a geometrical method of constructing a picture space which, within certain limits, corresponds point for point with a human observer's view of actual three-dimensional space. In pictures and reliefs which conform to the rules of this system of perspective the picture space is completely organized around a single viewpoint and objects may be as precisely located within this notional depth dimension as they are in the other two actual dimensions of the picture plane. The point from which the objects and events within the picture space are viewed may be varied — it may be to the side, above, below, or in the centre of the field of the relief or the picture plane — but once it is chosen, the positions and dimensions of everything else within the picture space may be geometrically determined in relation to it.

The relative sizes and positions of objects in a given view can be projected on a picture plane by purely mechanical objective methods. The easiest way to do this is to plot them on a transparent plane, such as a sheet of glass, which is fixed at right angles to our line of vision. Provided we keep one eye closed in order to eliminate the confusing effects of binocular vision and keep our heads in the same position throughout the operation in order to maintain a consistent view, nothing could be easier. Although Alberti wrote the first systematic exposition of Renaissance perspective, it was Brunelleschi who invented it and first experimented with this pane-

of-glass technique. It is almost as simple as taking a tracing. The same result may be achieved without the interposition of a transparent plane by either measuring the positions and proportions of things with a pencil, or similar object, held at arm's length in a vertical plane that corresponds to the transparent plane – a practice commonly employed by draughtsmen – or, if one is sufficiently practised, by estimating them without measurements, 'by eye' as it is sometimes called. The view of the world that is obtained in this monocular stationary vision corresponds with that obtained by a camera and with the kind of view that may be constructed according to the rules of theoretical perspective.

The role of perspective in art is frequently misconstrued. It is not necessary to know anything whatever about the theory of perspective in order to be able to record accurately the dimensions and positions of things in the ways I have just described. What a knowledge of the theory of perspective enables the draughtsman to do is to *construct* an invented or remembered scene which will correspond to the view he would have of it if he could actually observe it from a fixed point. The theory of perspective is based on the laws which govern the mechanical process of visually projecting an actual view on to a transparent picture plane.

Perspective is sometimes spoken of as though it were merely one of any number of conventional systems for representing three-dimensional space pictorially. But this is not quite true. Western perspective corresponds to certain objective facts of human perception and is not merely conventional. Within certain limits it provides either a true record of a view of a segment of the real world or a convincing construction of an imaginary view of what could be a segment of the real world. J. J. Gibson, a psychologist who has devoted much of his time to the study of visual perception, writes:

From what I know of the perceptual process, it does not seem reasonable to assert that the use of perspective in paintings is merely a convention, to be used or discarded by the painter as he chooses. Nor is it possible that new laws of geometrical perspective will be discovered, to overthrow the old ones. It is true that the varieties of painting at different times in history, and among different peoples, prove the existence of different ways of seeing, in some sense of the term. But there are no differences among people in the basic way of seeing – that is, by means of light, and by way of the rectilinear propagation of light. When the artist transcribes what he sees on a two-dimensional surface, he uses perspective geometry, of necessity.[1]

In itself, perspective, however expertly and ingeniously it may be used to conjure up a semblance of real space, is aesthetically neutral. We must make a distinction between its use as a mere means of recording an actual view or constructing a realistic

[1] See 'Pictures, Perspective, and Perception' in *Daedalus*, Winter 1960, p. 227.

imaginary one without achieving anything of artistic value, and its use by such artists as Donatello, Raphael, and Ghiberti. In the hands of these and other artists perspective becomes a means of artistic expression, not a merely mechanical procedure or illusionistic trick. They use it as a means of creating special kinds of organized space which do not merely provide a realistic spatial setting for the forms of the composition but are themselves an important element in the total expressiveness of the composition.

We must bear in mind that, although these primarily pictorial methods of representing depth produce their effect in a plane, they are not, in reliefs, applied to a two-dimensional surface, as they are in pictures. The relief sculptor has at his disposal a limited stratum of actual depth space, and his problem is to use these pictorial methods in conjunction with this limited actual depth in order to represent a greater degree of three-dimensionality of space and form than the relief actually possesses. They, as it were, assist the actual diminished depth space and increase its effectiveness as a means of representing a realm of fully three-dimensional space and form. We could say that in pictures these methods of representing depth enable the artist to make something out of nothing, while in reliefs they help him to make a little go a long way.

The use of perspective in reliefs has been strongly attacked, particularly by artists who were brought up in the Classical tradition. Joshua Reynolds, lecturing in 1780 to students at the Royal Academy, had this to say:

The next imaginary improvement of the moderns is representing the effects of Perspective in bas-relief. Of this little need be said; all must recollect how ineffectual has been the attempt of modern Sculptors to turn the buildings which they have introduced as seen from their angle, with a view to making them recede from the eye in perspective. This, though it may show indeed their eager desire to encounter difficulties, shows at the same time how inadequate their materials are even to this their humble ambition.[1]

Sculptors' manuals abound in dire warnings to the student against the attractions of perspective. Edouard Lanteri had this to say in the second volume of his manual:

I must now deal with a question which has given rise to endless discussions, namely the introduction of perspective in low-relief sculpture.

The Greek sculptors have always looked at the backgrounds of their reliefs as at a solid plane and not as representing air or sky, and everything justifies their point of view. To begin with, the shadows which a relief casts on the surface from which it arises proclaim very clearly the solidity of this surface, whether it be a wall, a vase, or the shaft of a column, for if the marble background should stand for the sky, it would be absurd to let shadows be projected on to it. Secondly, if the sculptor

[1] Discourse no. 10.

wishes to represent the appearance of a painting, he must progressively diminish the size of the figures which he means to be in the background; but he will be contradicted by the light, which will strike these figures as strongly as those in the foreground. . . .

Modern low relief, alas, is very far from Greek art. It has been subjected to the influence of painting, and to realise this you need only compare a specimen of the frieze by Phidias with the doors of the baptistery of St. John at Florence by Lorenzo Ghiberti . . . [Lanteri also mentions here *The Rape of the Sabines*, a relief by Giovanni Bologna.]. Ghiberti has brought in aerial and lineal perspective for the treatment of distance; he represents mountains, trees, sky and clouds, and he fancies thereby to have achieved a great progress over antique simplicity. But the brazen solidity of the background belies too clearly the vanishing lines and the illusory distance.[1]

More recently Sir Herbert Read, in the Mellon Lectures which he gave at the National Gallery of Art in Washington in 1954, attacked the whole Renaissance tradition of sculpture for its introduction of 'painterly prejudices' into the art of sculpture:

The theories of perspective developed by Brunelleschi and others in the fifteenth century had an immense effect on all the arts. However beneficial these influences may have been on architecture and painting – and I have my doubts about the effects of their influence on the latter art – in sculpture their effects were disastrous.[2]

Read was putting the point of view that sculpture is primarily an art of touch. Pictorial, especially perspectival, developments of the art were a 'perversion of the primary haptic sensibility'. But it is, of course, quite possible to accept Read's estimate of the importance of our sense of touch in sculpture in general without excluding the possibility of other kinds of sculpture. In an earlier essay Read said:

Painting, essentially a two-dimensional art, was for centuries dominated by the effort to achieve tri-dimensionality – or, more strictly, an 'aerial' or spatial perspective within which tri-dimensional objects can be given a position. Since the painter can thus within his frame control and 'fix' his conditions of lighting and atmosphere; and since he has, moreover, the whole range of colours at his service, he can achieve an infinite number of natural 'effects' beyond the capacity of the sculptor, who is limited to a few materials like stone, wood and metal, and has then to abandon his work to a lighting and environment which he can no longer control. . . . So conscious were Renaissance artists of this supposed limitation of the art of sculpture that they made what must be regarded as grotesque efforts to overcome it, compelling sculpture to imitate the effects of painting as in the bronze reliefs of Ghiberti and Brunelleschi.[3]

But Renaissance artists did not make the sharp distinctions between the two arts that we tend to make. They accepted what is

[1] Op. cit., vol. II, 1965 ed., pp. 129–31.
[2] Sir H. Read, *The Art of Sculpture*, London, 1956, p. 66.
[3] Sir H. Read, introduction to *Henry Moore*, London, 1949 ed., p. xi.

certainly true, that all kinds of intermediary art forms are not merely possible but also capable of yielding art of the highest quality. Why on earth should there not be painterly sculpture and sculptural painting, especially when the results can be as exquisite as the panels of Ghiberti's *Gates*? One of the marvellous things about relief as an art form is the fact that it includes such an enormous range of different kinds of work which varies from the nearly completely pictorial to the nearly completely sculptural.

In his panel *King Solomon and the Queen of Sheba*, as in some of the other panels for his *Gates of Paradise*, Ghiberti has used perspective to construct a deep and highly organized picture space. All the parts of the composition are represented from a single elevated point of view and are organized around a centre of vision which is located near the centre of the panel just above the heads of the two principal figures. The whole scene is carefully arranged like a stage set, although there are groups of figures, particularly in the foreground, which have about them some of the disorderliness of real life. The choice of an elevated viewpoint has enabled Ghiberti to bank the figures vertically, and the stepped-up levels of the floor have made it possible to arrange the main groups of figures on two levels so that they are clearly seen

King Solomon and the Queen of Sheba, panel from the *Gates of Paradise* by Ghiberti, finished 1452. Gilt bronze, 79 × 79cm. The Baptistery, Florence. *Mansell Collection*

one above the other. The recession of the relief is not continuous but is punctuated by strong horizontal barriers which mark off clearly distinguishable layers of depth space. This rhythmic and orderly recession of layers of space which are parallel with the relief plane is a most important feature of the design of the relief panels on the *Gates of Paradise*. The main groups of figures are clearly located within the first two layers of space. By interposing a low wall between them Ghiberti has avoided the visual confusion that could have occurred where the heads of the foremost figures are on a level with the legs of the figures in the second layer. The figures of Solomon and the Queen of Sheba occupy the centre of the stage and, because Ghiberti has left a gap in the wall and in the row of foreground figures, they are seen in full length and are clearly isolated from the rest of the figures.

The formalized architectural fantasy which provides a suitably impressive and dignified, if somewhat anachronistic, background setting for this celebrated meeting is more or less symmetrically organized about the vertical axis of the composition and consists of lines and surfaces which are either parallel with or perpendicular to the picture plane. There are no disturbing oblique surfaces. The perspective of this architecture converges strongly towards the centre and draws our attention towards the principal figures but our eye is stopped by the barrier immediately behind their heads. This barrier also serves as a background for the heads and makes a horizontal connection between them, which reinforces the direction of their gaze. The orderliness of the architectural setting, with its pattern of straight horizontal and vertical lines and repeated arches, contrasts with the irregular bunched and bossed forms of the figures and horses which weave round the lower half of the relief like a garland.

One of the main functions of the architectural backgrounds in Ghiberti's and other Renaissance reliefs is to articulate the depth space by establishing a fixed sequence of planes which are clearly related in depth. By placing the figures and incidents within layers of space which are defined by the architecture, the sculptor is able to show clearly the positions they occupy in depth space. This aspect of Ghiberti's composition is also brilliantly exemplified in the panel of *Jacob and Esau*. 48

PLANAR RELIEFS Ancient Egyptian and Assyrian reliefs afford the clearest, most thorough, and most artistically outstanding examples of an approach to pictorial representation which is common to many ancient styles of art. It is an approach which seems strange and sometimes baffling to modern viewers because it is so fundamentally different from our own approach. Through our familiarity with photographic images and the Western tradition of art and

illustration we have become so accustomed to naturalistic modes of representation that we take them for granted. We feel that they must be the most straightforward and normal ways of representing things pictorially, since they are closest to the way we see things. Consequently we tend to feel that anything else must be a deliberate departure from this norm, a variation made for some expressive or other purpose on what seem to us to be the obvious visual facts. In the case of the work of modern artists this is to a large extent true. No modern artist is unacquainted with or unaffected by naturalistic modes of representation, and if he works in another way, it is usually by a deliberate choice made for definite reasons. But in the case of primitive artists and artists in early civilizations the position is quite different. They worked either before the techniques of naturalistic representation were developed or before these had a chance to make any impact on their consciousness. Naturalistic modes of representation are not as instinctive in human beings as is sometimes supposed; they are the outcome of a certain special kind of detached objective attitude towards the visual world and the problems of representation, and they were acquired only after painstaking effort and many hard-won discoveries of the possibilities of pictorial representation.

As with so many other aspects of Western culture, it was the ancient Greeks who did this groundwork and laid the foundations for the development of the Western tradition of pictorial art. In looking at the work of such pre-Greek civilizations as ancient Egyptian and Assyrian we must therefore be prepared for qualities that are very different from those which we appreciate in the work of Renaissance artists, or in any other work that has been affected by what has been called 'the Greek miracle'.

Without an understanding of at least some of the main principles which underline the composition of these ancient reliefs our appreciation of them would be severely limited and we may easily fall into the error of interpreting them in the light of our own different visual attitudes. Some degree of insight into the approach of these ancient civilizations to the problems of representation may be gained by studying the drawings of pre-adolescent children and talking to them about their work. The child's approach, particularly to the problems of representing space, is similar to that of the ancient Egyptian and Assyrian artists. This is not to say that these early reliefs are childlike in any pejorative sense; the approach is similar only in certain fundamental respects. The ancient reliefs are the work of adult artists of mature intelligence, sensitivity, and technical ability and they include some masterpieces of the highest order.

The most fundamental difference between developed Western art and the styles of Egypt and Assyria is in their attitude to three-dimensional space. A pictorial realm of three-dimensional

space corresponding in any way with actual depth space appears to be entirely lacking in the ancient reliefs. The picture plane remains obstinately planar and never turns into a picture space. Where a Western artist would represent events occurring in depth by constructing a picture space and locating them within it, the artists of these ancient civilizations used a system of conventions for flattening them out on the picture plane.

It must be stressed that it is the appearance, not the *idea*, of depth which is lacking in Egyptian and Assyrian reliefs. The three-dimensional properties of things are not represented directly by means of a picture space; but the idea of them is present and they are translated, so to speak, into two-dimensional terms. This process is similar in some respects to orthographic projection, which is a graphic system used for describing the three-dimensional forms of objects by translating them into two-dimensional equivalents which do not require a picture space.

It is unlikely, to say the least, that in Egyptian art, which is the most planar of all styles, the extreme flatness is simply due to lack of knowledge of any pictorial methods of directly representing spatial recession. The planarity of Egyptian art is more positive than that. The Egyptian artist seems to have had a pronounced antipathy to depicting space and to have gone to great lengths to suppress anything which might suggest it. Such complete flatness, achieved in many instances with considerable ingenuity, seems to be the result of a deliberate policy, a determination to preserve at all costs the character of plane surfaces and to exploit their expressive possibilities.

Connected with this emphasis on planarity is a lack of any single consistent point of view for the composition. The elements of the relief may be unified by an overriding idea — the representation of an incident in the life of Pharaoh, for example — but they are not related within a coherent spatial framework and there is no single viewpoint to give the scene the kind of spatial unity which is a feature of Western art. The main units of a composition and the parts of a single object are represented in what to us would seem to be conflicting aspects. We may see in one composition, or in the representation of a single object, a combination of plan views and front and side elevations presented simultaneously in a manner which, as we have just remarked, bears some resemblance to the multi-view drawings of orthographic projection, which is the main graphic language of technical draughtsmen today.

Which aspect of the subject should be presented was apparently determined by an ideal of visual clarity. Each element in the composition is presented in its most characteristic aspect, so that it is immediately recognizable. This meant an avoidance wherever possible of foreshortening since, although foreshortening may be true to the momentary appearance of objects from a particular

Fig. 9

point of view, it is not 'true' to the nature of the object as we normally know and remember it.

In the representation of animals this approach presents no great difficulties. The most characteristic and immediately recognizable view of most animals is their profile. It is moreover a view which is usually comparatively easy to draw since foreshortening is at a minimum and the contour is more or less unbroken and continuous. The most characteristic view of the horns of cattle and goats, however, is not from the side but from the front. The Egyptian artist therefore represents the horns from the front and attaches this view of them to a side view of the head. It is interesting to note that the horns of gazelles are an exception; they are shown from the side, like the rest of the animal, presumably because the characteristic curve of the horns is most clearly revealed in this view. The sometimes extraordinarily observant and sympathetic renderings of animals — horses, camels, donkeys, lions, goats, gazelles, hippopotami, and a wide variety of birds — are one of the most delightful features of Assyrian and Egyptian reliefs.

Horse led by a Groom, from Nineveh, 7th century B.C. Stone, H. 3ft. 3in. British Museum, London. *Edwin Smith*

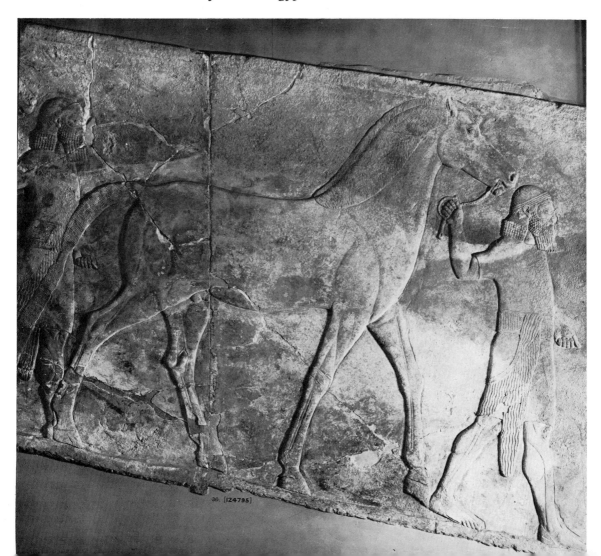

36. [124795]

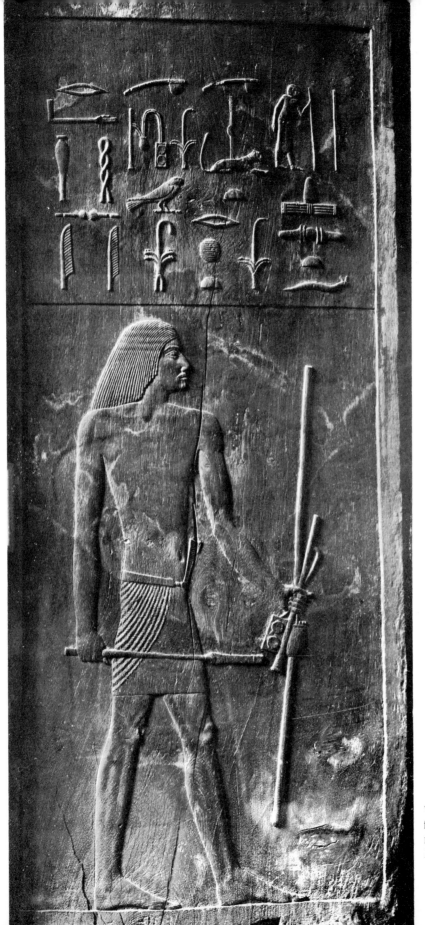

Wooden relief, *Hesire Standing*,
from Saqqara, 3rd dynasty.
H. 45in. *Hirmer Fotoarchiv
München*

The approach of Egyptian artists to spatial problems is most clearly demonstrated in representations of the human figure, where the problems are more complex than they are in animals. The typical human figure in Egyptian art is made up of a number of parts each of which is treated as a separate entity. The construction of the figure is governed by a set of conventions, a formula which remained more or less constant through three thousand years. These conventions are more strictly applied to the principal figures in the compositions than to the subordinate ones. 'The conventional attitudes of the principal figure which dominated the scene, whether king or owner of a tomb, were established at an early time and were the least subject to alteration of all the subjects in Egyptian art', writes W. Stevenson Smith, and he gives the following catalogue of conventions for the standing figure:

The head is in profile, with the eye full front. The full wig falls on the broad shoulders (or the short wig stops at the base of the neck) which are shown front view with the collar bones well marked. The arms, which hang from the shoulders, are in profile, showing the most characteristic outline of the arm and either the back or the front of the hand. The hand never appears properly in profile, as this would entail foreshortening and hiding part of the fingers. The upper part of the chest is seen from the side, showing one nipple of the breast, but the torso is slightly twisted lower down to show the navel in what is almost three-quarter view. The legs are again shown in profile, the feet well apart as if in a striding position, while the inner side of the foot is always shown, giving the figure the appearance of having two left feet, or two right feet if facing left.[1]

That the Egyptian artist did not adhere to his conventions entirely through lack of knowledge of alternative modes of representation is demonstrated in a number of reliefs depicting scenes of real life and, oddly enough, in representations of sculptured figures, which are shown with their shoulders in a competently handled side view. The figures of servants, in particular, show a great deal of flexibility in the use of the conventions.

This method of treating objects, figures, and animals gives good clear shapes on the picture plane, and one of the most outstanding qualities of these ancient reliefs is the sensitivity they display to areal shape and the quality of line that defines it.

The representation of the figure in many Assyrian reliefs is bound by conventions which are similar to those of Egyptian art, but there are some reliefs which achieve a greater freedom of movement and a more naturalistic articulation of the main components of the figure. The dominance of the picture plane, however, is still complete and the movement of the figures takes place in a lateral direction, not in depth. They look back over

[1] *A History of Egyptian Painting and Sculpture in the Old Kingdom*, London, 1949 ed., p. 273.

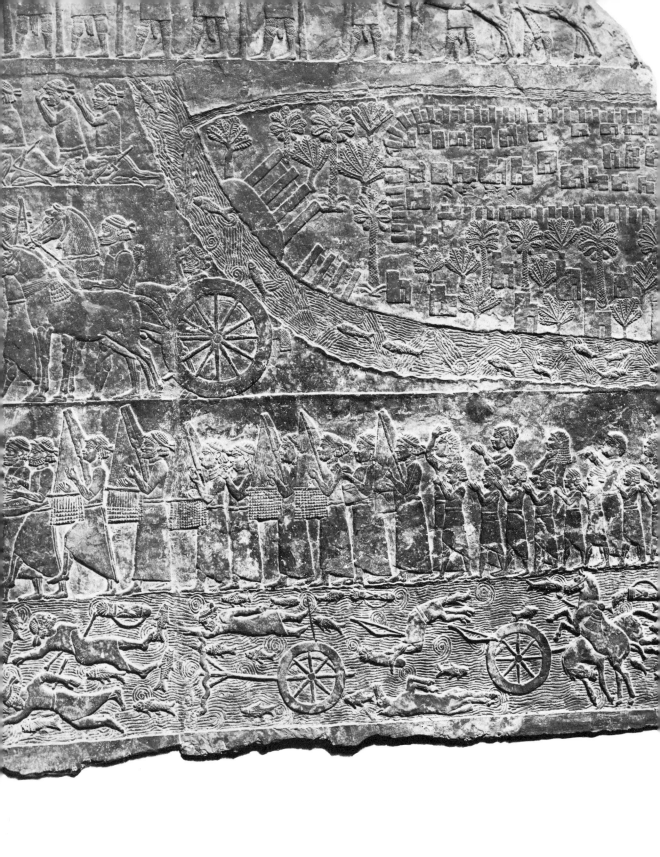

Capture of Susa by Ashurbanipal, from Kuyunjik, 668–627 B.C. Stone, H. 149cm. British Museum, London. *Mansell Collection*

their shoulders (which unlike those in Egyptian art are usually shown in a proper profile view) but they do so in a way that shows their heads in profile. If they fall, they do so parallel with the picture plane. Whether they are kneeling, falling, firing an arrow, riding a horse, spearing an enemy, or lying dead on the battlefield, their main axis is always parallel with the picture plane and their main components are depicted either frontally or in profile.

The principles which govern the representation of individual human figures and animals also govern the composition as a whole. The emphasis on planarity and the combination of several viewpoints in one composition are clearly shown in many Assyrian reliefs and we shall take a scene from one of these as our example.

The main achievements of Assyrian art are its reliefs and among these the most important are the *orthostats* (stone facing slabs) which covered the lower part of the walls in the rooms and corridors of the palaces of the kings Ashurnasirpal and Ashurbanipal. Our illustration showing the *Capture of Susa by Ashurbanipal* is taken from one of these. In general these reliefs provide a sickening record of destruction and slaughter by a brutal military power. When the king is not killing his enemies and destroying their cities he is killing animals with the same ruthlessness and apparent invincibility. Yet in spite of the monotony of subject these narrative reliefs contain a wealth of closely observed detail in the depiction of incidents and topography. We can see in the *Capture of Susa* how this has exercised the ingenuity of the sculptor in finding ways of representing his subject within the limitations of the conventions of his style. At the bottom of the relief the debris of battle – broken chariots, corpses of men and horses, bows and quivers – are shown floating down a river which is viewed as though from above. The three rows of capitulating citizens are viewed from the side. The enclosure of the city and the moat round it are shown in plan but the buildings and trees inside the enclosure are shown in elevation. The fortress at the bend of the moat obviously presented a problem which the artist has solved by the not very satisfactory procedure of making it perpendicular to the bank of the moat. It was presumably more important to show that the fortress was upright with respect to the moat than to have it upright in the relief. The effect of all this in an isolated small section of the orthostats is lively and decorative, but when these reliefs are viewed as a whole scheme the decorative effect is lost. They are reliefs for looking at closely, bit by bit, rather than as total compositions.

THE GROUND LINE One of the most common pictorial devices used in these ancient reliefs is the ground line, or base line as it is sometimes called. This is also a universal feature of children's drawings during one

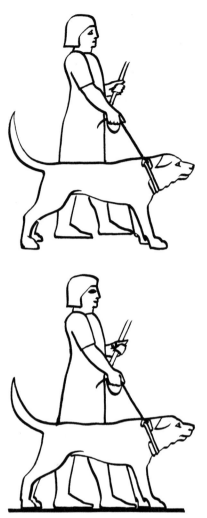

Fig. 10

phase of their development. A ground line can only be conceived where there is no concept of a picture space. It has meaning only within the context of a planar style of art.

If the background of a picture or relief is thought of as a picture space then, as we have already seen, the height of an object in the picture plane will signify its depth in space with reference to an implied ground plane. This can be seen in the panels of Ghiberti's second Baptistery *Gates*, in which systematic perspective is used, and in reliefs, such as the Amaravati roundel, in which the less systematic methods of bird's eye perspective are used, although in the latter the exact relative positions of some of the figures in depth space is difficult to determine. But if no concept of a ground plane or picture space is evoked, then the figures and other objects could easily appear to be floating in a disorderly way in an amorphous two-dimensional space. In many forms of art in which there is no picture space the task of preventing this and giving spatial coherence to the parts of a picture falls to the ground line. It becomes the base on which things rest and from which they spring. It anchors the figures and objects down and links them together on the picture plane, giving them a rudimentary but definite spatial orientation.

By tying things together on the picture plane the ground line tends to stress the planarity of a relief. Even when a group of overlapping animals or figures is represented their hoofs or feet, which would in fact recede considerably, are all placed on the same ground line. The fundamental difference between a picture or relief in which there is a ground plane, and hence a picture space, and one in which there is a ground line and no picture space is illustrated in Fig. 10. The enormous conceptual gulf which exists between these two modes of representation is difficult for us to comprehend.

REGISTERS The use of ground lines leads to a horizontal arrangement of the elements of the relief and this in turn soon leads to another important characteristic of ancient reliefs, the use of registers. A register is in effect a strip existing between two parallel ground lines. It is widely used in ancient reliefs as a means of organizing the subject-matter of complex pictures and reliefs. Egyptian reliefs are usually built up from groups of figures each of which is performing some characteristic action. These groups are arranged within the registers so that we read them sequentially like a strip cartoon rather than simultaneously as we do a composite Western picture. They do not add up to a total spatially unified scene; but neighbouring scenes within the registers, or all the scenes on a wall, may be unified by a common theme in their subject-matter, such as hunting, crafts, battles, or agriculture.

Fig. 11 Ashurbanipal in his
chariot

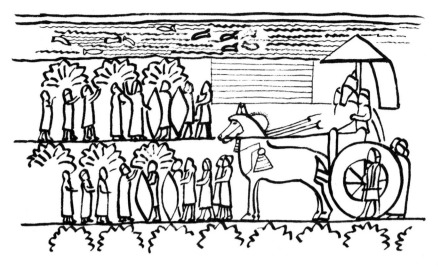

The use of registers could and sometimes did result in a
monotony of composition, but both Egyptian and Assyrian artists
were prepared to treat the registers with some freedom and we
commonly find parts of the subject-matter breaking through the
ground line and occupying two or three registers. The principal
figure in Egyptian reliefs is usually represented on a large scale
bracketing together a number of registers containing subsidiary
figures and incidents which relate to him. These departures from
the system of registers, the variations in the scale of the figures,
and the presence of small-scale carved hieroglyphics prevent
monotony. The total effect can in fact be extremely decorative.
Moreover the use of registers permits the inclusion of a wealth
of fascinating detail and incident with a maximum of visual
clarity.

Much has been written about the way in which the methods of
representing space in Egyptian art gives the works a remote,
other-worldly quality. The figures in the reliefs exist and the actions
take place in a realm of space and time that is not our own every-
day space and time. It is the general character of events, their
essential features, rather than the transitory aspects of any
particular event, which is represented. A photograph or an
Impressionist painting depicts a transitory moment with its
particular qualities of light, accidents of arrangement, particular
location and setting. A momentary state of affairs, a possibly
never-to-be-repeated glimpse of the world is made permanent in
the picture. There is nothing of this in Egyptian art.

But while we should be sensitive to the qualities of Egyptian art,
we must be careful not to project into the reliefs our own feelings
about the remoteness in time of Egyptian civilization or allow the

63

unfamiliarity of its imagery to give it an artificially exotic flavour. It is true there is a remote hieratic quality about much of the official art with its often tiresome and over-generalized stereotypes, but in the abundant scenes of everyday life there is warmth and humanity. Once we become accustomed to the Egyptian mode of representation, so that it no longer seems strange to us, we may begin to appreciate the ability of many of the artists to express their feeling for nature in their work. And we should begin to appreciate their sensitivity to line and shape, which, in the absence of space and volume, are aspects of the visual world on which they are able to concentrate all their attention. This is, however, something which we must leave to a later chapter.

Perhaps what we should enjoy above all in the work of Egyptian artists is a form of art in which the subject is so completely adapted to our powers of visual apprehension. Egyptian art, perhaps more than any other style, is designed in such a way that the eye can grasp it with a minimum of difficulty. Everything in it is stated with absolute clarity; nothing is merely suggested. Our present-day standards of objective truth in artistic representation are based on a mechanical, merely optical view of the way we perceive. The Egyptian artist is more concerned with presenting his subject clearly to our visual intelligence than with this kind of mechanical accuracy. As I said earlier on, objects and events are seldom revealed clearly in one view. Most of the transformations which things undergo in Egyptian art are in the interests of greater clarity.

LIMITED SPACE There are a number of relief styles in which space is treated in a primarily sculptural rather than pictorial manner. Foremost among these in terms of both influence and achievement are Greek reliefs. These display the sculptural approach to the spatial problems of relief in its clearest and purest form.

If we look at any of the great examples of Greek relief – the frieze from the Syphnian Treasure House at Delphi, the metopes from the Temple of Zeus at Olympia and the Temple of Hera at Selinus, the frieze and metopes from the Parthenon, the frieze from the Mausoleum at Halicarnassus, the great frieze of the Pergamon Altar, the reliefs around the base of the Ephesus Column, the Hegeso and other well known funerary stelae, and so on – we notice that they have a number of important spatial features in common.

First, in every case the background of the relief is spatially neutral or spatially indeterminate. It carries no hint of a constructed picture space and cannot even be seen as a ground plane in bird's eye perspective. It is a plain vertical surface which lies behind the figures and sets a limit to the recession of the composition.

It is true some backgrounds are more insistently solid and opaque than others. In some instances – the Horsemen frieze from the Parthenon and the Hegeso stele, for example – the background is a 'soft' one, so to speak, which is representative of the void between and behind the solid forms. If it were painted blue, as it usually was, then this kind of background could suggest a featureless abstract distance like the sky. In other instances – the great frieze from Pergamon, for example – the background is a solid impenetrable barrier, like a wall, behind the figures. But whether the background is 'soft' or 'hard', its predominant character is that of a vertical, featureless, plane surface which does not represent any kind of spatial setting for the action of the relief.

31
187
160

However, while the back plane has no pictorial spatial function, neither is it treated as a mere working area, a two-dimensional surface *upon* which the forms exist as in a planar or purely ornamental relief. The figures in Greek reliefs exist *in front of* or *against* their background. They are not mere protruberances from a plane but have a high degree of autonomy as forms.

The second thing we may notice is that the figures in all the reliefs are standing on a shallow platform or protruding ledge. This is not obvious in some instances – the Horsemen frieze from the Parthenon, for example – because the relief slabs have been removed from the architectural setting which provided the platform, but it is clear enough where the ledge is part of the same slab as the relief. The effect of this is to create a shallow stage for the action of the relief.

The third thing that we may notice is that the forward extension of the space occupied by the solid forms is limited by an implied front plane which connects all the highest points and surfaces of the composition. This front plane is usually identical with the front face of the slab of stone from which the relief was carved.

The Greek reliefs may, therefore, be thought of as occupying a space between two parallel planes, a solid back plane which is really there and an implied front plane. The character of this space has been well described by the nineteenth-century German sculptor Adolf Hildebrand in his book *The Problem of Form in Painting and Sculpture*:

Think of two panes of glass standing parallel, and between them a figure whose position is such that its outer points touch them. The figure then occupies a space of uniform depth measurement and its members are all arranged within this depth. When the figure, now, is seen from the front through the glass, it becomes unified into a unitary pictorial surface, and furthermore, the perception of its volume, of itself quite a complicated perception, is now made uncommonly easy through the conception of so simple a volume as the total space here presented. The figure lives, we may say, in one layer of uniform depth.[1]

[1] 1907 ed., p. 80.

65

For Hildebrand the two most important compositional aspects of Greek reliefs were, first, the organization of its forms within the two-dimensional plane, which enables the viewer to grasp the composition and subject clearly as a picture, and second, the organization of the forms within a unified layer of depth space, which enables the viewer to perceive clearly the volume and relations in depth of the form. As an assessment of certain characteristics of Greek reliefs this is undoubtedly valuable and true, but Hildebrand mistakenly thought that these principles were unchangeable laws which should govern the composition of all reliefs and he condemned any that did not conform to them.

If the figures in these reliefs have their natural depth of form, then there is no represented space whatever in the relief. Like figures in the round, they define their own space and their mode of spatial existence is actual. If, on the other hand, the figures are in low or middle relief and thus have less than their natural depth, then we interpret the space of the relief as having sufficient depth for them to exist in. In either case the figures generate their own space and we see them as occupying whatever depth of space they require for their activities and corporeal existence. The narrow layer of condensed relief space in the low and medium reliefs represents a deeper layer of natural space, but still a layer which is limited by a spatially neutral back plane.

The space of Greek reliefs is sometimes said to be a finite and discontinuous space, as opposed to the infinite and continuous space of Renaissance perspective, or a 'haptic' space, which we know primarily through our 'tactile-muscular intuitions', and which contrasts with the 'optical' space which is mediated to us by vision alone. It has also been said to be an example of space conceived as a *limit* rather than as an *environment*. If we must find a general term for the space of Greek reliefs, I would prefer to use a technically descriptive term and call it *interplanar space*.

If, as we have already said, there are some reliefs which are primarily pictorial and others which are primarily sculptural in conception, then Greek reliefs must be counted among the most sculptural and least pictorial. They lack the represented spatial setting of pictorial reliefs and the only kind of space which surrounds their forms is the actual space which is defined by the sculptured volumes of the forms themselves.

The spatial organization of Greek reliefs contributes greatly to their expressive character. The sculptor tends to spread out his figures within their restricted layer of space so that they lie parallel with the plane of the relief and are posed in attitudes which do not violate the integrity of the front and back planes by suggesting any extension of the action beyond them. Now while this severely limits movement in depth, it does not affect lateral movement, which is often violent. And since lateral movement is

the kind of movement which is most readily comprehensible from a frontal viewpoint, its predominance in Greek reliefs makes an important contribution to their often mentioned clarity of composition and extreme visibility.

The front plane of the reliefs has its own special role to play in the expressiveness of their composition. The implied but definite spatial barrier of the front plane confines the actions of the figures to a realm of space from which the spectator is cut off. He contemplates the actions from outside and is not invited to become involved. The effect of this front plane in reliefs is similar to that of the spatial envelope which is implied by the outer limits of many free-standing stone sculptures. This corresponds to the shape of the block of stone from which the sculpture was carved and it encloses the sculpture in its own private realm of space. The remote, somewhat withdrawn and self-contained character of Greek reliefs is largely a result of this. It is reinforced by a tendency of Greek sculptors to relate their figures one to another within the relief space and not to the spectator or to a space outside the relief. This shows most obviously in the way in which the figures at the end of a relief are so often turned inwards towards the centre and away from the edges of the composition.

A great many medieval reliefs display an approach to space which is similar in many respects to that of Greek reliefs. A superb example is the relief around the bronze font of St. Barthélemy's, Liège, which is the work of Rainer of Huy. Rainer was a Romanesque

Baptismal font, by Rainer of Huy, 1107–18. Bronze, H. 25in. St. Barthélemy, Liège. *Photo Ann Munchow*

metalworker in the region of the Meuse and like the great goldsmith-sculptor Nicholas of Verdun, who was from the same area, he produced work which was stylistically in advance of contemporary architectural stone sculpture. His font represents the Molten Sea which was made for Solomon by Hiram, a metalworker from Tyre who, as is said in the Book of Kings, 'was filled with wisdom, and understanding, and cunning to work all works in brass'. This description also characterizes the great northern European metalworkers such as Rainer and Nicholas of Verdun, who produced so much magnificent work during the early Middle Ages.

There are four scenes modelled in relief around the wall of the font, all on subjects connected with baptism. Each scene is self-contained but is not completely cut off from the others by being confined to a separate panel. The separation, but not isolation, of the scenes is achieved simply and effectively by placing a tree between them. The trees exist in the same space as the figures and they separate the incidents in this space without dividing up the area of the field. The figures and trees are supported and connected by a continuous thin wavy ledge and they exist within a shallow layer of space which is limited by the plane of the wall behind them. There is no suggestion of a picture space of any kind. In fact the impenetrable material nature of the surface of the wall of the font is actually emphasized by the lettering engraved on it. Within this confined relief space the figures move with considerable freedom and they are completely autonomous in relation to the background. They are conceived as existing in front of the background and separately from it. This is unusual since in most Romanesque reliefs the figures are closely tied to the background surface. In many instances there is only one continuous surface, which has figures in some areas and not in others; everything, in the literal sense of the term, is superficial. But in Rainer's reliefs there are two independent components: the background surface and the figures. Neither is absorbed in the other; rather they enter into an equal partnership.

Because the figures on the font are built up by modelling and are not carved into a pre-existing surface, there is no necessary limit to their forward extension. Nor is there any front plane which connects the highest surfaces, as there is in Greek reliefs. Nevertheless the movement of the forms is contained within a limited layer of space and is mainly lateral. There are no free limbs projecting from the side of the font. The only projecting parts are the heads of the supporting oxen, but this is in conformity with the Biblical description which states that 'all their hinder parts were inwards'.

The lower of the two lintels from the south portal of the Portail Royal of Chartres shows various scenes from the life of the Virgin:

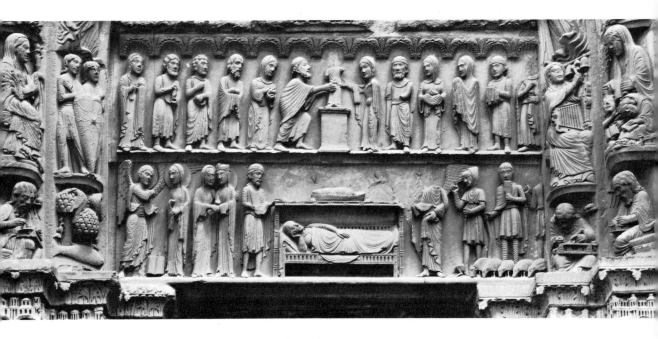

the Annunciation, the Visitation, the Nativity, and the Shepherds
being led by an Angel. The upper lintel shows the Presentation
in the Temple. The figures on the two lintels are spread out in
rows across a shallow space like actors in front of a curtain and
are posed frontally, in profile, and in three-quarter view against
a solid back plane. Their feet are placed on a horizontal strip which
serves as a floor and where necessary as a ceiling to the relief
space. The movements of the figures are gentle, restrained, and
subtly varied, and although they are disciplined to fit the shallow
relief space, the figures do not appear constrained or awkward in
any way. Many other examples of reliefs in which the figures
inhabit a limited space in front of a solid background and move
independently of the background are to be found over the doors
of Gothic cathedrals and churches. In fact, one of the main
characteristics of Gothic architectural sculpture is that it is not a
mere architectural excrescence. The figures are not simply spread
out on the surfaces of the buildings but lead their own life in
their own space. As Henri Focillon neatly puts it: 'Gothic man . . .
obeys both the laws of the architectural system to which he
belongs and also, so to speak, the biological laws of the species which
he represents.'[1]

The space occupied by the figures in the scenes of the Passion
on the parapet of the western rood screen of Naumburg Cathedral 70
is a shallow boxed-in stage-like space hollowed out under a
canopy and flanked by columns. There is no pictorial extension of
the space through the background and each scene takes place within
the limited actual space available. The figures themselves define the

[1] *The Art of the West, Vol. II, Gothic Art,* London, 1963 ed., p. 78.

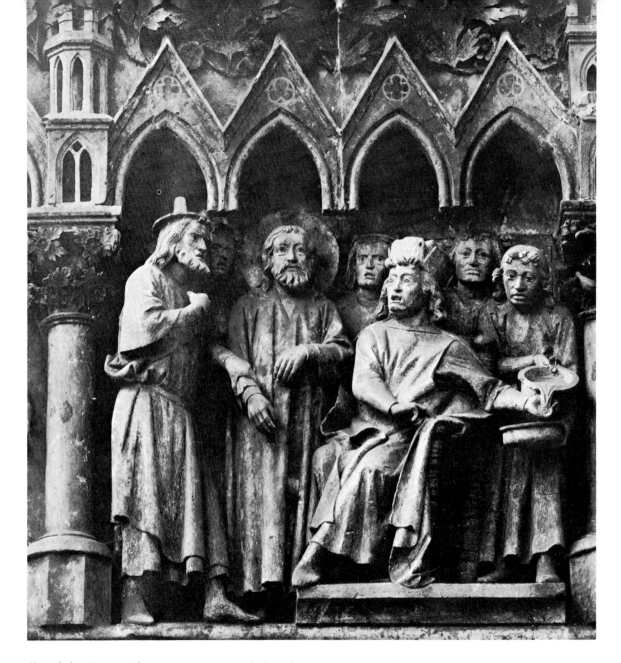

Christ before Pontius Pilate,
from west rood screen,
Naumburg Cathedral. *c.* 1260.
Bildarchiv Foto Marburg

space and they have a massive dignity and a breadth and fullness
of volume which remind one of the figures in Masaccio's great
Brancacci Chapel frescoes. These highly sculptural figures are packed
closely into their confined space like so many independent statuettes
and their solid sculptural forms completely dominate the reliefs.

A sculptural approach to space is also apparent in many Indian
reliefs. In the relief from the Vishnu Temple at Deogarh Vishnu is
shown lying on the world serpent, Sesha, during the cosmic
interval between the destruction and re-creation of the world.
The goddess Lakshmi is supporting his foot, and Garuda, the sun
bird, and another goddess are behind her. Brahma, seated on a

lotus, and other divinities are above, and a row of figures representing demons and personifications of Vishnu's powers are below. The space of the top two-thirds of this relief is stage-like space similar to that of the Naumburg reliefs. Although some of the figures are arranged in depth, the space of the relief is strictly limited and the background is a solid wall. The stage-like quality of the space is enhanced by the raised platform on which Vishnu reclines. The pose of the sleeping god, with its long relaxed lines, is remarkably expressive of sleep and is designed with great

Vishnu Reclining on Sesha, from south face of Vishnu Temple, Deogarh, India. Early 6th century. Stone. *India Office Library, London*

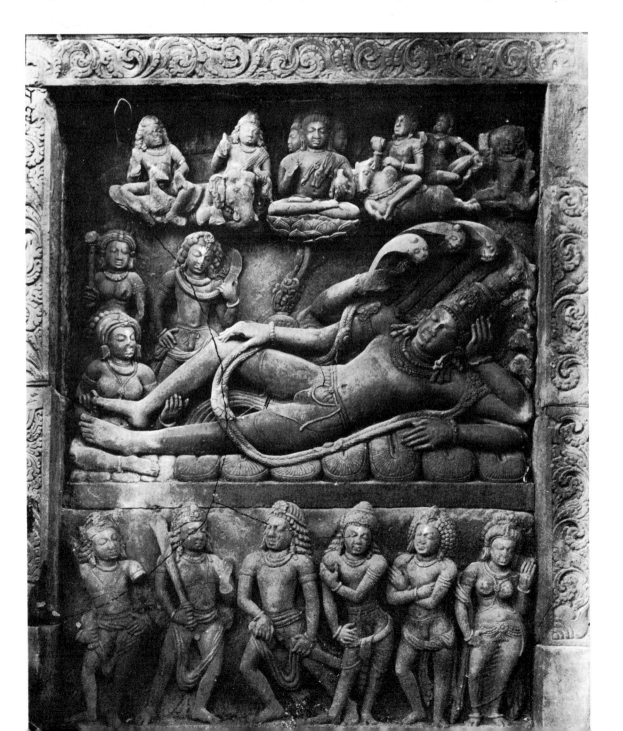

ingenuity to fit into a narrow space and to present a clear view to the spectator.

The space in front of the raised platform is a narrow strip like the spaces of the Chartres lintels. It is just deep enough to contain the full volumes of the row of figures. But although the space is restricted and all the figures are standing, there is a great deal of movement and freedom in their poses and in the arrangement of their limbs and accessories (swords and drapes). What could easily have become a cramped and static row of units has been made into a lively and interrelated group. It is interesting to notice how and with what success both the Indian sculptor and the sculptor of the Chartres lintels have treated the problem of arranging a row of figures with various poses and gestures within a shallow space.

SPACE IN BAROQUE RELIEFS

Gianlorenzo Bernini, the astounding genius who dominated the Baroque era and profoundly influenced the whole course of European art, was one of the most original and daring artists of all time. There is no field of art which was not either directly or indirectly influenced by him and, like Michelangelo before him, he had a revolutionary effect on architecture, painting, and sculpture. Perhaps his most startling achievement was to break down the traditional boundaries of the arts and to fuse architecture, painting, and sculpture into one unified artistic conception. Professor Wittkower, whose writing on Bernini and on Baroque art in general is extremely illuminating, has this to say about this aspect of Bernini's work:

What is the group of *Saint Teresa and the Angel?* Is it sculpture in the round or is it a relief? Neither term is applicable. On the one hand, the group cannot be dissociated from the aedicule, the background, and the rays of light; on the other, it has no relief ground in the proper sense of the word, nor is it framed as a relief should be. In other words, Bernini created a species for which no term exists in our vocabulary.

Moreover, even the borderline between painting, sculpture, and architecture becomes fluid. Whenever given the opportunity, Bernini lets his imagery flow from a unified concept which makes any dissection impossible. His own time was fully aware of this. In the words of Bernini's biographer, Filippo Baldinucci, it was 'common knowledge that he was the first who undertook to unite architecture, sculpture and painting in such a way that together they make a beautiful whole'. The Cornaro Chapel is the supreme example . . . the painted sky, the sculptured group, and the real and feigned architecture are firmly interlocked. Thus, only if we view the whole are the parts fully intelligible. This is also true of Bernini's primarily architectural works. . . . The creation of new species and the fusion of all the arts enhance the beholder's emotional participation: when all the barriers are down, life and art, real existence and apparition, melt into one.[1]

[1] R. Wittkower, *Art and Architecture in Italy 1600–1750*, Harmondsworth, 1958, pp. 105–6.

72

Bernini was responsible for the introduction of a new approach to the treatment of space in sculpture. A number of his earlier sculptures, including *David*, *Longinus*, and *Habakukk*, are not entirely self-contained works of art. Although they are intended to be placed in a niche or against a wall, they do not keep their distance within a clearly defined frontal plane and space of their own, leaving the spectator outside and, spatially speaking, uninvolved. The figures obtrude into the spectator's own spatial world and draw him into the sphere of their own activity. By formal means, such as openness of contour, violent foreshortening, and movement in depth, and by psychological means, such as the projection of their gestures, looks, and actions into the surrounding space, they break down the distinction between the space which is inside the work of art, so to speak, and the space which is outside it. The consequences of this new approach to space were felt in architecture as well as in the representational arts.

Tomb of Maria Raggi, by Bernini, 1643. Vari-coloured marble with gilt bronze medallion. Life-size figures. S. Maria Sopra Minerva, Rome. *Phaidon*

The implications of the new approach were not worked out within the category of relief sculpture by Bernini himself. His personal vision needed new forms of art for its full realization and the categories of sculpture in the round and sculpture in relief were inadequate for his purposes, as Wittkower has said. Bernini did produce reliefs which, like everything else he produced, were highly original. In such works as the Tomb of Maria Raggi, for example, he renounced the frame and used a rich polychromy of coloured marbles and gilt bronze and also established a prototype for a new kind of funerary monument. But it was left to more reserved and classically inclined artists to incorporate the new spatial ideas within the more traditional mode of relief. The main contribution here was made by Algardi in his chief work *The* 21 *Meeting between Pope Leo I and Attila.* Again we cannot do better than to quote Professor Wittkower's enlightening comments:

Once the traditional reserve towards this relief has been overcome, one cannot but admire its compositional logic and psychological clarity. Its unusual size of nearly 25 feet height has often led to the fallacious belief that its style, too, has no forerunners; but in fact the history of the illusionistic relief dates back to the early days of the Renaissance, to Donatello and Ghiberti. In contrast, however, to the *rilievo scacciato* of the Renaissance, Algardi desisted from creating a coherent optical space and used mainly gradations in the projection of figures to produce the illusion of depth. The flatter the relief grows, the more the figures seem to recede into the distance, while the more they stand out, the nearer they are to us. The figures in the most forward layer of the relief are completely three-dimensional and furnish transitions between artistic and real space; the problem of spatial organization is thus turned into one of psychological import and emotional participation.

After Algardi had created this prototype, such reliefs were preferred to paintings whenever circumstances permitted it. This was probably due to the fact that a relief is a species half-way, as it were, between pictorial illusion and reality, for the bodies have real volume, there is real depth, and there is a gradual transition between the beholder's space and that of the relief. More effectively than illusionist painting, the painterly relief satisfied the Baroque desire to efface the boundaries between life and art, spectator and figure. Only periods which demand self-sufficiency of the work of art will protest against such figures as the Attila, who seems to hurry out of the relief into our space; for people of the Baroque era it was precisely this motif which allowed them fully to participate in Attila's excitement in the presence of the miracle.[1]

There are many levels of relief in the panels of Ghiberti's *Gates* 48, *of Paradise*, varying from the modelling in the round of figures on the front stage to the paper-thin modelling of those in the extreme background; but in spite of this the action takes place behind the imaginary window of the front plane and everything is disciplined

[1] R. Wittkower, op. cit., p. 176.

The Annunciation, by B. Cametti, 1729. From the Basilica di Superga, Turin. Marble, c. 5m. *Soprintendenza ai Monumenti, Turin*

74

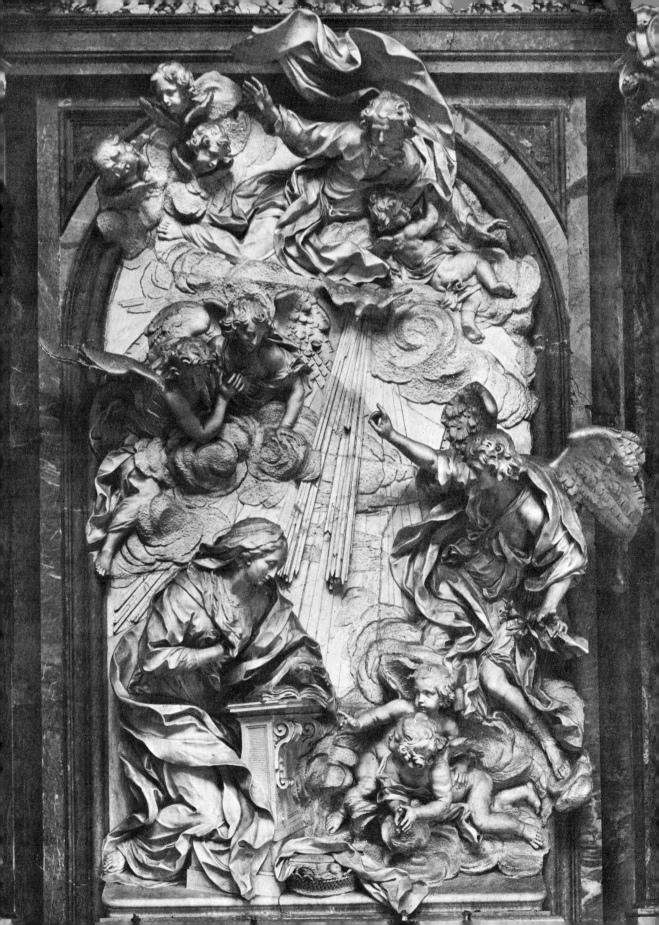

within the boundary of the frame. The relief does not so much advance towards us out of the panel as recede away from us into it. In Baroque reliefs such as Algardi's *Attila* and, even more so, Bernardino Cametti's *Annunciation*, the dominant movement is not into the relief but out of it; the action comes forward into the space of the spectator. Moreover the relief tends to break through the boundary of the frame, overreaching it in its violent forward surge into space. We are no longer observers of something which takes place in a spatial world which is cut off from our own. We are more directly involved, and become participants in the drama. The emotional effect of this treatment of space accords with the excited movement and violent gestures of the figures, the swirling draperies and clouds, and the transitoriness of the momentary actions which are represented. This all adds up to a powerful rhetorical onslaught on the sensibilities of the spectator. It is an art of powerful statement, often of overstatement, which the reserved Anglo-Saxon does not take readily to.

Cametti's *Annunciation* is an extreme example of the treatment of space in Baroque reliefs. The background suggests a vague distance but not a definite measurable depth. There are no converging orthogonal lines to give an effect of perspective recession into the depths behind the figures and no ordered sequence of receding planes of relief or overlapping layers. In spite of the billowing clouds we are strongly aware of the background as a physical surface. The figures lean violently out of this background into surrounding space and they project well beyond the frame of the relief. The swirling draperies above God the Father are blown well out into the space of the church and the Angel of the Annunciation seems to have just alighted on the clouds. With the significant exception of Mary, the only earthbound creature in the relief, all the figures seem to move outwards into space away from the background. The general effect of this, as of many Baroque works of art, is explosive. On both the formal and psychological levels the composition of this work of Cametti's expresses the excitement of supernatural events.

The space in a Renaissance perspective relief such as Ghiberti's *Solomon* or *Jacob* panels is like that in Fig. 12. We are led into the 48, 5 relief from the edges of the frame. The effect of Baroque reliefs is like that in Fig. 13. The relief comes out of the frame and advances into the spectator's space and draws him into its sphere of action. Baroque sculpture, as distinct from relief, takes this process one stage further. Traditional limits and frames are abolished and the sculpture advances so far into the spectator's environment that it involves him directly and breaks down the separation between the space of art and real space. Analogies with methods of presenting performances in the theatre and the degrees of audience involvement readily suggest themselves.

Fig. 12

Fig. 13

Form (1): Form, Contour, and Background

Among the first things to strike us when we look at a range of figurative reliefs in different styles are the variations in the corporeality of the forms of the figures and the variety of relationships which exist between the forms and their background. There are figures in Egyptian reliefs which lead a tenuous wraith-like existence in a more or less completely two-dimensional spatial world, and there are figures in Indian reliefs which have an exaggerated fullness of volume beside which the forms of even young, well-built actual human bodies seem timid and unassertive. The Egyptian figures are completely surface-dependent. They are flattened and spread out on a surface in a way that makes their existence as independent solid bodies apart from the surface unthinkable. The Indian figures, on the other hand, lead an almost completely independent existence in three-dimensional space. They are only lightly attached to their background and are solid bodies which appear to have formed around their own axes in front of the background. We have the impression that they could at any moment step away from the wall, column, or slab to which they are attached. It is part of the fascination of reliefs that their forms cover the whole range of modes of spatial existence between the completely flat and linear and the fully in the round.

The qualities that will concern us in this chapter are the outcome of the interaction of three different aspects of the treatment of forms in relief. These are, first, the degree of projection of the forms from their background; second, the way in which the contours of the forms are related to their background; and, third, the ways in which the forms move in relation to their background. We shall begin by discussing these three aspects separately in fairly general terms in order to get a grasp of the principles which are involved. After that we shall be in a better position to see how they combine in so many different ways in a great variety of styles and types of relief. Most of our examples will be taken from the human figure, since it is the most common and important subject of reliefs, but we must bear in mind that most of the principles which are embodied in representations of human bodies apply also to the bodies of animals and to other complex organic forms.

DEGREES OF PROJECTION Perhaps no other feature of relief sculpture has such a profound effect on its visual character as the degree of projection of its forms from their background or matrix. There are any number of possible degrees of projection between the almost flat and the fully in the round. The main traditional categories are: high relief

77

(*alto rilievo*), in which the forms have over half their natural depth and are to some extent separated from their background; medium relief (*mezzo rilievo*), in which the forms have about half their natural depth; and low relief (*basso rilievo, bas relief*) in which the forms have under half their natural depth. The term 'medium relief' is not much used nowadays. Low relief is frequently referred to by the French term '*bas relief*', although there is no consistency in the way this term is used. The Italian terms, '*alto*', '*mezzo*', and '*basso*' are seldom used today but they were once fairly common and may often be found in old books. As a means of classifying reliefs these three categories are too generalized to be useful in any but a rough and ready way. They take no note of the immensely varied ways in which forms may project and they do not distinguish other differences in the treatment of forms which are of the utmost importance.

The most elementary ways of creating an image on a surface are by drawing an outline or filling in a silhouette. Relief begins when these completely two-dimensional graphic methods of representation are reinforced by some degree of actual projection of the image into the third dimension, however slight. Almost all reliefs do in fact start out as outline drawings which the sculptor subsequently develops into relief, and it is more than likely that relief originates historically as a development from drawing.

There are two main ways of developing an outline drawing into a relief. One is to cut back the surface all round the outline in order to leave a raised silhouette which may subsequently be developed into a more elaborate image showing any amount of detail and surface modelling. The other is to build up the forms within the outline in some plastic material such as clay or wax. Let us consider for the purposes of illustration the familiar image of a human head in profile. Examples of such heads in low relief are probably the most widely known of all works of art, certainly of all reliefs, since they occur on almost all coins and are handled daily by everyone.

What, then, are the ways in which the degree of projection of the head from the background may vary? Suppose first that we start with a head which has its natural proportions, is fully in the round, and is placed in profile against a background surface. This is one extreme limit of relief sculpture; it is as high as it can go. One way to decrease the height of the relief would be to lower the head into the background as though we were burying it or immersing it in water. We could continue to do this so that less and less of the head projected at each stage, but we would reach a critical point when the head was half immersed in the background. The relief would then be half round — a rendering of half a human head in its natural proportions — and the plane of the background would coincide with the median plane of the head. Up to this point we

Fig. 14(i)

78

Fig. 14(ii)

Fig. 14(iii)

would have had a clear view of the profile of the head. But if we continued immersing it beyond this point, it would cease to be recognizable as a complete image of a head because the outline on the background would no longer be a profile. Eventually there would be nothing showing but the tip of an ear. This method of decreasing the projection of a relief cannot, therefore, go below half round.

We may create a second series of reliefs by starting with the half round head and progressively decreasing the height of the modelling of its forms. The relief would then become flatter and flatter until it passed through the stage of most heads on coins and eventually became nothing but a drawing, which has no projection at all. At all stages in this series the head would preserve a constant profile on the level of the background plane but the depth occupied by the forms of the head would progressively decrease in relation to the other two dimensions.

In order to illustrate a third way in which the degree of projection of a relief may vary we must start again by considering a head which has its natural proportions, is fully in the round, and is placed against a background plane. Now suppose we progressively diminish the amount of depth space occupied by the head so that its cross-section changes from a near circle to an ever narrower ellipse. We should then be representing the same amount of the head − but its actual projection would diminish and its form would become more and more compressed. We should have a head which was flattened and against a background, but otherwise complete. This method of flattening form is sometimes used in free-standing sculptures.

These then are the main ways in which the degree of projection of the forms in a relief may vary. Our examples have been deliberately simplified but they will serve for the present to illustrate the basic principles. There is one other point which should be mentioned here. We should bear in mind when we are speaking of the projection of forms in relief that it is not merely the height of the relieved forms above the background which is significant but also the degree of projection of the modelling of the forms themselves within their own contours. There is a type of relief which is made by cutting back all round the outline of a figure and then carving away the surrounding surface so that the figure is left as a raised silhouette with vertical side walls. However far such a figure is raised above its background we could hardly say, except in a very special sense, that it is in high relief.

The carving of a flat raised silhouette of this kind is the most direct and elementary way of beginning a carved relief, and it is in fact an extremely common first stage in the working of many types of relief, especially low ones. After this first stage the forms are usually rounded and given some degree of volume and interior

79

modelling, and other planes at an angle to the plane of the relief surface may be introduced in order to give movement to the figure. Some reliefs, however, do not develop in the direction of a greater complexity of plastic sculptural form but in directions which preserve the character of the raised silhouette. Instead of defining the inner forms and details by modelling they do so by incising into the raised silhouette without destroying its essential over-all flatness. Because these reliefs consist only of the recessed plane of the background and the raised plane of the figure they are sometimes called two-plane reliefs.

Many primitive and archaic reliefs are of this kind. Some are crude and clumsy and merely display their maker's lack of understanding of the relief medium and his inability to exploit its more subtle possibilities. But there are others which develop and exploit the expressive and decorative possibilities of the two-plane system itself in a positive and sometimes highly sophisticated manner, and although they do not have the fullness of form, the corporeality, and subtle inflections of surface modelling which we usually associate with sculpture, they do have other qualities for which they are highly prized as works of art.

First of all they may have great value as decorative pictorial compositions, or as patterns. The clearly defined antithesis of raised figure and recessed background, of negative and positive shapes, can provide an excellent basis for decorative treatment. But these reliefs cannot be regarded simply as two-dimensional works of art. Their figures *do* project in relief and they react to light and depend on light for their definition in a way that two-dimensional patterns and pictures do not. Moreover they do have actual mass and weight in varying degrees. The figures may project boldly and throw deep shadows on to the background, giving a strong contrast between the illuminated raised flat areas and the shadowed background, or they may project only slightly and give rise to delicate outlines and fine sharp contrasts of light and shade in their contours. Thus the degree of projection of these reliefs does matter. It has a marked effect on the expressive character of the work and affects its relations to the building or other object it decorates. But it is a special category of relief projection, which must be distinguished from the more usual categories of high and low relief.

Another feature of many of these reliefs which may be extremely expressive and beautiful is the incising or engraving of the interior detail. This provides an opportunity for the contrast of line with flat areas and for the creation of texture and linear pattern.

The supreme developments of the two-plane system of relief carving are found in Islamic and pre-Columbian architectural decoration and in certain pre-Columbian figure compositions. We shall discuss these later (see pp. 121ff.). A delightful example of

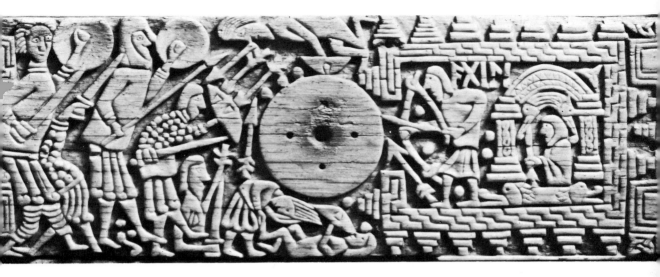

The Franks Casket, detail of battle scene, *c.* 9th century. Whalebone. *The Trustees of the British Museum, London*

one kind of development on a small scale is the Franks Casket, an Anglo-Saxon piece dating from about the ninth century. In this the runic letters and the figurative carving are treated in fundamentally the same way. There is a fine balance of background and raised shapes which creates a fairly even over-all pattern. A unity of scale is achieved by the way in which the larger figure shapes are broken up into smaller shapes comparable in size with the shapes of the letters.

RELIEF CONTOURS Figures in relief are marked off from their background by their external contours. The relations between these contours and their background, and the qualities of the contours themselves, are aspects of relief which are of the profoundest importance. In some styles the contours are the most powerful instrument of expression and agent of form in the relief. The qualities of the contours themselves as lines will be discussed later when we consider the linear aspects of relief in some detail. Here we shall be concerned primarily with their functions and qualities as boundaries between background and figure.

We shall begin by considering the ways in which the contours of forms in relief are related to their backgrounds in a purely physical sense, that is, regardless of what they represent. The various treatments of the edges of forms are a major item in the relief sculptor's repertory and we should be aware of the different effects they produce.

The edges of forms in relief may slope or curve down to a background surface and meet it at an open oblique angle. They may do this in such a gentle, gradual way that, except in a strong raking light, there is no pronounced contrast of lighting at the contour — no marked division between areas of shadow and light — but a

81

Fig. 15

gentle transition from the surface of the form to the background. The actual juncture of the two surfaces may be subtle but sharp and definite, so that it gives rise to a delicate but distinct contour line, or it may be blurred and softened so that the forms merge with or fade into the background. In some very low relief the angle at which the two surfaces meet may be so open that the contour in most lightings is too indefinite to be clearly visible. In such cases, it may be reinforced or clarified by a line actually engraved into the surface. This is a characteristic feature of Donatello's low relief style. The present-day Italian sculptor Manzù, who employs a technique similar to Donatello's, also uses lines freely cut into the clay as a means of sharpening the drawing of his extremely shallow reliefs.

97
215

If the forms meet the background at a steeper oblique angle so that the contrast in the direction and lighting of the surfaces becomes more pronounced, then the contour will become a stronger line and the forms will stand out more sharply against the background. But as long as the angle at which the two surfaces meet is an open, oblique one, then the contours will remain on a level with the background, the forms will appear to adhere closely to the background from which they spring and there will be no radical break in continuity between the surface of the background and the surface of the relief. As we have already seen in our example of a head in profile (pp. 78–9), there can be an oblique angle at the juncture of the two surfaces only if they meet at or in front of the widest part of the form. If the form is cylindrical, or spherical, or bi-symmetrical like our profile head, such a relief cannot be higher than half round.

If the attachment of the form to the background is made to occur behind the widest part of the form, then the visual boundary of the form (that is, its contour) will be raised above the background and the form will begin to exist visually not *on* the background but *in front of* or *against* it. This process of cutting back or modelling behind the contour is known as undercutting. It is, of course, an inevitable feature of high reliefs, in which it may be carried to the point of completely detaching the form from its matrix; but it may also be applied to low reliefs. In a low relief undercutting creates a strong shadow behind the contour and both detaches and emphasizes it. In higher reliefs it intensifies the shadows behind the forms and gives them something of the weight and corporeal independence of fully three-dimensional volumes.

The contours may also be raised above the level of the background without undercutting. The sculptor may do this by cutting straight back from the contour at right angles to the plane of the relief, thus leaving the modelled surface, including its contour, stepped up from the background. This process has been explained in connection with flat silhouetted reliefs but it is also common in

low reliefs. The depth of modelling in a relief of this kind may be slight but the modelled surface as a whole, or parts of it, may be lifted above the background to a relatively great height. In some cases the effect may be similar to that of slight undercutting but in general this method of treating the contour does not separate the form from the background as decisively as undercutting does.

The relations of the contour to the background are not usually the same throughout the whole relief. There are some reliefs in which all the contours are on the level of the background and others in which they are all raised to a uniform height above it. But in the majority of reliefs the height of the contour varies from figure to figure and in different parts of the same figure. In reliefs which attempt to represent the natural movement and articulation of the human body the relations between the contour and background are inevitably varied. A moment's thought about the natural contours of the human figure will reveal why this must be so.

NATURAL CONTOURS Most people are familiar enough with the idea of a contour as a line which defines the limits of the extension of an object in our field of vision but few people are likely to have looked more closely at them since it is probably only in connection with the representational arts that we need to inquire more deeply into their nature. The first thing to bear in mind is that the contour of an object is very rarely a continuous, unbroken line in one plane. The contour of a sphere, from wherever we view it, is always a circle in a plane perpendicular to our line of vision. But the contours of complex or irregular forms are hardly ever in the same plane. The contour of a human figure is *never* all in the same plane, although there are some positions in which it comes near to being so. The contour of a figure standing bolt upright in profile or front view is never far out of the median plane (that is, the plane which divides the figure in two) but we have only to introduce the slightest torsion or tilting of the main volumes to play havoc with it.

If the whole figure, or part of it, is turned to the left or right, then one side of the contour advances and the other recedes. If, for example, the top half of the figure is turned into a three-quarter view, then the contour of one shoulder will be considerably in advance of that of the other shoulder and neither of them will be in the same plane as the contours of the hips. When the forms tilt backwards or forwards out of vertical alignment then the contour advances and recedes as it progresses along the sides of the figure. The knee of a relaxed leg may protrude in front of the rest of the figure; a head may droop; the hips may be tilted forward at a different angle from the chest, and so on. The possibilities of movement in the complex articulated structure of the human figure are

almost unlimited and each of these movements may be viewed from a theoretically infinite number of positions and present a theoretically infinite number of different contours. The most important point about this for our present discussion is that the contour of a figure in motion is always a complex line which moves in all three dimensions of space. In some poses and from some views its variations in depth are restrained, but they may often be extreme.

Thus it is easy to see why it is that some parts of the contours of figures in relief may fade off into a background, while other parts may be sharply defined on it or raised above it. Variations of this kind can give rise to a subtle interplay of the contours with the plane of the background and to a diversity in the quality of the lighting of the edges of the forms, from intense contrasts of light and shade to almost imperceptible gradations from one pale tone to another, and from clear, sharp lines to soft, diffused transitions. The Hegeso stele is a good example of this. 187

The nature of the contours of a figure in relief is closely connected with the way in which the figure as a whole has been conceived in relation to its background, and it is to this that we shall now turn our attention.

FORM AND
BACKGROUND

As we have already seen, the background of a relief may represent a receding picture space or be a spatially neutral barrier or a vaguely defined region lost in shadow. In any case, whether it is made to represent space or not, it is in fact not space at all but the solid material substrate or matrix which supports the forms. The ways in which the forms are related physically to this underlying material substrate or ground are of extreme importance. They have a profound effect on the quality of the design of the relief and on its expressive character.

In many reliefs the figures are not treated as corporeal bodies in their own right but are, so to speak, bound to the surface, or spread out upon it, or otherwise integrated with it in ways that make their existence as independent entities unthinkable. They sacrifice their independence, their own organic structure and articulation, and conform to the surface from which they project or to the form of the matrix which supports them.

The figures in these reliefs are often treated as though they were made of some uniformly plastic substance which can be flattened, bent, stretched, or twisted in any direction. This is a method of treating natural form which is characteristic of many styles of ornamental art. In these styles animal and vegetable, as well as human, forms may be subjected to violent deformations and transformations partly in order to adapt their shapes to the shape of the field offered by the object they decorate and partly, no doubt,

out of sheer creative exuberance, an unrestrained inventiveness which is innocent of the 'objectivity' of naturalistic representation. But this approach to relief is not always extreme, nor is it confined to ornamental art. There are many single-figure reliefs and groups on a monumental scale whose forms are not arbitrarily or playfully distorted but are simply adapted to a superficial, plane-conditioned or surface-bound mode of existence.

In contrast to these reliefs, whose forms are determined largely by external factors, there are others in which the figures have been conceived primarily as independently existing structures of solids centred on their own axes. The natural proportions and articulation of the figures are respected and they either move or appear to be capable of moving naturally on their own axes independently of the background, as corporeal bodies in their own right. This does not mean that the figures are self-sufficient in the sense that they totally disregard their connection with a background or the fact that they exist within the condensed or restricted space of a relief. The forms of the figures have been arranged and adapted to suit their mode of existence in relief but this has been done without subjecting them to the demands of the relief medium in ways that infringe the laws which govern the articulation and mobility of the natural figure.

The prototypes of this approach to the representation of the figure are found in Greek sculpture of the Classical period. The 'principle of axiality', which Erwin Panofsky held to be 'the essential principle of classical statuary'[1] applies also to figures in relief. It requires 'the interpretation of the human body as an autonomous, quite literally "self-centred" entity, distinguished from the inanimate world by a mobility controlled from within'.

But what does this mobility amount to?

THE MOBILITY OF THE HUMAN FIGURE

Everyone is aware of the fact that although the human figure is an autonomous structure which is capable of moving in a great many different ways, its movements are not unrestricted but are subject to restraints imposed by its own anatomy. The figure is made up of two main structural systems: a rigid but articulated skeleton and a semi-fluid flesh structure. The combination of these two interdependent structures produces a complex system of three-dimensional forms which is extremely mobile but whose movements always conform to certain fundamental principles.

The movements which may take place within the human figure and which are of interest to the sculptor are of three main kinds. First, its main forms may rotate on their axes so that the head, the shoulders, the hips, the knees, and the feet may all be in different planes. This movement may be continuous, so that the whole

[1] *Renaissance and Renascences*, Stockholm, 1960, p. 60.

85

figure is turning in the same direction, or it may be varied so that different parts of the figure are turned in opposed directions (this is usually known as *contrapposto*). Secondly, the main forms may tilt laterally. The head may lean down towards a shoulder, one shoulder may be higher than the other, the chest may tilt to the right while the hips tilt to the left, the whole torso may lean or bend to one side, the arms may be spread-eagled sideways, and so on. Thirdly, all the parts of the body may tilt in depth. The head may drop on to the chest, the torso may bow or arch forwards, the knees may bend so that the thighs are inclined forwards and the lower legs inclined backwards, the arms may be directed forwards, and so on. And, of course, these three main types of movement may be combined to give an unlimited number of poses.

Every type of movement is not equally transposable into relief. The limited depth space available in reliefs imposes severe limitations on the amount of movement in depth which the relief sculptor can give to his figures and in general he confines this kind of movement to slight inclinations of the forms towards or away from the background. There is, however, no restriction on lateral movement, since this takes place in the plane of the relief. Again, since the human figure is not much wider than it is deep, there is little restriction on the rotation of forms.

The natural tendency in relief sculpture, especially on a large scale, is to keep the axes and main surfaces of the forms in planes which are parallel with the plane of the relief. This is certainly the tendency in all archaic and primitive reliefs. It requires some degree of sophistication in a sculptural tradition before the natural mobility of the figure can be exploited as fully and with as much understanding as it is in Classical sculpture. To achieve the variety of movement that there is in Greek reliefs while working within the limited depth space of a relief and at the same time observing the anatomical laws which govern the structure and mobility of the natural figure is, to put it at its lowest, a considerable technical feat. According to Gisela Richter it took 'almost two centuries of concentrated effort' for the Greeks to acquire 'an understanding of the structure of the human body'.[1] This approach to the representation of the movement and organic corporeality of the figure is not, however, confined to Classical sculpture or to the particular brand of naturalism which is associated with Graeco-Roman art and its descendant styles. It may also be found in Gothic and Indian art. (It may well be, however, that the influence of Greek sculpture was a decisive factor in the development of this aspect of both medieval European and Indian sculpture.)

Panofsky contrasted this Classical approach to the figure with the approach of the Romanesque sculptor, who tended to think of his work 'as a piece of inorganic and homogeneous matter

[1] *Three Critical Periods in Greek Sculpture*, London, 1951, p. 1.

bulging out into projections, retreating into cavities, incised with sharply defined contours but never losing its homogeneous density', and who was consequently 'unable to represent the living creature as an organism articulated into structurally different parts'.[1] Nevertheless, as we shall see, the approach of the Romanesque sculptor put within his grasp qualities of form and expression which were quite different from anything attainable within the Classical approach. Neither of these two fundamentally opposed treatments of the forms of relief is intrinsically better than the other from an aesthetic point of view. They are simply different.

Discussion of the autonomy and corporeality of the forms of reliefs is complicated by the fact that form and space in reliefs may be simultaneously both actual and notional in varying degrees. It is obviously possible to achieve a greater degree of independence and actual fullness of volume in a higher relief than in a lower one, but the corporeality and autonomy of form of a figure in relief cannot simply be equated with the degree of projection of its forms from the background. Corporeality is not the same as mere bulk or mass and forms do not acquire autonomy by simply protruding a long way out from their matrix. The notion of corporeality applies to the way in which the figure has been conceived, and that conception may be realized in either a low or high relief, or even in a drawing or painting. But of course, while the forms of low reliefs have only notional corporeality, the forms of higher reliefs may be independent three-dimensional solid forms in their own right apart from what they represent.

[1] *Renaissance and Renascences*, p. 60.

DRAWING AND
MODELLING IN LOW
RELIEF

Some feeling for drawing in general and some awareness of the special qualities of different kinds of drawing are essential for the appreciation of a great deal of relief sculpture. It would be possible for a sculptor to produce work in the round of the highest quality without having any knowledge whatever of drawing; and it would not be necessary to us to know anything about drawing in order to appreciate his work. But in order to produce almost any kind of work in relief a sculptor must be something of a draughtsman as well as a sculptor. Drawing is implied in his work and draughtsmanship is an essential part of his skill. It is therefore something which we must take into account when we are looking at his work. This is particularly true of low reliefs.

In a drawing everything is actually in the same plane and any variations in depth which we attribute to its forms and contours are entirely notional. They are represented by breaks in the line where one form comes in front of another (a device which is at least as old as the Lascaux cave drawings), by a fading or softening of the lines which represent deeper-lying parts of the contour, by the use of tone to represent cast shadows and surface modelling, by the relations of contours to the interior lines and interior modelling, and by numerous other graphic methods. Many reliefs approach very closely to the condition of drawing. They project only slightly from their background; their external contours are all in the same plane – the plane of the background; and their effects of recession and movement in depth are produced mainly by graphic methods. We could say of some of them that they are about nine-tenths drawing and one-tenth sculpture.

In the low relief medallion portrait of Catherine de Medici by 91 the great French sixteenth-century sculptor Germain Pilon, the three-dimensional form of the head is well represented in three-quarter view but there is very little projection of form. The impression of three-dimensionality is achieved mainly by means of a combination of drawing with subtle modelling of the main planes and surface forms.

The qualities of Pilon's portrait become more apparent when they are contrasted with those of another low relief head and shoulders in a totally different style. For this purpose I have selected a detail from the magnificent Egyptian New Kingdom festival relief from the Tomb of Ramose at Thebes. In Egyptian reliefs, as 90 we have already seen, the parts of the body are not functionally related to provide a single coherent view but are combined in an unnatural manner to create an image in which all the forms and

contours are spread out in the same plane. This principle is clearly shown in our illustration. The head is in profile, while the shoulders and eye are rendered frontally. In contrast to this the forms and contours of Pilon's medallion have been observed with great care from a specific viewpoint and all the parts of the relief are consistently ordered to provide a single view in depth of the head and shoulders. In the real head seen from this view the variation in depth between, say, the contour of the right side of Catherine's face and the contour of the back of her head would be considerable, but in the relief they are actually on the same level. The contours of both reliefs are in fact on the back plane. But while Pilon's outline represents a natural contour which varies considerably in depth, the Egyptian outline is not a rendering of a natural contour. The Egyptian figure is an image which could only exist in a low relief or a drawing, since it has been conceived completely as an image on a surface. Pilon's portrait, however, has been conceived as a fully corporeal head and shoulders and we could without much difficulty convert it into a high relief or a fully three-dimensional sculpture. The Egyptian relief lacks both actual and represented corporeality; the Pilon lacks only actual volume and depth but fully represents the corporeality of a human head and shoulders.

Both reliefs rely heavily on drawing as a means of creating their own special kinds of expressive form, although the kinds of drawing employed are extremely different. The Egyptian relief pre-dates the Greek discovery of how to render solid corporeal bodies on a two-dimensional surface as though they were in three-dimensional space, a discovery which, when fused with actual modelling, produced the prototypes of the approach to low relief which is exemplified in the Pilon medallion. Some element of this notional corporeality exists in most low reliefs which have directly or indirectly come under the influence of Greek art.

In order to model the entire plastic surface of a head and to suggest its three-dimensional form as Pilon has done, within the confines of such low relief, a sculptor must not only be a first-rate draughtsman but must also have a complete mastery of the subtleties of modelling and a full understanding of the form of the human head.

One of the main problems of such low relief work is to preserve the natural depth relationships of forms while condensing them within the shallow token depth of the relief. We have already discussed some aspects of this problem in a previous chapter, under the heading of overlapping. But there we concentrated mainly on the relations in depth of one figure to another figure within the spatial context of the whole relief. Here we are concerned with the relations in depth of the component forms of the individual figures themselves, the forms within their own contours. In order to represent these relationships convincingly

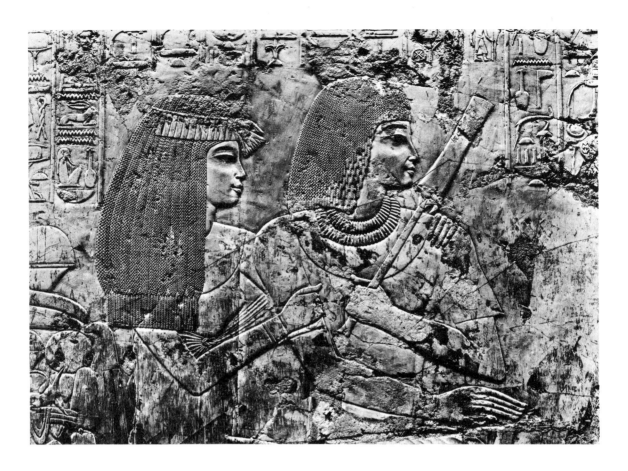

The Brother of Ramose and his Wife, detail of festival relief, Tomb of Ramose, Thebes, 18th dynasty. Stone. *Hirmer Fotoarchiv München*

in low relief a sculptor must attend carefully to an aspect of relief modelling which is usually referred to as the *superposition of planes*. This contributes enormously to the vitality and plastic qualities of reliefs and is something which we should be able to recognize and appreciate in them. It is worth devoting a paragraph or two to an attempt to elucidate it.

A simple three-dimensional form with one continuous surface — for example, an egg or a sphere — has a point on its surface which is closest to us, and from that point the surface recedes regularly and without interruptions in all directions to its contours. The surfaces of the main masses of the human figure are not like this. The human head and torso, for example, are composite forms. Their surfaces are not just shells which contain the forms as an oyster shell contains an oyster or a tin contains toffees, nor are they merely the outer limits of a homogeneous lump of matter, like the surface of a billiard ball. They are, rather, the outsides of complex anatomical structures composed of many interrelated parts, and the variations and irregularities of their surfaces are the outward and visible signs of these interior structures. In any view of the main masses of the human figure some forms underlie others and appear from behind them. In a torso seen from the front, for instance, the

rib cage lies behind the pectoral muscles or breasts, the neck lies behind the collar bones and in front of the trapezius muscles, the main structure of the arms comes out from under the deltoids, and so on. In a profile view of the head the wing of the nose lies over the central ridge of the nose and part of the upper lip, the eye is in front of the main plane of the nose, the cheek and the temple lie above the eye, while the ear is in the highest plane of all, unless the hair forms another still higher plane. These are, of course, only the more obvious planes. The more closely we look into the anatomical structure of the figure, the more numerous and complex these relationships become.

By attending carefully to this superposition of planes a sculptor may create an impression of depth and roundness of form no matter how shallow or flat the actual relief may be. The ordered

Catherine de Medici, by G. Pilon, 1589. Bronze medallion, 162mm. Cabinet des Médailles, Paris. *Photo Jean Roubier*

and consistent relations of planes within the total projection of the relief will help to create an image of the human figure which has a convincing structure, and will give unity and proportion to the depth and weight of its forms. It may also give variety and expression to the contours and surfaces of the relief.

The superposition of planes in the contours of low reliefs is especially important. It produces subtle changes of lighting, and movements and breaks in the lines, which contribute a great deal to the expressiveness of the relief and are important indications of form. It is a relatively simple matter to draw an outline on a surface, cut around it or fill it in to a more or less even depth, and then suggest a few internal contours and other features which will give it the semblance of a human head or figure. But it is a difficult and much more interesting matter to create contours and surfaces in low relief which will represent a complex plastic structure in depth and also serve as important vehicles of sculptural expression.

The qualities of surface modelling, which are directly linked with the qualities of the contours and reflected in them, are among the most variable qualities in relief sculpture. The surface forms of reliefs may be flat or rounded, hard or soft, sharply delineated or blended into one another, broad and simplified or broken up into numerous facets, bland and expansive or nervous and cramped, thin or full, loosely or tightly modelled, and so on. This is a topic which we shall take up more fully in a later chapter which discusses the role of light and shade in reliefs.

In a relief such as Pilon's portrait of Catherine de Medici the strong impression of three-dimensionality, of a lucid and powerful but almost entirely notional corporeality, is created by the mutually reinforcing interaction of drawing and modelling. Further examples will serve to clarify the roles of drawing and modelling in low reliefs.

The Classical Mayan low relief from Palenque which is known as *The Tablet of the Slaves* relies almost entirely on a refined technique of drawing for the definition of its forms. The main features of its composition are a number of large raised flat areas which stand out against a blank background as the land masses in a map stand out against the sea. Each of these large masses, consisting of a principal figure and its associated detail, has been separated from the background by cutting back sharply to a more or less even depth all round its external contours. The resulting outlines are the strongest lines in the relief. On these flat raised areas the interior forms and other details are delineated mainly by means of shallow engraved lines. There is a slight amount of interior modelling, especially in the heads of the figures, but its role is subsidiary to that of the lines. In the drawing of the interior lines there is a definite intention to represent something of the corporeality of the figures. The curves of the lines of the waistband, the armlets, and

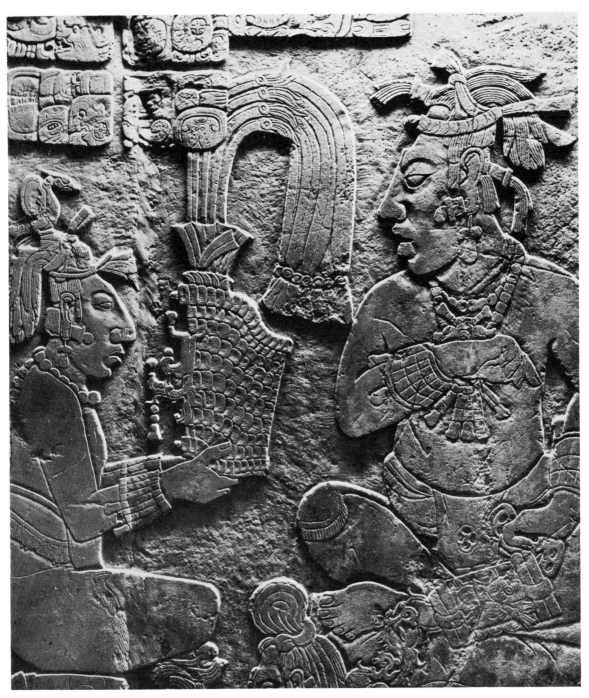

Detail from *The Tablet of the Slaves*, Palenque, Chiapas, Mexico, *c.* 700–800. Stone, 151 × 164cm. Museo de la Ruinas, Palenque. *Eugen Kusch*

the necklaces all help to suggest in a typically draughtsmanlike manner that the forms are rounded and have another side. But in the poses of the figures there is a lack of oblique views and a concentration on profile and frontal presentation which is typical of flat planar styles of relief. However, the planarity of this Mexican relief is not as extreme as that of Egyptian reliefs. With very few exceptions such things as the collars, waistbands, sleeves, and

93

armlets of Egyptian figures are not rendered in a way that defines the sections of the forms in depth or suggests that they have volume.

The distinctive character of this relief is largely due to the contrast of the delicate drawing of the interior lines with the bolder cutting of the exterior contours, and to the consideration which has been given to the shapes of the large raised figured areas in relation to the shapes of the ground between them. The relief is in the main a sculpturally reinforced drawing, but a drawing of a kind which is different from that of both Pilon's medallion and the figures from the Tomb of Ramose.

The small low relief figure of a spear thrower from a statue base found at Athens is a late Archaic work dating from the end of the sixth century B.C. At this time Greek sculptors had not yet fully acquired the understanding of the structure and movement of the figure which is characteristic of their later work. The movement of this figure is convincing enough but it is not entirely natural. The

Spear Thrower, from a statue base, late 6th century B.C., Greek. Marble. H. 32cm. National Museum, Athens. *Hirmer Fotoarchiv München*

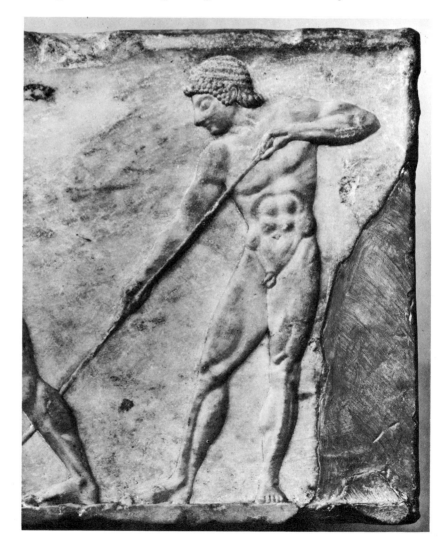

lateral tilting of the forms has been rendered fairly naturally and there is a fine strong continuous curve running through the whole figure from the powerfully planted left foot to the broad, tilted shoulders, but there is no natural rotation of the body as a whole. Rotational movement is represented by combining profile views of the head and right leg with front views of the other parts of the body, without any suggestion of a transition from one to the other.

The interior structure of the figure is clearly modelled and is perhaps over-emphasized to the point of making the figure rather unpleasantly lumpy in places. One gets the impression that having gone to so much trouble to get to know the surface anatomy of the figure, the sculptor was reluctant to omit any of it. The elaborate anatomical modelling is reflected in the character of the contour and its quality varies with the quality of the modelling which gives rise to it. The fullness or flatness of the forms just inside the contour, the varied angles at which they meet the background, and the superposition of planes of modelling in the anatomical detail of the contour all have an effect on the lighting around the edges of the figure and thus impart variety to the contour.

SUNKEN RELIEF Perhaps the most surface-dependent of all forms of relief is that which is known as sunken, or sometimes as *coelanaglyphic* or intaglio relief. The characteristic feature of this kind of relief is that it does not protrude from the surface but is sunk, or recessed, into it. This is brought about by a reversal of the usual procedure for beginning a relief. Instead of cutting away the surrounding surface and leaving the figure raised above it, the sculptor leaves the surround where it is and carves the relief within a deeply incised line. The result is a relief whose contours are sunk below the surrounding surface and whose highest parts are on a level with it. The main effect of this method of carving a relief is to produce a strong outline. The step down to the contour of the sunken relief either catches the light or creates strong lines of shadow and thus encloses the figure in a sharply defined band of light and shade.

The sunken relief was one of the main types of relief used in ancient Egypt and in many ways it is a typical Egyptian conception. It is more permanent than other forms of relief, which in view of the ancient Egyptians' obsession with overcoming time must certainly have counted in its favour; it emphasizes rather than relieves the planarity of the surfaces of Egyptian architecture; and it counters the form-obliterating effects of strong direct sunlight by harnessing it to produce a strong shadow or light line for the outline.

In order to show that this method of carving a relief is not

Detail from ivory plaque from Begram, Afghanistan, 1st century. Height of figure, 11cm. Museum of Kabul, Afghanistan. *Photo Dominique Darbois*

necessarily confined to Egyptian modes of representing the human figure I have included a beautifully delicate and more intimate example in ivory. This is an Indian work discovered in Afghanistan in 1937. It is totally different in spirit from any Egyptian sunken relief. The subtle plasticity of its surface modelling and the fore-shortened three-quarter view from which it is represented make this figure more akin to Greek or Roman low reliefs or to Pilon's medallion. This is not surprising since the relief originates from a town in which the Hellenistic and Indian cultural traditions met.

STIACCIATO RELIEF

Apart from being one of the greatest sculptors of all time by virtue of the quality of form and expression in his work, Donatello was also one of the most technically inventive. Indeed he may well be the most inventive genius in the whole history of sculpture. One of his most remarkable innovations is a form of relief which has come to be known as *stiacciato* (flattened-out) relief. It first appeared in a small panel of *St. George and the Dragon*, which was set below the niche containing the sculptor's well known statue of St. George. In its use of linear perspective, its effects of light and shade, atmosphere, and distance it anticipated qualities which were more fully exploited by Renaissance painters. John Pope-Hennessy has said of this relief panel that 'it records one of the most remarkable advances in sheer seeing that has ever taken place.'[1]

But although the *St. George* panel was the first of its kind, the method of stiacciato relief is most clearly shown in Donatello's later marble relief of *The Ascension with Christ Giving the Keys to St. Peter*. The degree of projection of the forms in this work is minimal and the modelling is extremely delicate and subtle. The

[1] *Italian Renaissance Sculpture*, London, 1958, p. 17.

96

definition of the forms of the figures depends very largely on drawing. The angles at which the surfaces of the figures meet the background are so slight that in places the contours would be imperceptible if they were not reinforced by an incised line. In many places the forms are deliberately faded off into the background, and it is this which largely accounts for the atmospheric quality of the relief. The background and figures are intimately connected to form a continuous plastic surface which flows without abrupt changes over the whole relief, and the figures have no actual independence or sculptural corporeality at all. In these reliefs and in some of those of Donatello's most distinguished follower in this stiacciato technique, Desiderio da Settignano, we are as close to drawing as relief is ever likely to come.

Donatello's experiments in low relief carving were not limited to the extremes of the stiacciato technique. He also developed amazingly flexible and expressive methods of cutting marble within the more usual limits of low relief projection. These techniques were taken up in the low relief work of a whole group of Florentine marble carvers. There is nothing in the whole history of sculpture which resembles the low reliefs of these *Quattrocento* sculptors, who include among their number Bernardo and Antonio Rossellino, Mino da Fiesole, and Desiderio da Settignano. And there is no material which responds so sensitively to delicate treatment in low relief as the white marble which was their favoured medium. Their work is delicate and intimate rather than heroic or monumental, and it contains an extraordinarily subtle and expressive combination of interior modelling and drawing. Walter Pater wrote of these sculptors:

They are haters of all heaviness and emphasis, of strongly opposed light and shade, and seek their means of delineation among those last

The Ascension with Christ Giving the Keys to St. Peter, by Donatello, 1430. Marble, 41 × 115cm. *Victoria and Albert Museum, London: Crown Copyright*

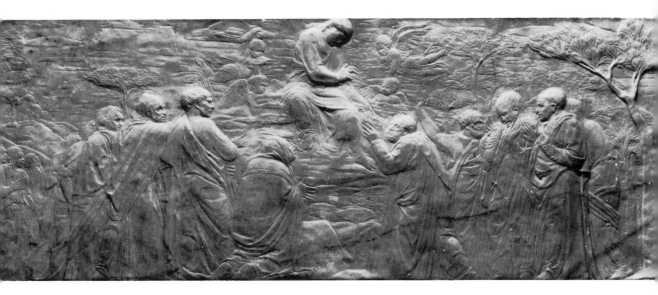

refinements of shade which are almost invisible except in a strong light, and which the finest pencil can hardly follow. The whole essence of their work is *expression*, the passing of a smile over the face of a child, the ripple of the air on a still day over the curtain of a window ajar.[1]

As Pater suggests and Ruskin asserts more explicitly, these reliefs rely heavily on drawing and 'chisel-painting'. The sculptor 'does not carve the form of a thing, but cuts the effect of its form'.[2] However, there is a great deal of variety within a narrow range in the projection of their forms. Their contours are a particularly flexible and expressive feature. Both the height of the contours above the background and the angle at which they meet the background are constantly changing in order to express the movement of the forms and the quality of their interior modelling. In most of their low reliefs of the Madonna and Child, parts of the figures, especially the heads, are undercut so that they begin to separate from the background. But frequently it is an undercutting which is intended to sharpen a contour line rather than one which actually begins to complete the roundness of the form. This is a point which requires some elaboration.

The purpose of undercutting is sometimes merely that of raising a contour from the background by creating some degree of actual physical separation and a cast shadow behind it. All that is required is that the stone should be cut away behind the contour, and since the undercut portions are invisible from the front, this is often roughly done. An example of this occurs in the *Virgin and Child* panel ascribed to Francesco di Simone, a follower of Desiderio. The modelling of the Child's head is extremely low but the whole head is raised relatively high above the background and undercut roughly and sharply. This is difficult to see from a photograph since everything is converted into an entirely pictorial image. (It is worth remarking in this connection that the apparently receding interior space behind the figures is deceptive in a photograph. It is in fact a completely notional space drawn on the background plane in perspective. There is no actual recession at all and the back plane is completely flat.) More extreme examples of this kind of undercutting abound in Antonio Mantegazza's *Lamentation over the Dead Christ*.

The other kind of undercutting is not an artificial device for separating a form from the background and stressing its contour but a feature which arises when the forms are modelled or carved beyond their widest part so that their all-roundness is not merely suggested but is beginning to be actual. This is the beginning of a process which leads naturally to higher forms of relief. It will be the main topic of our next section.

Virgin and Child, ascribed to Francesco di Simone, *c.* 1470. Marble, 1ft. 4½in. × 1ft. ½in. *Victoria and Albert Museum, London: Crown Copyright*

[1] 'Luca della Robbia', *The Renaissance*, London, 1873.
[2] J. Ruskin, *Seven Lamps of Architecture*, Library ed., London, 1903, in vol. XIII, p. 215.

From our earlier description of some of the characteristics of the natural contours of the human figure it is apparent that when the forms of a figure in relief are made to project beyond a certain minimal level, some separation of their contours from the background becomes inevitable if there is to be any attempt to represent the natural articulation and movement of the figure (pp. 83ff.). In fact, when the movement in depth of the contour ceases to be primarily a matter of drawing and is therefore no longer entirely notional, then the relations of the contour with the background plane will be constantly changing. The relief can no longer be bound by a continuous contour which coincides with the juncture of the forms with the background. Some parts of the contour will be on the level of the background plane, others in varying degrees, will be in advance of it. (Only very rarely, and then for special purposes, will it be suggested that the contour is behind the background plane since this would give the impression that the form is buried in the matrix.) It follows from this that the receding surfaces of some of the forms will have to be carved or modelled to a depth which lies beyond their widest parts, that is behind the parts which form their contours. When this happens, the sculptor may either cut straight back from the contour at right angles to the background and create a raised contour or he may continue to carve round the form behind the contour.

In Classical Greek sculpture the human figure was conceived in artistic terms as an articulated structure of three-dimensional forms and there is always some interplay between the forms of the relief and the background plane. In the Horsemen frieze from the Parthenon, this is handled with remarkable subtlety. Superb drawing and a complete grasp of the plastic structure of the horse and the human figure have produced contours of great flexibility and expressive power. The pose of the youth by the horse is such 35 that no part of him is greatly in advance of any other part and there is nothing which will stretch the available depth of relief uncomfortably beyond its limits. But within these limits of some two or three inches' depth the contour varies from the relatively deep undercutting of the head, the left forearm, the right shin, and left inner knee to the marvellously fluid line on the level of the background along the left side of the figure. The contours of this figure are not mere lines drawn on the background, to which the interior shapes are made to conform, but are the natural result of the modelling of the forms. The contour has not been imposed upon the figure as a mere boundary line but has grown organically and inevitably from the inside, as a natural conclusion to the form. Its relations with the background are therefore not arbitrary, mechanical, or merely decorative, but are expressive of the relations of the organic structure of the figure to the background.

The figure of Hermes on the column base from Ephesus, which is

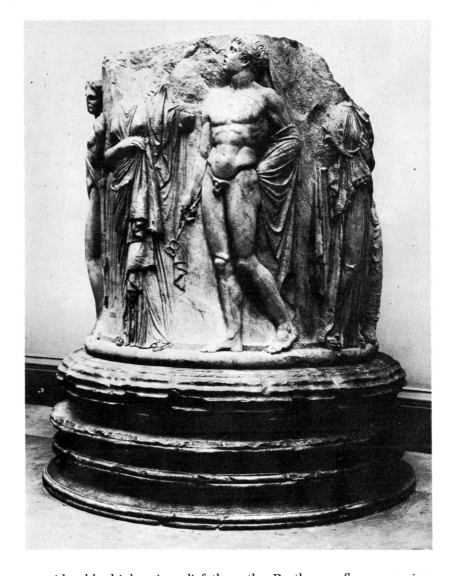

Hermes, from a column base from Ephesus, *c.* 340 B.C. Marble, height of base 1.8m. *The Trustees of the British Museum, London*

considerably higher in relief than the Parthenon figure, carries this process a stage further. Because the figure is turned to one side many parts of the other side of its body are raised from the background. These parts, however, are not roughly undercut or merely cut back at right angles to the plane of the relief. Instead they are carefully completed as forms right up to the point where they meet the background. The figure may therefore be viewed not only from a position directly in front but from a whole range of frontal positions. We may change our angle of viewing without the artificiality of the relief becoming objectionably obvious.

When forms are carved in this way to a depth beyond their contours, they begin to assume an independent existence as forms which are in front of the background. They acquire some of the independent corporeality which we associate with sculpture in the round. This partial release from the background may occur in isolated parts of a figure or all round it. Such reliefs are conceived

primarily not as drawings, nor as mere outcrops from a surface, but as compositions of volumes which exist in their own right and which may rotate and tilt on their own axes and set up varied relationships with the background plane.

As the relief becomes higher and the axes of the main forms move further forward from the background plane, so parts of the figure – the head, part of a leg or an arm – become completely separated physically from the background and are carved or modelled in the round. This process of actual separation may continue to a point where the figure is attached to the matrix in only one or two places and is virtually a fully corporeal statue in its own right.

The beginnings of this process are clearly shown in a most restrained fashion in the grave relief from Salamis. Most of the forms of the principal figure are carved beyond the contour and the whole figure is visually detached from the background. The far side of the face, for example, is almost as completely carved as the side which faces the viewer. All the movements of this youth are parallel with the plane of the relief and we sense strongly how everything has been kept within the limits of the space available between the front face of the original slab and the back plane. But this interplanar existence has been contrived without any arbitrary distortion or feeling of constraint. The left arm hangs naturally in the space at the side of the body, without any artificial straightening or flattening, and the right arm reaches out along the background in a perfectly natural gesture. The relaxed naturalness of the movement of both arms has required that the wrists project from the background beyond their natural thickness and the sculptor has therefore completely released them from the background by carving all round them. They are the only parts of the figure which are free-standing.

The restrained movements of the figure in relation to its background, and its relaxed existence within a limited interplanar space, contribute greatly to the 'classical calm' and self-contained, slightly remote quality of this beautiful gravestone. Again, the apparent naturalness should not deceive us into thinking that this relief is merely a straightforward rendering of a natural figure, a mere 'imitation of nature'. The naturalness is in fact an achievement of consummate artistry and a complete mastery of the techniques of relief sculpture. Only the most superficial acquaintance with relief sculpture and a complete ignorance of the problems of achieving an articulated structure in a rendering of the human figure could lead anyone to suppose that such a result could be achieved by mere copying of the forms of nature.

The techniques of really high relief were first perfected by the Greeks, who found that a boldly projecting relief which is partly detached from the background read better than a low one from a distance in the strong outdoor sunlight of Greece and that its

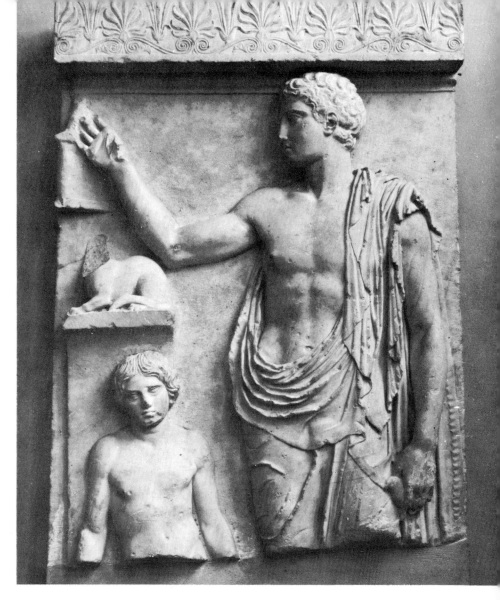

Sepulchral stele for a youth, from
Salamis, *c.* 410 B.C. Marble, 1.09m.
National Museum, Athens. *Sheila
Adam*

fully round forms were more in scale with the strong volumes and powerful projections of their temple architecture.

The sculpture for the metopes of the Parthenon was carved in very high relief. Metopes are almost square stone panels which are a feature of Doric temples. They are situated at a considerable height from the ground, just below the cornice, and they alternate with the triglyphs all round the temple. Those from the south side of the Parthenon depict scenes from the legendary battle of the Lapiths and Centaurs. In each panel a member of the Lapith tribe is shown in violent conflict with a Centaur. The Lapiths are represented as noble and beautiful human beings while the Centaurs are embodiments of brutishness and sensuality. The carvings may thus take on universal significance as representations of the eternal conflict of good and evil.

Some of the figures are poor in quality, stilted and awkward in pose and lacking in structure and plastic subtlety; others are very beautiful. The Lapith in our illustration is almost completely in the round and free standing. In its original setting this group would cast strong shadows on the background and light would also penetrate behind the figures directly to the background. The fully round forms would modulate the light on their own surfaces into

Lapith Fighting with a Centaur, from the south face of the Parthenon, *c.* 440 B.C. Marble, H. 1.34m. British Museum, London. *Edwin Smith*

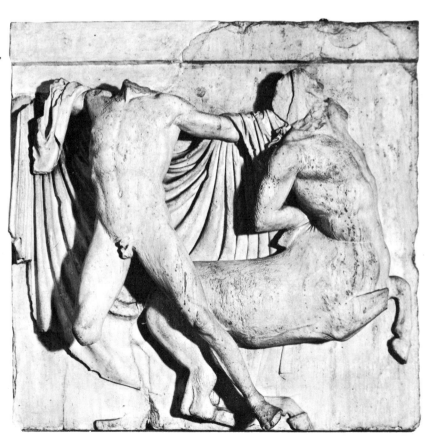

strongly contrasting shadows and highlights. The over-all effect would be bold and powerful. The technique adopted for these metopes is in direct contrast to that used for the frieze, which was situated in the dimmer light beneath the ceiling of the colonnade. In such a position a violently projecting high relief full of deep shadows would be visually confusing.

We should remind ourselves occasionally when looking at these Greek reliefs, as we should when looking at most pre-Renaissance reliefs, that they were originally painted. The colours added definition to the forms and reinforced the effect of the natural light which fell on them. As we see them now, damaged, sometimes fragmentary, and grey and pitted, in the dull stone-lined hall of the British Museum, they are magnificent enough, but they are very unlike their original selves.

THE HUMAN FIGURE
IN INDIAN RELIEFS

Although there are family resemblances which run through all Indian styles of sculpture and their derivatives, there are also differences which are as great as those among the various styles of European sculpture. The Indian tradition and the closely related traditions of South-East Asia have produced an immense wealth and astonishing variety of relief sculpture. It includes the early Buddhist reliefs on the stupas of Bharhut and Sanchi; the strangely mixed style of Gandhara, where the Graeco-Roman and Indian traditions meet and fuse; the voluptuous softness and ripeness of the volumes of Mathura sculpture; the profoundly spiritual Gupta Buddhas; the crowded scenes and refined decoration of Amaravati; the theatrical 'Baroque' groups occupying box-like stages at Ellura and Elephanta; the great Pallava relief of *The Descent of the Ganges*, which is carved on a huge granite outcrop on the seashore at Mamallapuram, near Madras; the extravagant virtuosity and luxuriance of Hoysala; the low tapestry-like reliefs in the galleries of Angkor Vat, with their wonderful flowing lines and complex dynamic composition; and the ten miles of relief carving on the Buddhist temple-mountain of Borobudur in Java. Without travelling to the Far East we can know most of this sculpture only through photographs, but there are fragments and individual pieces in a number of European and American museums.

The treatment of the human figure in Indian art is in many important respects quite unlike its treatment in Western art. The naturalism of Graeco-Roman and Renaissance sculpture arises from a careful observation of the detailed anatomical structure of the body and an attempt to translate what was observed directly into sculptural terms. This is as true of idealized versions of the human figure as it is of realistic versions. The forms and proportions which were idealized were those which had been directly studied

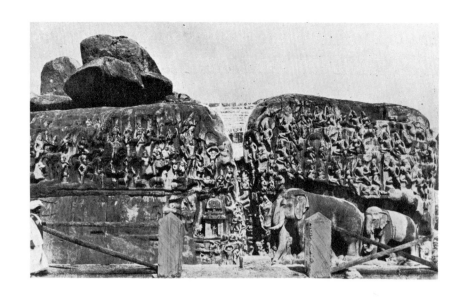

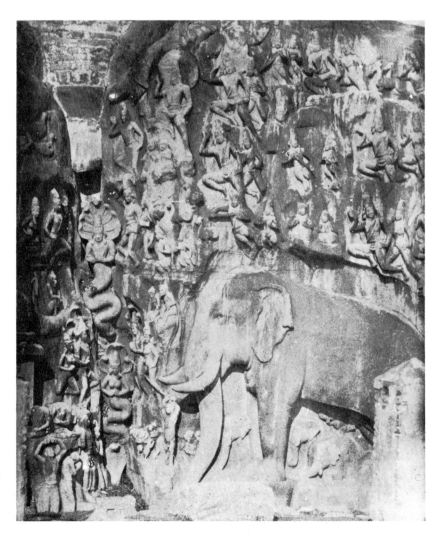

The Descent of the Ganges, from
Mamallapuram, India, *c.* 650.
Rock-cut relief, 84ft. × 28ft.
India Office Library, London

from nature. This is sometimes put in Aristotelian terms by saying that the sculptors have attempted to realize the perfection of forms towards which nature is striving but which is never attained in any individual actual figure. The forms and proportions of Indian figures are not closely modelled on anatomical forms. Indian sculptors translate the human figure into simpler, more regular, and less naturalistic shapes than those of the Classical Western tradition. For one thing the surfaces of Indian sculpture are not broken up nearly so much by the mobile surface anatomy. The neck, for example, is represented by a fairly straight cylinder unmodified in its sections by the shapes of tendons and muscles. This almost cylindrical neck fits straight down on to the plane across the top of the shoulders, like the neck of a pot, and the shoulders are conceived as a continuous curved surface passing under the neck. In a typical Greek figure the shoulders grow up into the neck and do not seem to pass under it. The juncture of the neck and shoulders in Indian sculpture is a line formed by the intersection of two simplified surfaces. The same juncture in a Greek figure is made more complex by subsidiary forms which bind one main form to the other. These include the muscles and tendons which run from the back of the ear to the middle of the collar bones, and the large trapezius muscles which are at the back of the shoulders and neck.

The juncture of an arm with a shoulder in an Indian figure is again an uncomplicated but subtle meeting of two solid forms. The Greek sculptor connects the main volume of the upper arm to the body by means of a complex system of linking muscles. The Indian sculptor treats the muscles as features of the main volumes themselves, not as separate intermediary forms, and he makes a direct connection between the two main volumes. The apparent simplicity of the Indian method is deceptive. This conjunction of surfaces is in fact extraordinarily subtle and well worked out.

Again, Greek sculptors conceived the chest as an underlying barrel-like shape overlaid by a pattern of secondary forms based on the musculature. We can sense this underlying shape because it comes to the surface in a number of places and because it controls the disposition and relations of all the minor shapes which overlie it. In Indian figures, however, the whole of the top part of the torso is conceived as one complex form. Pectoral, abdominal, and shoulder muscles are not conceived as separate shapes attached to an underlying volume but as features of a large single complex shape which reaches down to the waist and is complete in itself.

The lack of detailed realistic anatomy does not mean that Indian sculpture shows no understanding of the structure and organic unity of the human figure. Far from it. It is because they had a sound knowledge of the general forms and articulation of the human body that Indian sculptors were able to create such

mobile, subtle, and expressive sculptural equivalents for them. A spirit of objective scientific inquiry which would lead to a detailed anatomical knowledge was simply not a primary motive in their work, as it was in the work of Greek sculptors. The qualities of their forms, no less than their subject-matter, were determined primarily by religious and metaphysical considerations, and by canons of beauty and expressiveness derived from what has been called the principle of 'poetic analogy'. The forms of the sculpture stand in a metaphorical rather than a literal relationship to the forms of nature. According to Philip Rawson:

Indian texts, like the Pratimamānalakshanam and the Vishnudharmottaram, make it quite clear that an Indian sculptor, when he was forming something which was recognizably part of a human body, like a leg, hand, lip or eye, should make it the shape of some other thing, and thus attribute to it what I call a poetical analogy. The plastic version, as it were, of the poetic 'your eyes are like stars.' Analogy of this sort, extended into a ramified structure by means of amphiboly, being the lifeblood of poetry, we may well expect to find the same principle at work in the forms of art. The 'goddesses' of Khajuraho are given eyes which following the texts we can recognize as fish-shaped. Indian poetry prepares us to understand this with its virtually stock epithet for the eyes of a pretty girl 'like silver fishes'. This apprehension of the quick flickering glances of a long-eye girl – 'like fish in a dark pool' is clearly meant to be offered to the spectator's mind in the plastic image no less than in the poetic context.

Exactly this same process is described, and poetical analogies are suggested, for many other parts of the body. The trunk of an elephant for the shoulder and arm, or for the hip and thigh; the bill of a parrot – the bird of love – for the high, elegant Aryan nose; the lower petal of a Sesame flower for the lower lip, and so on. This process of formal suggestion is carried out through the inflected surfaces of the recognizable conventional sense-units out of which the figure is composed, and the forms are made in this way capable of reflecting emotionally charged situations.[1]

One of the most outstanding qualities of the forms of Indian sculpture is their convexity. The surfaces of all the main forms are broad unbroken convex planes. They appear to be sustained by a more or less even pressure from inside which is forcing the surfaces outwards and keeping them in a state of tension. This expansive convexity is in fact an outward sign of the presence of an interior vital breath, or *prana*, which fills the vessel of the body. Again Rawson is informative on this point:

. . . it seems that to the Indian eye only that was real which, like a pot or fruit, gave evidence of its *content* of space by its convexly curved surface. Just as the Indians have felt the life of the body to depend upon its content of vital breaths – prānas – so is the adequacy of a form to express a reality dependant on its *containing* space.

[1] 'The Methods of Indian Sculpture', *Asian Review*, 1964, vol. 1, no. 3.

This quality, which is almost universally present in the modelling of both reliefs and sculpture in the round, is reflected in the contours of the figures, which tend to be long unbroken curves. The lack of anatomical detail and the continuity of the surfaces leads to a lack of superposition and a continuity in the contours of reliefs.

The approach of the Indian sculptor to the problems of articulating the forms of the human figure is consistent with his approach to the modelling of the forms. Indian figures are not articulated by anatomically accurate joints at the knees, ankles, hips, shoulders, etc., but by joints which arise inevitably – by geometrical necessity, so to speak – from the intersection and interpenetration of the volumes. As often as not this joint is a simple clear line. The ingenuity of the Indian sculptor shows very clearly in his ability to adapt his methods of articulating the figure to a great variety of poses.

The qualities of the forms of Indian sculpture are stressed by the relationship to them of the costumes, especially the jewellery. Head-dresses, collars, armlets, girdles, and anklets all encircle the forms of the figure and visually underline their fullness of volume. They provide extremely valuable visual clues to the real thickness of forms in high relief and to the notional thickness of forms in low relief. Moreover the hard sharp detail of the jewellery emphasizes by contrast the expansiveness and plainness of the surface and, especially in the female figure, the full softness of the flesh.

Mature Indian reliefs vary as much as Greek reliefs in their degree of projection, and their figures are organic structures centred on their own axes which move as freely as Greek figures against their backgrounds. It is worth noting, however, that this mastery of the Indian sculptor over the structure and movement of the human figure was achieved only after a process of development which has certain similarities to the development of Greek sculpture. There is an early phase of Indian sculpture which corresponds to some extent with the Archaic period of Greek sculpture. It is in fact sometimes referred to as the archaic phase of Indian sculpture. Probably the best known works from this period are a number of carvings from the early Buddhist stupa of Bharhut, one of which 110 we shall discuss in a moment.

FORM AND
BACKGROUND IN
ARCHAIC AND
ROMANESQUE RELIEFS

As we have just seen, mature Greek and Indian reliefs treat the figure as an organic whole and attempt to represent its movement, structure, and articulation. Works of this kind show more clearly than any others the varied interplay which is possible between the forms of a figure and its background. There are, however, many types of relief which do not set out to represent the figure in a way that requires any significant variation in the relationships

Yakshi, from Bharut,
c. 100 B.C. Stone, 2.14m.
Indian Museum, Calcutta.
India Office Library, London

between its forms and the background. If the figure is represented frontally with all its movements taking place in a lateral direction (that is, in the plane of the relief), then there is no undue difficulty in keeping all the forms at an even depth from the background and surrounding them with a fairly uniform contour. We have already seen how this condition is achieved in Egyptian reliefs, which are extremely flat. But a plane-conditioned character is also possible in figures which project much more than those in Egyptian reliefs. Examples are common in ancient Near Eastern, Archaic Greek, Romanesque, pre-Columbian, and early Indian art.

The fundamental difference between these figures and the figures of the mature Greek and Indian reliefs shows most clearly in their movement. It does not originate from within the figures themselves but conforms to conditions which are external to them. They are not formed with reference to axes of their own like the mature Greek and Indian figures but with reference to the surface on which they are spread out and flattened. There are certain advantages in this method of treating the figure. These are, first, an increase in its purely decorative value – it is easier, for example, to treat the outlines freely in a decorative manner; second, a closer relationship between the figure and the surface it decorates; and third, the preservation of the plane character of the surface.

These advantages have been fully exploited in a number of Archaic Greek carvings. A good example is a metope representing *Heracles and the Cercopes* from the Treasury of Heraion at Sele. By spreading out the forms of the figures, especially the shoulders, arms, and legs of the central figure, the sculptor has created a strong all-over pattern of spaces and boldly projecting areas of relief which admirably fills the square field of the metope.

Our main example of this kind of relief, however, is a lovely sensuous carving of a Yakshi which decorates a pillar of the stone railing from the stupa of Bharhut. Yakshis are female tree spirits associated with fertility. They belong to an older form of religion than Buddhism but they became a favourite image in Buddhist art. This Yakshi embracing a blossoming mango tree illustrates a popular Indian belief that a tree will flower if it is touched by the foot of a beautiful girl. It is one of the most widely known of all Indian sculptures.

The figure of the Yakshi has not been conceived as an autonomous structure centred on an axial system of its own and related to the surface of the pillar as to a back-drop against which it moves. Rather it has been conceived as a decorative image spread out on the plane of the surface of the pillar. Fundamentally it is a two-dimensional image, the interior of which has been raised into attractively rounded forms. The figure hardly moves at all in depth. It is presented frontally with all movements taking place in a lateral direction. Its forms and contours do not move towards and

away from the background but are related to it in an almost uniform manner throughout the relief. The forms, in fact, give the impression that they are pressed against the background and there is a certain lack of articulation which gives the figure a somewhat rubbery appearance, particularly in its limbs. The interior modelling has the breadth and convexity which are characteristic of Indian sculpture, and there is a highly decorative, if somewhat slack, sinuosity in the curves of the contours. The tree trunk, which bends over and under the limbs of the figure, is treated in a similar manner. The translation of the leaves and foliage of the tree into decorative stonework is a fine example of something which recurs again and again throughout the history of Indian sculpture. It is a tropical counterpart of that wonderful feeling for vegetable life which pervades the sculptural decoration of many of the great Gothic churches.

The qualities of this Yakshi from Bharhut will become more apparent if they are compared with those of a later figure. The movements in depth of the ninth century female figure with a bird are restrained, but its legs are not artificially pressed against the

Female figure with a bird, Indian, early 9th century. Sandstone, 81.5cm. Patna Museum. *Royal Academy*

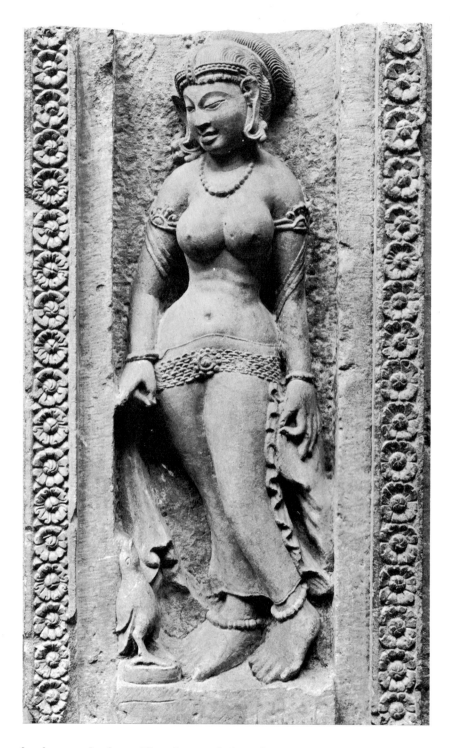

background plane like those of the Bharhut figure. There is a subtle *contrapposto* running through the entire length of the figure. Its shoulders are at a slight angle to its hips and its head is turned to one side and tilted down, which brings it out from the background. The relief is bolder and the figure moves around its

axis independently of the background plane. The method of treating the relief, if not the quality of its forms, has much in common with Classical higher reliefs. In other Indian figures this axial rotation is carried to extremes which are comparable with the extravagant serpentine poses of European Mannerism.

Some of the problems raised by the articulation of the figure are avoided in clothed figures if the costume is treated in a way that makes its shapes more or less independent of the shapes of the body. We shall understand this more clearly if we realize that there are two main ways of treating clothing in sculpture. In one of them the clothes enter into a functional relation with the articulated body underneath and their linear rhythms may reinforce or contrast with the deeper-lying movements of the structural parts of the body. This is typical of Greek and Roman sculpture and of styles which have been influenced by them. In works of this kind the robes, or draperies as we should perhaps call them in these instances, enter into varied relations with the background. They follow the movement of the body and set up new movements of their own so that they complicate and diversify rather than simplify the relations between the figure and the background. In many archaic and other non-naturalistic styles, however, the costumes are not like this but are made into simple symmetrical or nearly symmetrical volumes in their own right which convey little or no hint of the structure of a body underneath. Long skirts and other full-length robes, for example, may be made into simple bell-like or near cylindrical volumes which conceal the movement of the figure from the waist down. It is not then necessary to find an answer to the difficult problem of relating the legs and hips to the background. If a figure in such a costume is presented in strict frontal or profile view and its movements are restricted in order to keep its axes parallel with the plane of the relief, then the contours may be more or less uniform all round. It becomes possible to construct a figure in relief which is half round like half a pillar, with contours which are on the background and coincide almost completely with the median plane of the figure. There are many Romanesque and ancient Near Eastern reliefs which conform to these principles.

When we speak of the flatness, or planarity, of a relief we must be clear in our minds whether we are referring to a quality of the forms themselves or to a quality of their arrangement, or composition. A great deal of confusion and misapprehension of the true qualities of sculptural styles results from a failure to make this elementary distinction. It is clear enough that Egyptian reliefs are flat or planar in both respects. The forms are extremely flat within their contours and all their axes, surfaces, and contours are in a single plane parallel with the plane of the relief. Egyptian reliefs are all stylistically very similar and it is possible to generalize fairly

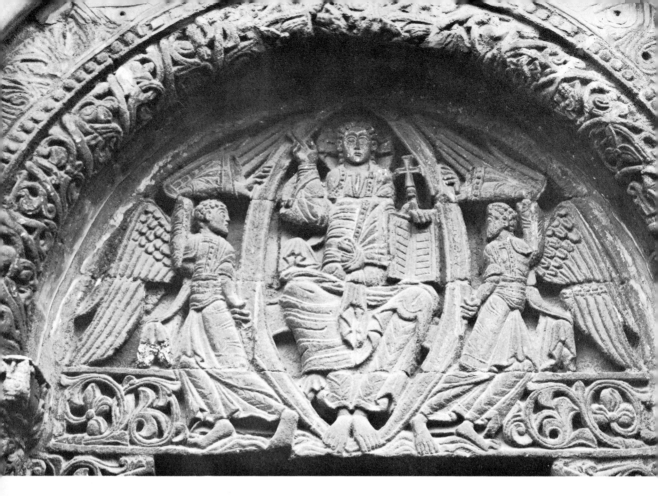

Christic in Majesty,
from the Prior's Door, Ely
Cathedral, *c.* 1140. Stone.
Edwin Smith

broadly about them. But with styles like Romanesque, which include works of great diversity, we must be on our guard against obscuring important differences through trying to make all-embracing generalizations about their qualities. This point may be clarified by reference to some well known Romanesque tympana.

The Romanesque relief on the tympanum over the Prior's Doorway at Ely Cathedral represents *Christ in Majesty*. He is seated on a rainbow within a mandorla supported by two angels. In his left hand he holds the Book of Law and his right hand is raised in benediction. The design on the tympanum itself has been continued down into the centre portion of the lintel. This is an unusual feature; it was customary to stress the differences in the architectural functions of the lintel and tympanum by treating them as separate fields for sculpture.

The forms of the relief are raised considerably above their background but apart from a certain amount of curvature at their edges they are almost as flat in themselves as the forms of Egyptian reliefs. Their arrangement, too, is completely planar. The figure of Christ is severely frontal and his head, hands, knees, body, and feet are all arranged in one plane. The angels' wings, heads, bodies, and limbs are twisted into unnatural positions so

that they are all disposed either frontally or in profile. This does not, however, involve any actual torsion in the forms. The transition from the front view of the shoulders and chest to the profile view of the legs is not brought about through any actual movement of planes. It all takes place behind the broad sashes. Where the figures enter the top of their sashes they are facing the front and where they come out of the bottom they are in profile. All the main surfaces, contours, and axes of the forms are in a single plane parallel with the plane of the whole relief. The over-all effect is one of flatness across the top surfaces of all the forms. The deeply hollowed-out spaces between the forms do not lessen the flatness. They read as dark shapes which emphasize the contours and increase the pattern quality of the whole composition.

The Ely tympanum is undoubtedly a work of considerable vigour and individuality but in comparison with the great French Romanesque tympana of Vézelay, Autun, Moissac, Conques, and Beaulieu it is a modest achievement. The subjects of these master-pieces of visionary art are drawn from the Bible, especially the Book of Revelation, and most of them show Christ in his awe-inspiring role as judge at the Last Judgement. (Vézelay is an exception; the subject there is Pentecost.) The doorway through which people entered the church was considered a suitable place

Christ of the Second Coming, from the tympanum of St. Peter's, Moissac, 1115–35. Stone, w. 18ft. 8in. *Archives Photographiques*

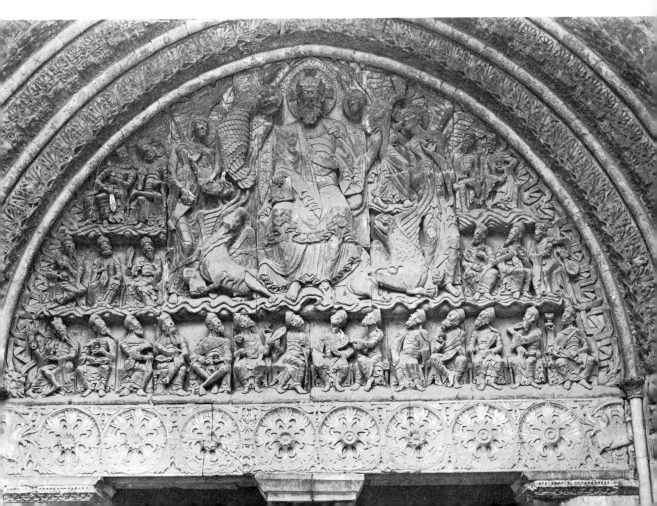

for a reminder that the sum of all their actions in this world had meaning only in relation to a world that is eternal and transcendental and that everyone would be ultimately judged and either rewarded with everlasting bliss or punished with everlasting torment.

The tympanum at Moissac is a masterly translation into visual images of chapter four of the Book of Revelation. It shows Christ seated on a throne surrounded by the four beasts and the four and twenty elders with the sea of glass stretching in waves under his feet.

The tympanum of Autun by Gislebertus is a less literal and more personal interpretation of the scriptures. Christ is seated as usual on a throne with arms outstretched. He is surrounded by a mandorla which is supported by four angels, two standing and two flying. The space to Christ's left and right is divided into two registers, the upper one of which represents heaven. The side of the tympanum which is on Christ's left shows the weighing of souls and the punishments of the damned. On the other side stands a group of apostles, including St. Peter who is carrying an enormous key to the gate of heaven. St. Peter is watching over the blessed souls entering heaven, which is symbolized by arcading. The lintel depicts the Resurrection.

For some reason this work is often referred to as a low relief and is said to be in a flat or planar style. All the figures are in fact carved in high relief and many of them are almost completely free

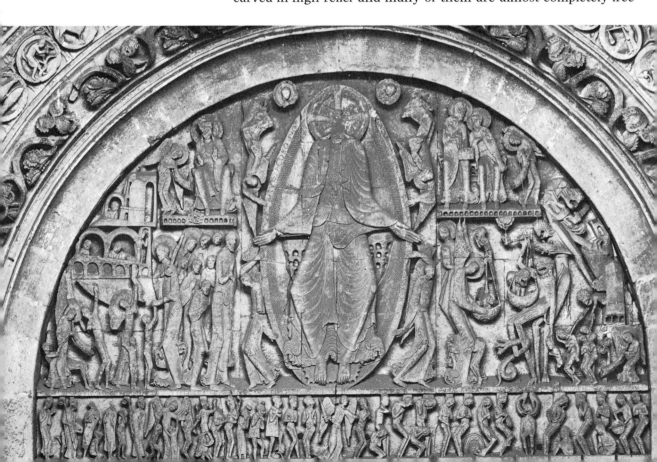

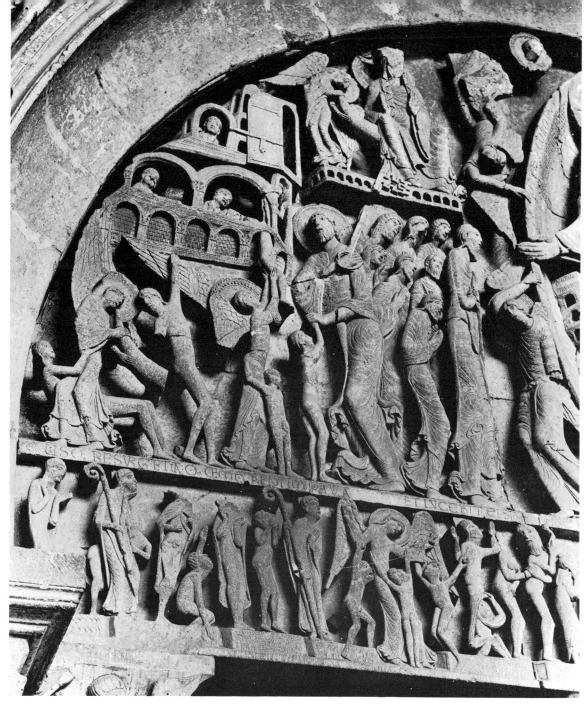

The Last Judgement, with detail showing the group of apostles, by Gislebertus, from the tympanum of Autun Cathedral, *c.* 1130. Stone. *Archives Photographiques*

from the background and in the round. Some of them are extremely tall and slender but their forms have their full depth and volume. The chief exception to this is the enormous figure of Christ himself. The very scale of this figure demands a different treatment from the rest. If its forms had been given their true dimensions in depth and if its front surfaces had not been flattened, then it would have projected out of all proportion to the rest of the relief. By compressing this figure into the dished space of the mandorla Gislebertus

117

was able to preserve the continuity of the front plane of the tympanum. Most of the figures are arranged vertically against the background and there is very little movement in depth. There is, however, a good deal of lateral movement and torsion in the figures. The figures along the lintel are more like statuettes standing on a ledge than figures carved in relief on a background. The articulation and movement of the figures, like their proportions, are not natural. We are encountering here a world of expressive forms which is quite outside anything dreamed of in a Classical tradition. When the demands of expression or the exigencies of the space of the architectural field required it, Romanesque artists were prepared to treat the forms of the human figure with the utmost freedom. In this instance the elongation of the figures, their unnatural twisted and curved poses, and their symbolic dimensions are all conducive to the expression of a visionary, transcendental theme and to the powerful emotional effect of the relief on the beholder. The warning contained in the visual imagery is reinforced by the inscriptions on the relief around the mandorla and over the lintel. These say:

I alone dispose of all things and crown the just
Those who follow crime I judge and punish.
Thus shall rise again everyone who does not lead an impious life
And endless light of day shall shine for him.
Here let fear strike those whom earthly error binds
For their fate is shown by the horror of these figures.

Although there is plenty of movement and little frontality or flatness in the forms of the majority of the figures, the relief as a whole does give a strong impression of being compressed into a narrow layer of space between a back and a front plane. This over-all plane-like effect is enhanced by a number of features – the existence of registers; the complete lack of any notional space; the flatness of the leading edges of the frame of the lintel, the mandorla, and the arcaded platform which divides the registers; the flatness of the principal figure; and the density of the forms which are crowded into the narrow layer of space. Thus there is some justification on compositional grounds for saying that the relief is flat or planar; but to do so without qualification could be misleading as to the character of the figures in the relief.

We usually think of reliefs as compositions of figures, animals, and other motifs projecting from some kind of background or matrix which supports them. But there are many reliefs which are not so much *supported* by their ground or matrix as *contained* by it. This difference may often be largely one of the relative importance of the back or front plane of the relief.

In the majority of reliefs everything is related to a back plane which underlies the whole composition and which we perceive as the surface of the ground of the relief. Consider for example a

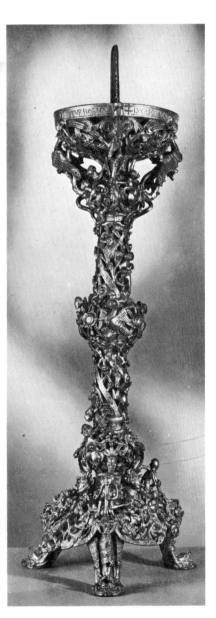

The Gloucester Candlestick, c. 1110. Gilt bell metal, 23in. Victoria and Albert Museum, London: Crown Copyright

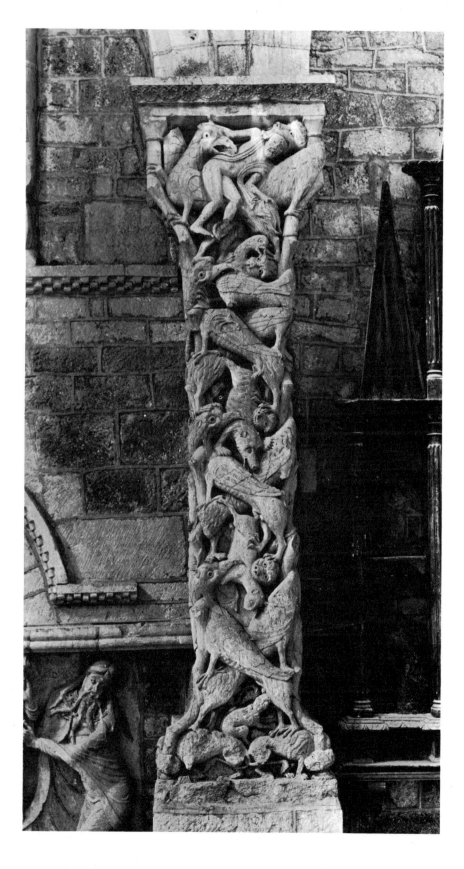

Animal Pillar, from Church
of Sainte Marie, Souillac,
1125–50. Stone. *Archives
Photographiques*

Fig. 16

Fig. 17

simple stone block or an architectural member such as a column capital. If it is carved as in Fig. 16, then the faces of the block or capital serve as back planes which support the figures and, depending on the height of the relief, we see the figures as forms which are either *on* or *against* a background surface. Enough of this surface appears between the figures to give the impression that it continues beneath them and that the shape of the block or capital is complete in itself without the relief. The relief is, so to speak, an additional feature, an excrescence on the surface, which could be removed without substantially affecting the shape of the capital or block.

In other types of relief everything is formed in relation to the front plane and we read the space of the relief back from this. The figures in these reliefs do not appear to be supported by the background – there may in fact be nothing which we can conceivably interpret as a background from which the forms could project. The spaces between the figures may be hollowed out in an irregular way that does not suggest the existence of any continuous surface which passes beneath the figures. The forms of these reliefs do not exist on or against a surface but themselves constitute the surface. They are contained within the total shape of the object which serves as their matrix. In the case of our simple block and capital (Fig. 17) the relief lies below their surfaces and does not affect their outlines. With reliefs of this kind we cannot remove the relieved forms and leave the underlying shape intact. We could, however, fill in the hollows of the relieved surface and thus eliminate the relief without affecting the shape of the matrix.

In speaking of these contained reliefs we might be more inclined to refer to the *depth* of the relief rather than its height, and it seems more appropriate to refer to the boldness of its forms rather than the degree of their projection.

Examples of this approach to relief are common in such Early Christian and Romanesque carvings as column capitals and shafts, caskets, ivory panels, fonts, and so on. In some instances the matrix of the relief may be so deeply cut into and so completely occupied by sculptured forms that its whole mass appears to be converted into sculpture rather than just its surface. Instances of this are particularly common in Romanesque architectural sculpture. The well known animal door pillar at Souillac is a superb example. But the extreme development of this kind of sculptured decoration is reached in a work such as the Gloucester Candlestick. In this masterpiece of Romanesque metalwork the complex interlaced forms are not really relief decoration at all. They do not decorate a pre-existing surface which underlies them, nor do they themselves make up the surface of an underlying object which could exist without them. Rather, they themselves

120

have become the object. There is no matrix or substrate. The ornamentation has, so to speak, devoured the candlestick and assumed its form.

The civilizations of pre-Columbian America in Mexico, Central America, and the Andes produced some of the world's great sculpture, but like most of the non-naturalistic sculpture of the past it has had to wait until the twentieth century for its own special qualities to be appreciated. Over the last fifty or so years it has been admired, especially by sculptors, for the imaginative freedom with which it treats the forms of nature. Sculptors who during the earlier part of the twentieth century were trying to escape the naturalistic traditions of Western art were attracted by its formal inventiveness, its tendency to abstraction, its technical vigour, and its power of expression. Another appealing feature was the way in which pre-Columbian sculptors exploited the expressive possibilities of stone and ceramics as materials and of carving and modelling as processes. Whether their sculptures were based directly on the observation of human and animal forms or were products of fantasy, they were conceived as forms which could be achieved by working the materials with the utmost directness and economy. Nowhere has the ductility of clay been exploited to better effect, and nowhere, except perhaps in ancient Egypt, have sculptors shown such feeling for the mass, weight, and hardness of stone. It is not difficult to see an affinity between pre-Columbian carving and some of the work of such first-generation modern sculptors as Brancusi and the early Cubists, or to appreciate its powerful effect on the work of Henry Moore — an effect which he has acknowledged on a number of occasions.

It is pre-Columbian sculpture in the round which has had the widest acclaim and the greatest influence on modern sculpture but the American civilizations also produced a vast amount of relief. Most of the reliefs are either architectural decoration or are carved on ritual vessels, stelae, altars, carved boulders (known as zoomorphs), and other objects of religious significance. The relief carving has the same directness and economy as the sculpture in the round and it includes many works of great beauty and imagination.

In books which deal generally with world art the arts of pre-Columbian America are sometimes treated rather summarily as an interesting and perhaps exotic footnote to the main story of the development of art. This attitude may not be justifiable, but it is understandable. Pre-Columbian art is not a tributary of what most Europeans regard as the mainstream of world art, running from the ancient Near East, through Greece, Rome, Byzantium, the Middle Ages, and the Renaissance to modern

Europe. Moreover its iconography is little understood, its history, to say the least, is full of gaps, and there is no literature which could provide interesting background information to its images and symbols. Almost all we know of these civilizations is their art, and this is limited to those few arts which produced durable objects.

It will not do, either, to call pre-Columbian art 'primitive', as is often done, without a good deal of qualification. The wide spectrum of work produced over a period of some two thousand years in the extensive area covered by Mexican, Central American, and Andean civilizations includes work which is extremely sophisticated in a number of important ways – intellectually, imaginatively, expressively, and in its refined feeling for line, pattern, composition, materials, and the qualities of natural form. A great deal of the relief sculpture presupposes long, intense, and highly intelligent thought and experiment on the possibilities of sculptural and pictorial expression. It is true the term 'primitive' is not often used nowadays as an aesthetically derogatory term. But it does still carry implications of a lack of sophistication in the treatment of such aspects of art as proportion, spatial relations, composition, the structure and movement of the figure, and so on – a naïvety with regard to the conceptual or intellectual, as opposed to the aesthetic, aspects of pictorial and sculptural art. It is in just this sense, however, that so much pre-Columbian art, especially Mayan, cannot be considered primitive. The spatial and formal qualities of some of the Piedras Negras reliefs and the drawing of many of the Palenque reliefs could be considered on a number of these scores to be more 'advanced' than those of Egyptian or Assyrian reliefs. Perhaps only in a technological sense can pre-Columbian art be regarded with some justification as primitive. Nevertheless, as G. Kubler remarks:

The American peoples of antiquity explored and developed the ultimate possibilities of Stone Age technology. The mechanical learning of American Indians before A.D. 1000 is like that of Neolithic peoples on other continents. But the great difference is in the aesthetic quality of their achievements. American Indian sculpture, worked by Stone Age methods, is frequently of such formal and expressive complexity as to belong to the outstanding works of world art.[1]

Although there are family resemblances which run through most pre-Columbian styles, there are also wide differences of character. At one extreme the Mayan reliefs of Piedras Negras are elegant, refined, and naturalistic. The curvatures of their lines and movements of their surfaces are imbued with the rhythms of life. They have an organic fluency and plasticity which must owe much to a close observation of natural form. They exploit the relief medium in the most subtle ways, with complex overlappings

[1] *The Art and Architecture of Ancient America*, Harmondsworth, 1962, pp. 32–3.

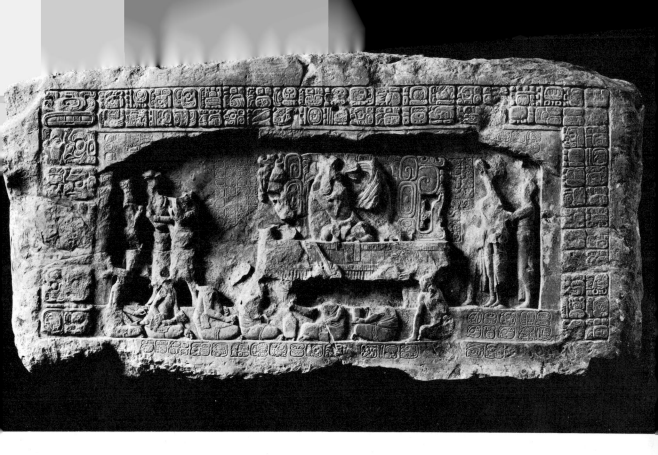

Lintel no. 3 from Piedras
Negras, *c.* 510. Stone. *The
University Museum,
Philadelphia*

of figures in different planes, and in one well known panel
(Lintel no. 3), they even achieve a composition of figures in
different planes of high relief. At the other extreme many pre-
Columbian reliefs are abstract, geometrical, highly stylized, mainly
rectilinear reliefs with vertical side walls and interior contours
which are incised into a flat, raised plane. The range of works
includes such outstanding achievements as the massive stelae of
Quirigua and Copan, with their powerful high relief figures and 128
encrusted, deeply pierced surrounding stone overgrowth; the
great boldly carved rhythmic sweep of the Serpent frieze of
Xochicalco; the elaborate pictorial fantasies of the ball court 127
panels of Tajin; the imaginative and skilfully carved compositions
of Yaxchilan; the elegant low relief and superb drawing of 126
Palenque; the bold projections and recessions and stylized fantasy
of the Serpent and Rain God wall reliefs of Teotihuacan and the
stone mosaics of the Puuc region; the delicate incised reliefs of 210
Chavin de Huantar, such as the Raimondi Monolith; the clay
mural decorations of Chan Chan; the abstract stone mural
patterns of Mitla; and lastly the widely admired masterpiece of
Andean sculpture, *The Gate of the Sun* at Tiahuanaco. In addition 124
to these monumental works there are exquisite small jade reliefs,
relief carved stone and pottery vessels and wooden drums, and
some repoussé work in metal.

The Gate of the Sun, Tiahuanaco. Date unknown, given as after 300 A.D. Stone, H. of gate 9ft. *Canning House Library, London*

Fig. 18(i)

The human figure rarely achieves any structural autonomy in pre-Columbian reliefs. It is not centred on an axial system of its own which would enable it to move independently of its background but is conceived primarily as an outcrop from the background or matrix. Usually it is spread out on the surface with its forms and pose adapted to suit a planar mode of existence. Movement takes place in a lateral direction parallel with the plane of the relief and there is an almost complete lack of torsion. As in Egyptian and other planar styles of relief, the parts of the figure are represented either in profile or frontally. The head in low relief seems always to be in profile, no doubt because the profile view lends itself more readily to low relief carving than the front view, which presents the sculptor with some awkward problems of foreshortening. Sometimes the torso is represented frontally with the head and legs in profile, as in Egyptian art; sometimes the whole figure is in profile (and it is worth noting that here the awkwardly foreshortened view of the shoulders is represented with greater understanding than it is in either Egyptian or Mesopotamian art); and sometimes the whole body is represented frontally, with the head in profile and the feet splayed out sideways in opposite directions. These are the main conventions which govern the representation of the figure in low relief. Within their limitations the pose of the figure is extremely flexible and a variety of movement is achieved.

124

Fig. 18(ii)

In high relief the head is often represented frontally and the arms and feet may project obliquely in a plane not parallel with the plane of the relief. The movement of the figure, however, is usually extremely restricted, as in the almost fully in the round figures of some of the Copan stelae, which are arranged stiffly along a strictly vertical axis. The badly damaged Lintel no. 3 of Piedras Negras is an exception in this as in other respects. The figure seated on the throne is represented leaning forward out of the vertical plane of the relief with his weight resting on his left arm, which is extended in front of his body, and with his left hand grasping the edge of the throne.

A great deal of pre-Columbian relief has very shallow modelling with little rounding of the forms and a more or less uniform external contour. The figures in the Yaxchilan reliefs (Lintels nos. 126 24 and 25), for example, are carved in shallow uneven relief on a plane which projects about two inches above the background, and their external contours are cut back at right angles to the plane of the relief. The effect of this is to make a very distinct separation between the patterned shapes in relief and the plain shapes of the background areas. The balance between these two sets of shapes is one of the most attractive features of these compositions. Within the figures themselves there is a great deal of delicately cut detail. The rendering of textile patterns on the costumes by means of extremely shallow relief enriches the whole composition without breaking up the main masses. In principle the system of relief used in these Yaxchilan panels is similar to that of the Palenque *Tablet of the Slaves*, which we have already 93 mentioned, although in the Palenque relief the interior detail is delineated more by incised lines than by relief modelling.

Many pre-Columbian reliefs have sharp edges at their external contours where the flat plane of the relief surface meets the vertical side wall at right angles. This of course emphasizes the physical flatness of the relief. But as if this were not enough, the sculptor often gives even greater stress to the flatness by outlining the shapes with a double contour or raised strip or fillet, as in the ball court reliefs of Tajin and the great feathered Serpent frieze at 127 Xochicalco. Quite obviously in many of these reliefs the sculptors were more concerned with clear, crisp outlines and with the decorative qualities and clear definition of raised two-dimensional shapes than with creating any impression of three-dimensionality. Sharpness and clarity of image and an appropriateness of scale for the building were probably the prime objectives, and there is no doubt that such images read very well from a distance. The desire to preserve the flatness of the wall or other surface was also no doubt a strong motive.

The interplay between the sharp edged, flat, raised shapes of the relief and the shapes of the recessed background is a major feature

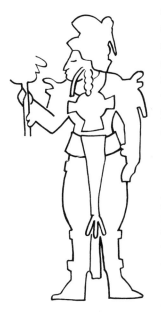

Fig. 18(iii)

of the frieze of *The Gate of the Sun* at Tiahuanaco. So too is the 124
interplay between the shapes and the network of incised lines
which overlays them. According to Kubler the reliefs on the Sun
Gate 'hold the attention both from a great distance and at close
quarters' because they 'command the eye by the bold masses, and
at the same time by the delicate web of incisions'.[1] An interesting
feature of this finely proportioned and highly organized com-
position is the difference in the degree of projection of the central
figure and the rest of the relief. A difference of scale between the
principal and subordinate figures in such hierarchic reliefs is
quite common, as when a large Madonna or Christ is surrounded
by ranks of smaller angels; but a difference in the degree of

[1] Op. cit., p. 308.

Lintel no. 24 from Structure
23, Yaxchilan, 726. Stone,
4ft. 2in. *The Trustees of the
British Museum, London*

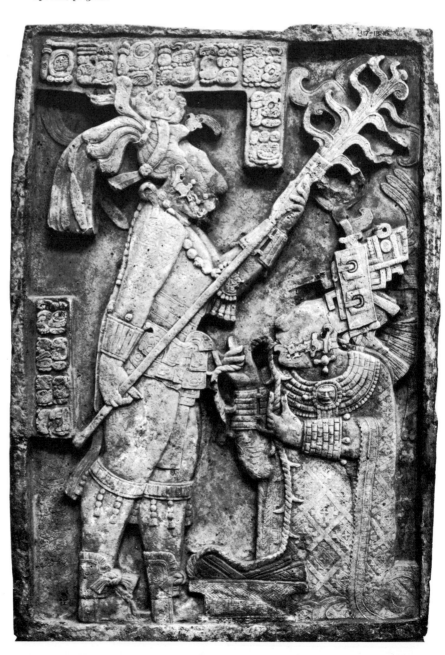

Section of the Serpent frieze, Xochicalco, 8th or 9th century. Stone. *Eugen Kusch*

projection is not at all common. Some of the dangers such a difference could give rise to are too great a discrepancy in weight, too sharp a contrast in lighting, and too abrupt a transition from high to low relief. These dangers are avoided in the Sun Gate relief by an absence of undercutting and by the manner in which the relief of the main figure is brought down in a series of steps from the high plane of the face to the low relief of the radiating outer shapes of the head-dress. The level of projections of these outer shapes matches that of the rest of the frieze. The unity of the composition is also preserved by breaking up the surfaces of the central figure into shapes which are similar in scale to those of the rest of the design and by covering them with a similarly scaled network of incised lines.

Although flatness of relief and sharp edges are features of many pre-Columbian reliefs, they are by no means universal. The edges of the forms in the Yaxchilan panels are softened in an extremely

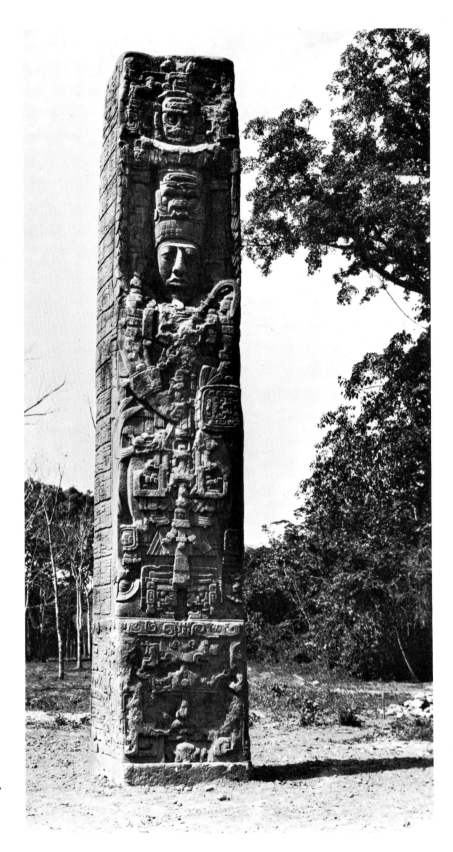

Stele E, Quirigua, Guatemala,
c. 510. Stone, H. 35ft.
Courtesy of the Carnegie
Institution, Washington D.C.

subtle way to give an effect of roundness. This is particularly noticeable in photographs, which usually make the forms look much more rounded than they are. Many of the figures in the Palenque and Piedras Negras reliefs are given a rich fullness of form by a subtle rounding of their modelling and by the superposition of planes at their edges.

The role of costume and related accessories in pre-Columbian art is of paramount importance. Head-dresses, ritual costumes, and other regalia of extraordinary and baffling complexity frequently overwhelm the figures. They appear to be elaborated out of sheer fantasy, but they are obviously not merely the products of a sculptor's imagination since great efforts are made to ensure that each item is clearly presented. Their treatment is usually highly conventional and two-dimensional. Even where the forms of the hands and faces are modelled fairly fully, the rest of the figure is often submerged under a fantastic overgrowth of flat shapes and decorative detail. The planes and features of the head of the enormous figure on Stele E at Quirigua, to take one outstanding example, are modelled with a fair degree of naturalism while the rest of the figure serves merely as a support for the elaborate superimposed accessories and items of dress. The contrast between this method of treating costume and the method of Indian sculpture is striking. Indian sculptors used costume, as we have already pointed out, as a means of stressing the three-dimensionality of the forms of their figures. They did this mainly by emphasizing the way in which the costume fitted round the body in depth. Pre-Columbian sculptors, with some notable exceptions, converted their costumes into rich flat patterns which overwhelm and conceal the forms of the underlying figure and seem to exist in their own right. In many instances this elaboration departs so far from reality that the reliefs may be seen as remarkable abstract compositions rather than as figurative sculpture.

The most notable exceptions in the treatment of costume are, once again, the reliefs of Palenque and Piedras Negras. In Stele no. 12 from Piedras Negras the costumes fit round the bodies. 22 This can be clearly seen in the collar of the principal figure and in the loin-cloths of the captives and the ropes which bind them. Even the sweep of the head-dress plumes around the point at the top of the Stele is rendered with a feeling for its plastic rhythms. The shapes twist, curve, and overlap in three-dimensions and the whole mass is conceived as a unity and modelled with great refinement.

CHAPTER 6 Line

The contribution of line to the form and expression of reliefs is often negligible or of minor importance. In some instances its role is quite secondary to that of light and shade. The hollows in the reliefs may be designed to trap shadows which do not define the outlines of the forms but overflow and obscure them and create shapes of their own. As a result we may be more aware, in the over-all effect, of contrasting patches of light and dark than of linear rhythms. In other reliefs the role of line is subordinate to that of more purely plastic, or sculptural, features such as the surface modelling and the arrangement of volumes. In works of this kind one form may glide smoothly into another or into the background without giving rise to any distinct linear boundaries, so that the main over-all effect is one of continuously flowing or rippling surfaces. Or the solid masses may be so powerfully and fully modelled that we are more aware of their weight, movement, balance, and interior structure than of any linear rhythms which they may generate. But in contrast to these non-linear styles there are other styles of relief in which line does play an important part. In some it is of paramount importance, being stressed to the point where it takes precedence over all other aspects.

At the risk of oversimplifying, we could say that among the various methods of treating the forms of relief we may identify three fundamentally distinct approaches. These may be called the painterly or colouristic, the plastic or sculptural, and the linear or graphic, approaches. Obviously this is not meant to suggest that in adopting one of these approaches a sculptor has concentrated on one aspect of his work to the entire exclusion of all others or that we should look at his work in only one way. All that is meant is that each of these approaches emphasizes a different aspect of visual experience and is primarily, but not solely, concerned with light and shade, or volume and plasticity of surface, or line. One or other of these is the main means through which the sculptor has achieved form and expression. In the present chapter we shall discuss the functions and qualities of line in a number of different kinds of reliefs, but we shall concentrate most of our attention on those styles which are mainly graphic, or linear.

We may begin by taking note of the fact that there are a number of different kinds of linear features which may be present in reliefs. We use the term 'line' to cover several related but different features of the visual world and works of art. It should help us to understand the significance of line as an element of reliefs if we are aware of this.

In reliefs, as in the visual arts in general, the principal lines are almost always the *external contours*. Since we have already

considered these at some length in connection with the relations between form and background all we need here is to remind ourselves of one or two of their main characteristics. The first thing to bear in mind is that the external contour of an object is not an independently existing line but a visual boundary, the limit of the extension of the object in our visual field, which marks it off from its surroundings. The shape of an external contour is not therefore a fixed property but a variable one which is determined both by the shape of the object itself and by the view we have of it. In fact it might be more accurate to regard external contours not as properties of the actual three-dimensional objects themselves but as something which we abstract from our view of the objects.

When an object is represented in a drawing it can be given only one invariable contour, which is all in the same two-dimensional plane. When it is represented in low relief its contour will have spatial properties which more or less approximate to those of a drawn contour. But in high relief its contour will be more like that of an actual three-dimensional object; it will not be all in one plane and within limits it will change shape as we move across the front of the relief and see its forms from different angles. Nevertheless, whether the relief is high or low, its contours are never lines existing in their own right, the mere traces of a moving point such as a pen or pencil. They are always the boundaries of forms which to some extent actually project into space. Their qualities, therefore, largely depend on the qualities of the forms which give rise to them and on the way in which those forms actually relate to their background. Smoothly flowing forms will give rise to smoothly flowing contours, and complex agitated forms will give rise to complex agitated contours.

In addition to the external contours there are several other linear features which may be present in a relief. These are usually referred to as the *interior lines* because they are all contained within the over-all shapes bounded by the external contours. They include the outline of forms which overlap or cross the main forms. The outline of an arm which crosses the body, or of a child which is held in front of its mother, are examples. Then there are the outlines of the smaller forms which are carved or modelled on the main masses — the outlines, for example, of the features of the face within the general contour of the head, of the breasts against the mass of the chest, and of the musculature of the body.

Edges formed where planes meet at an angle may be rendered sharply so that they become a linear feature. We may see more clearly what is meant here if we consider, for example, the planes which make up a simple box. If we look at the box from a point of view which enables us to see more than one of its faces, we may notice that it has two kinds of linear features: an external contour which defines it against its background, and one or more

Fig. 19

Fig. 20

Fig. 21

interior lines which arise where its faces meet and form an edge. Any faceted form will give rise to some interior lines. Curved planes as well as flat ones may be made to meet in a way that creates linear edges. In the treatment of the human figure in relief the meeting of planes at the ridge of the brows, or in the structure of the nose, or at the thoracic arch, or along the edge of the shinbone may give rise to linear edges. Drapery, too, may be interpreted as a structure of sharp edged planes.

Closely related to these edge-lines are the lines which may occur at the intersections of forms. The intersection of the neck and the plane of the shoulders, of the lower and upper arms at the inside of the elbow, of the upper and lower leg at the back of the knee, and of the thighs and the hips at the groin are all examples.

Lines of another kind arise where forms are pressed closely together. The line between closed legs of a standing figure or between an arm and the body when the arm is held close to the side are examples which are frequently met with.

Then in a somewhat different category from what we have so far discussed are such linear features as thin strap-like or pipe-like components – forms which are so drawn out that their predominant character is linear. Examples of these are the stalks of plants, the branches of trees, the folds of draperies, the abstract motifs and drawn out necks and limbs of animals and figures in the ornamental reliefs of the tribal cultures of Dark Age Europe and the South Pacific.

And then finally there are lines which do not derive from the three-dimensional form of the relief but are more superficial in the sense that they overlie the forms and are primarily graphic in character. Usually their main purpose is decorative but they may also serve other purposes. Opportunities for the creation of such lines exist in the treatment of jewellery, costume, hair (including beards), and the patterns of such things as leaves, feathers, branches, and moving water.

These then are some of the main opportunities which exist in reliefs for the creation of line. Broadly speaking they are of two kinds: those which derive from the plastic *forms* of the relief themselves and those which are additions to the forms.

THE QUALITIES OF LINE

Like most of the elements in representational art lines may have both a descriptive and an expressive function. They describe, or delineate, the subject-matter of the relief so that we can recognize what it is meant to be and at the same time they also have a character of their own which enables them to function as vehicles for the expression of a variety of moods or feelings. For the appreciation of reliefs, or of any other works of visual art for that matter, it is absolutely essential that we apprehend not merely what

the forms describe but also the expressive qualities of the forms themselves.

I say 'the expressive qualities of the forms themselves' because there is another kind of expression which may be merely described by the forms. A sculptor may indicate that a figure is in pain or ecstasy, or in a state of fear, anger, despair, grief, determination, aggressiveness, and so on by simply giving it the appropriate facial expressions, bodily pose, and gestures. These are, so to speak the most obvious and outward means of representing certain familiar human feelings, of giving 'expression' to a work of figurative art. But what is most highly valued in works of art is not the kind of expression which merely registers the outward signs of mental states but an expressiveness which pervades the forms and composition in a much more intimate way. It may have to do with the expression of psychological states but this is only part of its function. The forms (including the lines) and composition of works of art may be given expressive qualities which are found not merely in human bodies but throughout the whole world of natural and man-made objects. These are the qualities which provide the raw material of so much poetic metaphor and simile because they may be common to and thus establish links between objects which in most other respects are entirely disparate.

According to Rudolf Arnheim:

. . . expression can be described as the primary content of vision. We have been trained to think of perception as the recording of shapes, distances, hues, motions. The awareness of these measurable character- istics is really a fairly late accomplishment of the human mind. Even in the Western man of the twentieth century it presupposes special conditions. It is the attitude of the scientist and the engineer or of the salesman who estimates the size of a customer's waist, the shade of a lipstick, the weight of a suitcase. But if I sit in front of a fireplace and watch the flames, I do not normally register certain shades of red, various degrees of brightness, geometrically defined shapes moving at such and such a speed. I see the graceful play of aggressive tongues, flexible striving, lively colour. The face of a person is more readily perceived and remembered as being alert, tense, concentrated, rather than as being triangularly shaped, having slanted eyebrows, straight lips, and so on. This priority of expression, although somewhat modified in adults by a scientifically oriented education, is striking in children and primitives, as has been shown by Werner and Kohler. The profile of a mountain is soft or threateningly harsh; a blanket thrown over a chair is twisted, sad, tired.[1]

It is certainly true that in our sensory experience these expressive qualities have some priority over the more neutral geometric-technical properties of things. We usually feel that one curve is stronger, tauter, or more tense than another certainly before, and more than likely without, realizing that one curve is parabolic

[1] *Art and Visual Perception,* London, 1967 ed., p. 430.

and the other elliptical. And we are usually impressed with the calmness or agitation of a scene without stopping to analyse that what gives it this character is a predominance of verticals and horizontals or of opposing diagonals. And it is also true that these expressive qualities are usually uppermost in an artist's mind while he is working, so that he may be constantly striving to impart the 'right' expressive qualities to his forms and constantly testing them by whether they 'feel' right, or have the desired character. Yet there is a sense in which the measurable geometric-technical properties are more fundamental. How does line become expressive in different ways? What attributes has it that may be varied in order to achieve different kinds of expressiveness, so that we can speak of the boldness, dynamism, fluency, nervousness, lyricism, delicacy, decisiveness, suppleness, rigidity, and so on of the lines of a drawing or relief? The answer is of course that variations in the expressiveness of lines are produced by varying their geometric-technical properties.

Now in appreciating works of art what is most important is that we should perceive and respond to the expressive qualities of the forms, just as in appreciating poetry we should perceive and respond to the expressive qualities of the sounds of the words and the rhythms of the metre. But once the magic has been experienced the more curious spectator or reader will want to know how it has been brought about. He will then find pleasure in discovering the means by which the expressiveness has been achieved. What then are the main variable basic properties of lines? Briefly, they are:

1. *Length* This is too obvious a property to require much comment. All lines have some length. What matters in any visual design containing lines is not the absolute measurement of their length but their length in relation to each other and to the scale of the design. A design containing a preponderance of short lines will have a different quality from one made up mainly of long lines.

2. *Thickness or breadth* In theory, of course, a line has only the one dimension of length, but in practice this is only true of those lines which are boundaries of areas or contours of solids. Any line which exists in its own right, such as an incised line or a pencil line, has some actual thickness. However, although the contours of forms in relief have no thickness of their own, they may acquire thickness as a result of the behaviour of light. By varying the angle and depth at which the forms meet the surfaces behind them, by undercutting, and by varying the quality of the modelling just inside the edges of the forms a sculptor can, up to a point, control the thickness of his contour lines. I say 'up to a point' since these lines are lines of light and shadow and their thickness will be affected by the quality and direction of the illumination

134

of the relief. Incised lines and lines created by ridges and flutings will vary according to the width and depth of incision or projection.

3. *Strength or intensity* The lines of a relief may show up as either light lines or shadow lines of varying intensity. This again will depend partly on the quality and direction of the light and partly on the contrast of angle between the edge of a form and its background. It will also be affected by undercutting, which frequently has no other purpose than to intensify a contour.

4. *Direction* There are two things involved here which should be considered separately. First, there is the *attitude* of a line in relation to the other lines and the main axes of the relief – its verticality or horizontality, for example. We are speaking of the attitude of lines when we say that they are conflicting, or opposed, or parallel, or radiating from a common centre. Second, there are the *changes of direction* which occur within a line itself. These give rise to all the different qualities and degrees of curvature and angularity of lines. The varieties of curvature are, of course, limitless. Some geometrical curves and some of the more common types of curves have names, but with the curvature of lines, perhaps more than with any other of their properties, we are obliged to resort to description in expressive terms or in terms of metaphor and simile. Even when we may not be aware of doing this, our language does it for us; as when, for example, we speak of a flowing or serpentine or catenary (like a hanging chain – Latin, *catena*) curve. A straight line is, of course, a line with no curvature; it does not change direction.

5. *Continuity and brokenness* A continuous line is one which stretches without interruption from one point to another. A broken line is one which we read as a single line but which is made up of a number of separate or overlapping sections. This usually occurs where parts of the contours of compound forms lie in different planes. In drawings such breaks are one of the most powerful ways of showing the articulation and three-dimensionality of forms. They are employed in a similar way in low reliefs to create an impression of greater three-dimensionality than the forms actually have. We have already discussed this at some length in a previous chapter in connection with the super-position of forms (see pp. 90ff.).

EXAMPLES Most of the reliefs of the great archaic civilizations are strongly linear. With few exceptions the more plastic or painterly methods of treating form are later, more sophisticated developments. Ancient Egyptian, Assyrian, early Greek, early Indian, and pre-Columbian American reliefs are all largely dependent on line for the definition of form and as a means of expression. The so-called conceptual approach to art of these early civilizations

aimed at the clear delineation of each item in a composition. They were not so much interested in representing the transient appearances of objects and events as they were in the clear representation of their more abiding, essential aspects. The attitude which reaches its most extreme form in Impressionist painting has no place in their art. If a thing was worth representing at all for these ancient artists, it was worth representing clearly, in its most unmistakable aspect. In seeking out the more enduring, tangible aspects of things they arrive inevitably at a style in which there are clearly defined boundaries and sharply defined details.

Egyptian reliefs, perhaps more than those of any other style in the world, rely on line for the definition of form. Their main and minor forms are crisply and clearly outlined, and decorative features such as hair, collars, and pleated costumes are rendered as linear textures. The cutting, on the whole, is shallow and delicate but it is also clean and assured. The external contours are usually the most heavily stressed lines and they clearly separate the figured areas from the background plane. The outlines of human figures, animals, and other objects are simplified and unbroken. The costumes fit closely to the body and do not interrupt the continuity of the outline. Modulations of the surfaces within the contours affect the quality of the lines but do not break them. There is nothing superfluous, fanciful, or accidental about the lines; they all have a descriptive as well as a decorative function. Unlike the medieval sculptor, the Egyptian never seems to let himself go and enjoy the possibilities of line for their own sake. And there is no play of the lines over the forms as there is in Classical reliefs, where it serves to accentuate or make more visible the three-dimensionality of the forms. The forms of Egyptian reliefs are either covered with flat textural patterns or are left plain.

The illustrated detail from the Tomb of Ti at Saqqara shows part of a herd of cattle being driven across a ford. The drover in front is carrying a calf which is too small to cross on its own and the calf is looking back at its mother, who is reaching up towards it. One of the other cows is bending down to drink the water. This is one small incident from a number of relief scenes depicting life on the estates of the occupant of the tomb. In Egyptian religion the continued prosperity of the dead in the hereafter was magically provided for by these images from life.

Like many more of these Old Kingdom reliefs from Saqqara this detail reveals an acutely sympathetic observation of nature. Once we become accustomed to the spatial conventions of Egyptian art we have no difficulty in seeing that the rendering of the drover and cattle is a superb piece of naturalism executed by a highly sensitive artist. There can be no doubt that the artist was depicting an aspect of rural life which he remembered with delight, and it

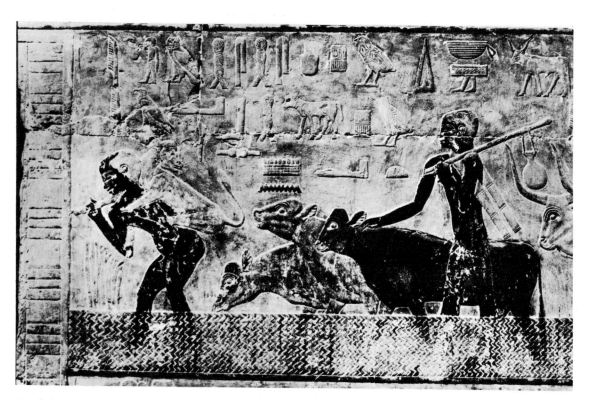

Detail showing Cattle fording a stream, from *The Return of the Herd*, Tomb of Ti, Saqqara, fifth dynasty. Stone. *Hirmer Fotoarchiv München*

must have been this enjoyment of his subject which brought out the best in him. But it would be a mistake to assume that the warmth and vitality of the scene are entirely due to its appealing subject-matter. One can imagine the same scene depicted with all the muscle-bound rigidity of the worst Assyrian reliefs. It is the quality of the forms and composition, and in particular the quality and arrangement of the lines, which contribute most to its expressiveness. The external contours have an organic fluidity and variety of curvature which shows a remarkably sensitive appreciation of the structure of the forms they enclose. Some of the linear features which are particularly noticeable are: the hard, bony, straight lines along the fronts of the cows' heads; the taut, arched line of the back of the neck of the cow that is drinking; the long subtly varied lines which stretch from the lower jaws along the throats and over the chests of the two leading cows and which admirably express in the changing quality of their curvature the changing nature of the forms they define; the awkward, gawky angles and straightness of the lines of the calf and the tense bowed lines of the thighs of the drover who is bearing its weight.

By way of contrast to the homely naturalism of the previous example we may consider once more a detail from the Ramose Tomb in which a basically similar technique of carving has been used to create a work of quite a different character. Egyptian representations of the figure are always simplified and unfussy, but the

137

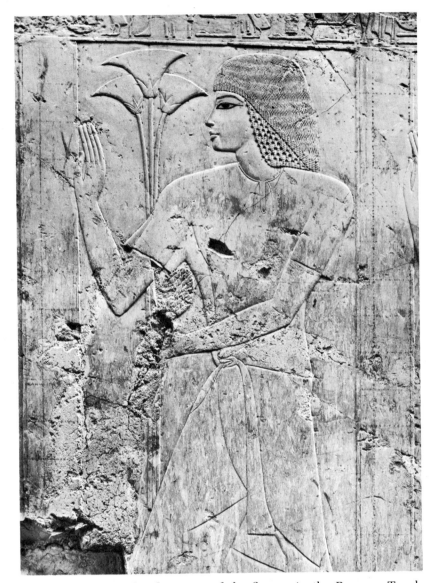

Almsgiver with Papyrus, detail of festival relief, Tomb of Ramose, Thebes, 18th dynasty. Stone. *Hirmer Fotoarchiv München*

classical purity and refinement of the figures in the Ramose Tomb are unusual even in Egyptian art. For sheer economy of means there is nothing in the world that surpasses them. The lines are so controlled and, in spite of their delicacy, so sure, that the merest hint of an inflection reads as a powerful indication of form. Notice, for example, the slight fullness in the outlines of the upper arm and the outward curve of its termination at the armpit. But although the curves of the figures are highly controlled and formalized, they are not emptied of vitality and turned into a mere exercise in design geometry. In their apparent simplicity they contain, under pressure so to speak, the subtleties and complexities of living form. This refinement and concentration of vital rhythms, which is under the control of the artist's sensibility and does not deteriorate into intellectualized geometry, is also found

in a great deal of Gupta and Cambodian art. It is an approach that makes few concessions to the warm plasticity of actual flesh and blood or to the accidents and irregularities of actual draperies. The figures are gentle, remote, cool, and idealized beyond all particularities of place and time.

Romanesque reliefs seldom have the restraint and economy of Egyptian reliefs, and line in them is often an arbitrary decorative, or decorative-expressive, addition to the surfaces of plastic forms. We must remember that the linear ornamental art of the tribes which inhabited and invaded Europe during the Dark Ages contributed a great deal to the formation of medieval styles. Wherever in early medieval art the contribution of Graeco-Roman art does not predominate, that is, especially, in the north of Europe, the intricate linearism which is typical of Barbarian art makes itself felt.

Our detail of a group of apostles is taken from the lower register 117 to the right of Christ in Gislebertus's great tympanum at Autun. The unnatural elongation and slimness of the figures give rise to long external contour lines and, because the figures are almost in the round and deeply undercut, these lines are stressed by the depth of shadow behind them. Apart from the small figures which have arisen naked from the grave at the Day of Judgement, all the other figures are clothed from head to foot. The external contours of these draped figures are long and unbroken. They begin in a group of folds which toss and break around their feet like waves or flames and sweep almost without interruption up the whole length of the foremost figures. One particularly notice-able feature is the way Gislebertus has carved the left sleeve of St. Peter's robe where it goes over the hip so that its edge merges with the long outline of the back of the figure. The curvature of the contours is such that it reinforces the strong upward-flowing movement which runs through the whole group and gives it an insubstantial, flame-like quality. Although there are no weighty protruding folds in the drapery to break the continuity of the external contours, there is an elaborate pattern of folds suggested graphically over the surfaces of the figures. The beards and hair, which fits like a skull cap over the head, have also been resolved into a highly conventionalized linear pattern. These shallow incised interior lines bear little relation to the actual behaviour of cloth or hair. They swirl and flow over the forms in all directions and seem to have been created partly out of sheer fantasy, because the sculptor enjoyed line and decoration for its own sake, and partly to create an unnatural graphic dynamism which gives the forms an unearthly quality and enhances the spirituality of the whole relief.

We turn now to two fifteenth-century Italian low relief carvings on the theme of the Madonna and Child. Desiderio da Settignano's

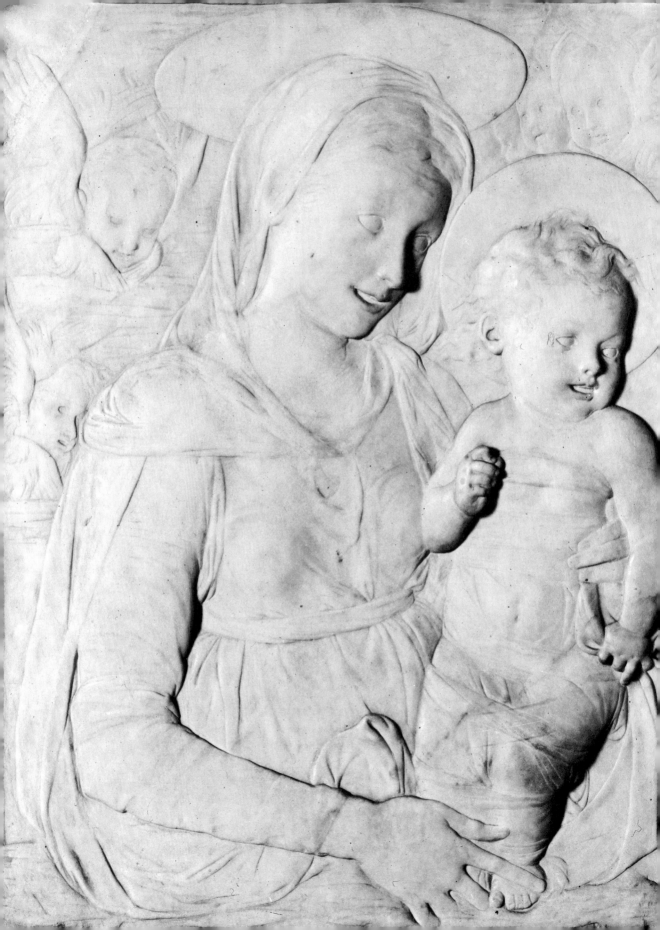

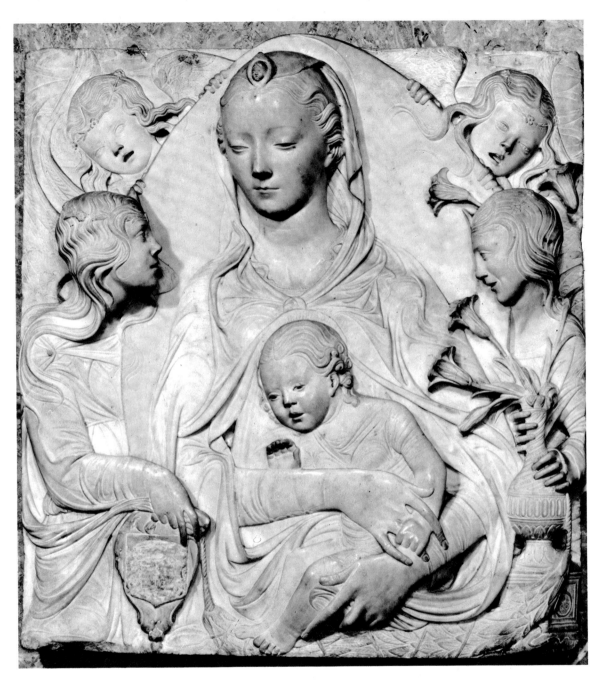

all too short thirty-five years of life (1430–64) began and ended
during the lifetime of Agostino di Duccio (1418–81). Yet although
the two artists were contemporaries who almost certainly knew
of each other's work, it would be difficult to find two artists who
display a greater difference in the qualities of their lines. Desiderio's
lines are full of minute changes of direction and breaks in
continuity. They have a nervous delicacy, a gentleness, and quiet
unassertiveness which is appropriate, in our example, to the

141

character and mood expressed in a more directly psychological way in the faces of Mary and the Child. They are neither rhetorical nor merely decorative but describe the form and represent material qualities in a naturalistic manner. There is nothing arbitrary about them. For the most part they are not clear-cut lines; their depth and intensity varies and they have an irregular scratched rather than a sharp edged quality. Many of them are little more than short incised 'touches' with the chisel. Agostino's relief is also gentle and delicate but it is in every respect more self-consciously 'designed', more contrived, than Desiderio's. Both Madonnas are human rather than divine but Desiderio's is a natural, homely humanity while Agostino's is elegantly aristocratic and artificial. If there is anything supernatural about Agostino's relief, it is a supernatural prettiness and sweetness.

The differences between the two works may be brought out more clearly if we compare a few details. Consider the treatment of the hair. In Desiderio's relief it is rendered as a vaguely unified plastic mass in which curls are merely hinted at by irregular incised lines. The hair of Desiderio's Child has a soft, downy appearance and merges with the form of the forehead without any clear line of demarcation. Agostino, on the other hand, has treated the hair as a highly stylized pattern of regular lines. These fall into graceful waves, and on the Child they twist round to form elegant tight little spiral curls. A similar difference pervades the drapery of the two reliefs. Desiderio's treatment is spare, full of irregularities, crumpled passages, and straightness. There are no lines which seem to be there purely for their own sake. Agostino's lines on the other hand are mostly decorative and are intended to be enjoyed for their own sake. They are full of graceful curves and elegant rhythms and counter-rhythms. Their linear design is confidently, even exuberantly, lyrical.

A comparison of the similarly positioned right forearms and hands of the two Virgins is most revealing. Agostino makes one continuous curve of the upper line of the forearm and the hand and carries the line right through to the ends of the extended first finger and thumb. But the line of Desiderio's arm and hand changes direction abruptly where the hand broadens out at the wrist. And although there is a connection through from the arm across the hand and into the extended finger, it is a straight line, not an elegant curve, and it is not continuous. Notice, too, the contrast in the lines of the fingers themselves in the two reliefs.

The outlines of the fleshy parts of Desiderio's figures – the head, arms, and shoulders of the Child, for example – are softer and more variable than those of Agostino's. This is true also of the modelling inside the contours. The lines down the left arms of both infants clearly show the difference. Finally, the lines of the facial features – the centre line of the nose, the outlines of the lips and the eyes –

are sharper in the Agostino than in the Desiderio, where their softness contributes to the 'dewy' look of the faces.

It would be wrong to conclude from all this that Agostino's relief is more carefully designed and that Desiderio's merely describes the forms naturalistically. Desiderio's relief is in fact designed with extreme care and sensitivity. Indeed, according to John Pope-Hennessy, 'in composition this is Desiderio's finest and most inventive Madonna relief'.[1] Pope-Hennessy does complain, however, that its execution is 'rather dry' and inferior to that of some of the sculptor's other works. The crux of the matter is that in this work of Desiderio's the design is less obtrusive than it is in the Agostino.[2]

We have already discussed at some length the role of contour lines in Greek reliefs (pp. 100ff.) and we shall not repeat what we have said about them. Instead we shall confine our attention to another important linear feature of Greek relief sculpture – drapery. Greek sculpture is almost exclusively an art of the human figure and its main elements are the forms of the human body and its clothing. The sculptors of ancient Greece made enormous and unprecedented efforts to master the structure and movement of the body and the behaviour of drapery, and out of their understanding and control of these two elements they developed a marvellously flexible, beautiful, and expressive kind of sculpture. They were fortunate in the kind of clothing they had to deal with. If the Greeks had worn Victorian frock-coats and trousers like the sculptured heroes of nineteenth-century industrialism who inhabit many of our town squares and parks, they would not have been able to develop so flexible and varied an art. As it was, Greek costumes were loose-fitting and could be wrapped around the figure in a variety of ways. Instead of being cut to fit the shapes of the body they were draped freely over them, sometimes revealing the underlying forms and sometimes hanging loosely away from them. The fabrics from which the garments were made varied in weight from heavy woollens to light-weight linens and the quality of their folds was therefore variable. Some fabrics fell into heavy voluminous folds and others crumpled easily into complex masses of small folds. Moreover some cloths were pleated and others were allowed to fall into their own natural folds. Some of the most brilliant qualities of Greek sculpture arise from the interplay of the solid volumes and plastic surfaces of the nude body with the contrasting linear folds of drapery. The aesthetic possibilities – the possibilities for art – which are inherent in the combination of these two contrasting types of visual form were exploited to the utmost. Greek sculpture is not an art which simply reproduced

[1] *Italian Renaissance Sculpture*, p. 303.
[2] A most sensitive and profound appreciative analysis of Agostino's reliefs is contained in Adrian Stokes, *Stones of Rimini*, London, 1934.

the nude and clothed human figure in a variety of poses but a highly refined and creative art for which the human body and drapery were the thematic raw materials.

In early Greek reliefs the folds of drapery are treated primarily as conventionalized linear patterns decorating the main masses. They are flat and shallow and in many instances are merely indicated by incised lines. But as the sculptors' understanding of drapery and control over their materials increased the forms became more plastic, more mobile, and more expressive. In fifth- and fourth-century sculpture there is an enormous range of treatments of drapery. Sometimes the folds fall in long stately verticals, as in the column-like girls at the van of the Panathenaic

Victory leading a Bull, from the Temple of Athene Nike, Athens, early 5th century B.C. Marble, 42in. The Acropolis Museum, Athens. *Hirmer Fotoarchiv München*

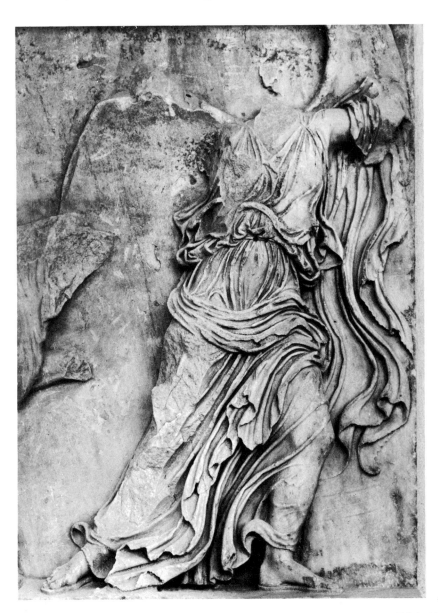

procession from the Parthenon; sometimes they flutter and wave softly around the forms of the figure, suggesting a gentle movement, as in the Victories from the Temple of Athene Nike on the Acropolis; sometimes they stream out behind the figures, as in the horsemen from the Parthenon frieze, where they suggest speed; sometimes they appear to be diaphanous and cling to the forms of the figure as though they were wet (the so-called 'wet' style); and sometimes they wrap tightly over the forms, creating taut straight folds which suggest contained energy.

One of the main functions of the lines of Greek drapery was to make the three-dimensionality of the forms more explicit. This was achieved either by wrapping the cloth closely around the volumes of the figure or by making it describe loose arabesques in space around them. The apparent disappearance of the folds behind the forms and their reappearance on the other side helps to define the depth and solidity of the forms and enhances our impression of their existence in three-dimensional space. They lead our eye into the depth dimension of the relief.

Many of these qualities of drapery are well displayed in the examples of Greek reliefs which we have already considered. Here I will show only one further example. It illustrates the extraordinarily dynamic effect which it is possible to achieve with the

31

145

assistance of line. It is a detail from the frieze by Leochares from the Mausoleum at Halicarnassus and its subject is the battle 145 between Greeks and Amazons. The freely flying draperies must surely have been included in the composition for their expressive value alone. They are certainly quite unrealistic and cannot have been put in to make the scene more natural. What they do, of course, is to add force, movement, and energy to the action of the warrior. They coil round inside the tilted saucer of the shield and are thrown out in the direction of the blow which is about to be struck at the fallen Amazon.

TOUCH AND SIGHT

Three-dimensional objects are both tangible and visible and we learn about them by exploring them with our hands and with our eyes. The information we acquire in both these ways becomes blended into a kind of composite visual-tactual knowledge which enables us to cross-refer, so to speak, between two kinds of sensory experience. By feeling things with our hands we are able to learn a great deal about their visual qualities, and by looking at them we are able to learn a great deal about their tactual qualities.

This knowledge is not emotionally neutral. We react to sensory experience with feeling and we are delighted or repelled in various ways by all sorts of visual and tactual qualities in things. Moreover our ability to cross-refer between sight and touch is also evident in these emotional responses. In particular, visual experiences can evoke strong reactions to the tactual properties of things. By simply looking at something we may feel in a vivid way how pleasurable it would be to run our hands over it or to pick it up and fondle it, or we may shrink away from it in disgust and put our hands out of the way behind our back.

This interdependence of tactual and visual experience is a most important element in our appreciation of all the plastic arts — painting, drawing, sculpture in relief and in the round, ceramics, and so on. In the two-dimensional arts, of course, there is nothing we can actually touch. If the work appeals to our tactual imagination and sensibilities, it must do so entirely through our eyes by means of visually represented tactual properties. But many three-dimensional works of art, such as pots and small-scale sculpture in the round, may depend very much for their aesthetic effect on the fact that we can actually pick them up and feel their weight, balance, surface-texture, and the all round-ness of their forms.

In appreciating reliefs we usually depend entirely on our eyes. We may feel inclined to run our hands over their forms if they are accessible, but this is not usually possible or necessary. Reliefs are intended to be looked at, not felt. Nevertheless, because visual and tactual experience are closely linked, it is possible for a sculptor to design his work in such a way that it will strongly affect our tactual imagination and sensibilities. Its forms may be addressed through our eyes to our sense of touch and they may evoke feelings which arise from our awareness and appreciation of their tactual qualities. A great deal of relief sculpture is designed in this way to appeal strongly to the tactual component of our sense of three-dimensional form. Other kinds of relief are not addressed to our sense of touch — at least, not in any significant way — but are

almost exclusively visual in their appeal. These are differences which will become more apparent as we proceed.

MODELLING SHADOWS We are able to see the form of a relief because different parts of its surface receive and reflect light in varying amounts and because these variations in the lighting correspond directly with movements of the surface. Changes of plane, varying degrees of surface curvature, convexities and concavities, flutings, channels, ridges, edges, figure against ground, undercutting, and all other features of the form of reliefs are made visible by corresponding changes in the intensity of the shading, or lighting, of the surface. We become extremely sensitive to such changes and highly skilled at interpreting them as indications of three-dimensional form.

Shadows which explain three-dimensional form in this way are called *modelling shadows*.

CAST SHADOWS Not every variation in the lighting of a relief corresponds directly with a variation of surface. Sometimes one part of a relief will cast a shadow on another part and this may well obscure rather than reveal its form. The effects of cast shadow on form are well known to figure draughtsmen who have been trained in a long-standing Western tradition of representing three-dimensional form by means of light and shade. When drawing a figure they will not just put in a cast shadow because there happens to be one on their model. They will ignore the shadow if it tends to obscure the form and use it only if it falls on the surface in such a way that it can be used to reveal form. One way in which relief sculptors use cast shadows to great effect is in undercutting around the contours of a figure. The shadows which are cast behind the undercut forms are used to show up the contours more clearly and to emphasize the separation of the forms from the background. Deeply hollowed out parts of a relief will also be in strong shadow under most lighting conditions. We may regard these also as cast shadows which are created in the hollows by the positive forms of the relief. As one would expect, cast shadows occur mainly in high reliefs. In them the forms project boldly enough to interfere with the light which is falling directly on the relief. But in a strong side light or top light long shadows may be cast even by the slightly protruding forms of low reliefs.

COLOUR IN RELIEFS Of course we cannot discuss the role of light and shade in reliefs without saying something about colour, since, as is well known, most reliefs before the Renaissance were coloured, usually brilliantly in a strong range of colours.

148

Enough has survived of the colouring of Egyptian reliefs for us to see that they were fully coloured like the paintings. Permanent colours such as the yellow, red, and brown earths, carbon black, and blue and green metal oxides were used. And as is common in many styles of sculpture, the eyes of Egyptian figures received special treatment and were inlaid with crystals and coloured stones. We know, too, that when Greek stone carvers had finished with their work it was handed over to painters. Archaic sculpture was freely painted with decorative vivid colours – hair, for example, could be bright blue or red. But in Classical and Hellenistic times the colouring became more varied, gentle, and realistic. Throughout the Middle Ages sculpture was as richly painted and gilded as the manuscript illuminations of the period. Marcel Aubert, writing on High Gothic sculpture, says:

Colour was an integral part of sculpture and its setting. Face and hands were given their natural colours; mouth, nose, and ears were slightly emphasized, the hair was gilded. Dresses were either covered in flowers or painted in vigorous colours; ornaments, buckles, and hems were highlighted by brilliant colours or even studded with polished stones or coloured glass. The whole portal looked like a page from an illuminated manuscript, enlarged on a vast scale.[1]

On a number of pieces of wooden sculpture such as the Romanesque lectern of Freudenstadt, the crucifix known as the *Majestad Battlo*, which is in the Museo de Bellas Artes in Barcelona, and many Late Gothic statues and altarpieces enough colouring has survived to give us some idea of the overwhelming richness that the applied polychromy of medieval sculpture could achieve. In a similar way Indian sculpture was brilliantly coloured after the form had been given a finishing layer of gesso. I can remember seeing some twenty-five years ago in the South of India a gopuram (that is, a great pylon-shaped temple gateway tower) which was heavily sculptured and freshly painted in bright colours. The effect as I remember it was startling and gaudy, but it is doubtful whether the colours applied then were like those which were originally applied.

The taste for monochrome sculpture which preserves the natural colour of the material from which it is made became fairly general after the Renaissance in most parts of Europe, although the practice of using colour continued, especially in wood and ceramic sculpture, and still continues in popular religious sculpture. During the last few years there has been a considerable revival of colour in sculpture. This is probably largely due to the fact that the materials used by many sculptors today – sheet iron and fibreglass, for example – either have no worthwhile colour characteristics of their own or rely on a covering of protective paint to make them durable.

[1] *High Gothic Art*, London, 1964, p. 60.

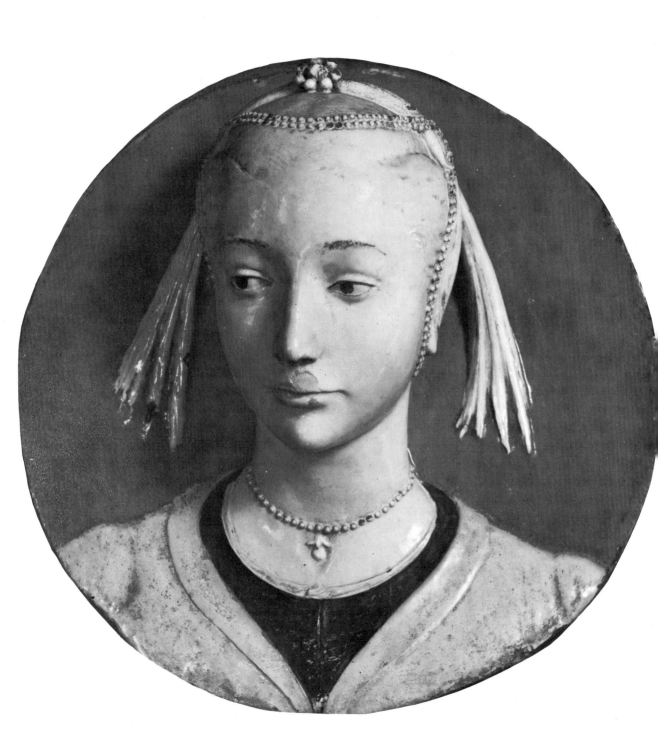

But how does colour affect the visibility of a relief and what are the connections of colour with light and shade? This is a large subject and we can only touch upon one or two of the more important aspects of it. The first point to notice is that a figure which is painted in one colour will show up clearly as a shape against a ground which is painted in a contrasting colour. The contour will thus gain strength through being the boundary of a coloured area as well as the boundary of a form. This applies not merely to the contrast between figure and ground but also to that between figure and figure. Compositions which in monochrome seem crowded and confused may do so largely because they have lost the colours which once distinguished one figure from another.[1] An Egyptian relief without its colour is a thing of very delicate – sometimes too delicate – lines. It is sometimes difficult to make out the shapes of the figures which are bounded by the contours. Low reliefs in darkened wood may also be confusing if the original intention was to distinguish one form from another by means of colour. The contours may not be sharp or steep enough to outline the figures clearly.

The second point to bear in mind is that different areas of the surfaces of the figures themselves may be distinguished by their colours. Various parts of the costumes of the figures, and their flesh, hair, eyes, eyebrows, and so on may be defined by colour. Very often the sculptor will leave details out entirely at the carving stage and rely on the painter to supply them. We have already encountered an example of this in the Greek relief of *The Abduction* 19 *of Basile*.

However, although colour will differentiate one *area* of a relief from another, it does not define the movements of the surface in three-dimensional space. It is variations in the relative amounts of light received and reflected by the different parts of the surface which model its form in three dimensions. A red shape will show up against a blue background by virtue of its colour, but changes of form within the contours of the shape itself will be revealed only by changes of tone. And in the composition as a whole the distribution of light and shade will be clearly seen superimposed, so to speak, over the distribution of colour. Whether the relief is coloured or not, bold projections will show up as highlights and deeply hollowed out recesses will be darkened.

[1] Tatiana Proskouriakoff's remarks on the probable role of colour in Mayan sculpture are of interest in this connection: 'The over-intricacy and lack of emphasis in some Maya sculptures, particularly those of Quirigua, have often been criticised and cited as a "baroque" trait. The effect is in fact confusing and poses an obstacle to the recognition of meaningful forms, but it should be remembered that these designs were probably painted, and that the use of polychrome would differentiate the individual forms and make them immediately perceptible to the eye.' See *A Study of Classic Mayan Sculpture*, Washington D.C., 1950, p. 181.

151

How well we are able to see the forms of a relief will depend very much on the direction and intensity of the light which is falling on it and on the way in which the sculptor has designed its forms to accommodate the kind of light which it is likely to receive. A sculptor seldom has complete control over the lighting of his work. In fact he can only have complete control when the work is illuminated artificially. Under normal circumstances a relief which is in a fixed position, either interior or exterior, is subject to a wide, although not unlimited, range of lighting conditions. If the relief is a portable one then it must, of course, submit to any kind of lighting. Natural lighting varies in intensity and direction at different times of the day, in different kinds of weather, at different times of the year, and in different parts of the world. Moreover a relief may be sited near or far from the spectator in a well or poorly lit position. And we must not forget the effect of the material from which the sculpture is made. White marble is capable in some lighting conditions of showing up the most subtle changes of tone and hence the most subtle inflections of surface form. Polished and unpolished metals and stones, coarse textured stones, light and dark woods, various types of clay, glazed terracottas – all these have intrinsic material qualities, apart from the applied colour we have already mentioned, which reflect light in different ways and in different degrees.

All these factors which affect the behaviour of light on a sculptor's work must be taken into account by him if he is to achieve the kind of effect he wishes his work to have. It is no use simply carving or modelling the form at close quarters or in a studio and hoping for the best when the work is seen from a distance or transferred to its site.

There are certain qualities in the forms of reliefs which will react in a broadly similar way in any normal lighting conditions. Simple instances of this are small drilled holes, deep grooves, undercuttings, and deeply excavated hollows. These will always be dark. On the other hand highly projecting convex surfaces, particularly those which are facing upwards and receive a top light, will usually be clearly lit over most of their area. There are, however, too many variables involved for there to be any simple rules about what does or does not work in this or that situation. The decisions must be taken literally in the light of a particular situation and they will depend on the kind of effect – the qualities of form and expression – that the sculptor hopes to achieve. We need pursue the sculptor's problems no further. The means by which he achieves his effects are not so much our concern as the nature of the effects themselves.

There is one further point which should be mentioned here. Ideally a relief which has been designed for a special site should be seen in that position. If it is an outdoor work we should be able

to see it day after day in all kinds of lighting — in the silver light of early morning, in the overhead light of the midday sun, in the shadow-casting golden glow of evening sunlight, on a grey dull day, and so on. A relief which has been designed for the dim interior of a church and for the flickering light of dozens of candles should not be exposed to a powerful artificial light or placed in broad daylight by a large museum window. The lighting of sculpture, especially reliefs, in museums calls for a great deal of care. Obviously the public wish to see the relief clearly but if it is to be on display in a permanent unchanging artificial light, then its qualities as a modulator of light will go largely unnoticed. It will be like a face with one fixed expression.

However, we should not be too purist about the siting or lighting of sculpture. Some of the capitals of Autun Cathedral have been removed from their original positions and displayed in a special room on eye level. Anyone who visits the Cathedral on a dull day has reason to be grateful for this since the grey stone reliefs way above one's head are hardly visible in a dim light. Two most important pieces of equipment for anyone visiting churches in Europe in order to see sculpture or frescoes are a powerful torch and opera glasses. Coin-operated light switches are sometimes provided for the larger better known works, but many of the smaller lesser known ones cannot be properly seen without a torch. Henry Moore's comments on his visits to Pisa are worth bearing in mind:

I remember going to Pisa as a student to see the Giovanni Pisano figures on the top of the Baptistery but about all I could get from them was that they represented a change away from Byzantine towards Renaissance. They were too high, they were just silhouettes against the sky and it was impossible, at that distance, to see the form inside the silhouette. These figures (because they were weathering too rapidly and some were becoming unsafe) have since been taken down from the Baptistery and put into a museum at Pisa where, four years ago, I saw them again. They are set up on eye-level and on turntable stands and I now think they are some of the world's greatest sculptures. Now that one can go near them one can respond to them as sculpture, as bumps and hollows, as volumes and taut compressions, and as humanist expression, and not merely as decorative architectural features.[1]

CLASSICAL CLARITY: LIGHT AND FORM

In some types of relief the primary function of the lights and darks is to define three-dimensional form. The figures in the reliefs are modelled in such a way that the behaviour of light on their surfaces corresponds completely with their tangible form. Our attention is not attracted to the light and shade for its own sake but passes through it, so to speak, straight to the form. Everything is distinct; each figure is clearly enclosed and defined against its background

[1] In P. James (ed.), *Henry Moore on Sculpture*, London, 1968 ed., p. 38.

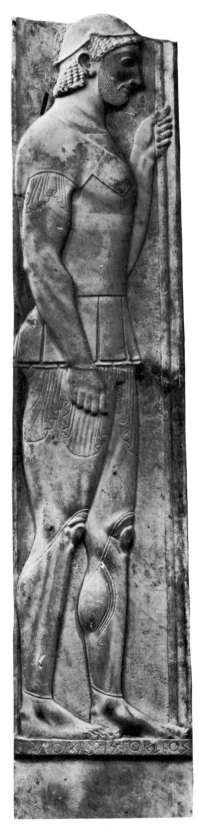

by its contours, and its modelling shadows perfectly reveal both its larger forms and surface modelling. Each individual form is intact and preserves its identity in spite of its function in the whole composition. If figures overlap, they do so clearly and we can see exactly where each belongs in an ordered sequence of depths. This lucidity of form is characteristic of many archaic and all Classical reliefs – it is in fact a large part of what we mean by 'Classical' when we use that term in a general sense and apply it not merely to the work of Greek sculptors at a particular time but to certain constantly recurring artistic qualities.

The aspects of the natural world which are stressed in these reliefs are those which may be clearly apprehended through our sense of touch. We are made visually aware of the tactual properties of what is represented, of its separate, self-enclosed identity as a tangible physical object, of the movements of its surface that our hands could have felt out for themselves without the aid of our eyes.

The care that the Classical sculptor takes to ensure that the behaviour of light on his works will create a clear form-defining contour and clearly model the surface may be seen in such low reliefs as the Horsemen frieze from the Parthenon, the tombstone 31 of Hegeso, and the earlier stele of Aristion. In all three works 187 great care has been taken to preserve the continuity of the main surfaces, to treat them as broad planes in which the surface modelling and decorative accessories are kept shallow and subordinate to the larger movements and do not break them up with strong shadows. In high reliefs great care is taken not to trap shadow in such a way that it will break up the surfaces and hamper our clear grasp of the main volumes of the composition.

The marvellous plasticity of surface for which so many Greek sculptures of the nude human figure are admired depends for its visibility on subtle nuances of light and shade. It is possible, and in some circumstances desirable, to enclose the features of the surface anatomy of a figure in sharp outlines so that each muscle, each bony protuberance, each facial feature, and even each lock of hair will stand out clearly and separately. This may be an appropriate treatment for the surface modelling of an athlete or warrior, where some expression of power may be required, or for a figure which has to hold its own as part of an architectural scheme which includes a good deal of crisply defined detail. But many figures, particularly female figures and more intimate kinds of sculpture, call for a softer, more blended type of surface anatomy. The mood may be gentle, more lyrical or delicate, erotic rather than military, or it may be more important to convey a feeling of motion, which a static, congealed surface structure would not help.

Changes in the surface of a human body are caused by the

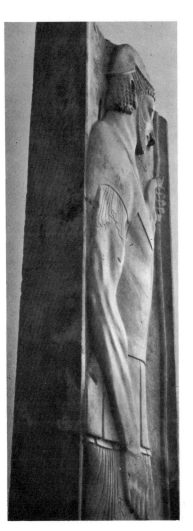

Stele of Aristion, late 6th century B.C. Marble, 2.5m. National Museum, Athens. *Hirmer Fotoarchiv München*, and detail, *Sheila Adam*

underlying flesh and bone structure; they are not haphazard and unstructured. Moreover, they are for the most part very minor changes which occur on the surfaces of large underlying solid masses. The Greeks resolved the whole figure into a complex and subtle structure of underlying volumes and overlying surface forms. So thorough was their conception of this structure that they were able to carve and model the surfaces of the nude figure in the most delicate and blended way while still preserving an intelligible structure, that is without creating meaningless slurs and slithers or mere vague impressions. The articulation is there but it is not obvious. These subtly blended transitions from one form to another and other gentle inflections of surface may be revealed only by the most careful, or most fortunate, lighting. It is this refinement of surface which makes so many people incredulous of the fact that Greek sculpture was coloured. Rodin, whose admiration for the surface modelling of Greek sculpture was almost fanatical, refused to believe that the sculpture was coloured. However, it is unlikely, to say the least, that having gone to so much trouble with the surface modelling, Greek sculptors would stand by and see their work destroyed by the application of crude colour. We can hardly doubt that where the modelling called for it the colour was of a matching subtlety. Praxiteles, whose special distinction it was to have introduced a particularly subtle kind of blended surface modelling into Greek sculpture, is said to have employed the master painter, Nikias, to colour his sculpture and to have preferred among his own works 'those on which Nikias did the painting'.

The variations of surface modelling in these Greek sculptures are always subordinate to the larger movements of the underlying volumes. In terms of lighting this means that the minor changes of tone are subordinate to the main distribution of light and shade. They do not interrupt but merely diversify the continuity of the main surfaces.

A similar Classical concern with rendering the tangible properties of three-dimensional form in visual terms is apparent in a good deal of Indian sculpture. It is evident in the broad curved expanses and clear contours of the Bharhut Yakshi, but 110 it is most splendidly displayed in the figures produced during the great Classical Gupta period at Sarnath and Mathura. Some of 156 the high relief images of Buddha from these two centres carry certain of the trends which are apparent in Greek Classical sculpture to an even greater degree of Classicism.

As we have already seen, the main forms of these figures are reduced to a number of extraordinarily pure, simplified volumes. Perhaps 'simplified' is not the right word for something so subtle. The volumes are certainly not broken up into a complicated mass of lumps and bumps or facets, and in that respect they are simple.

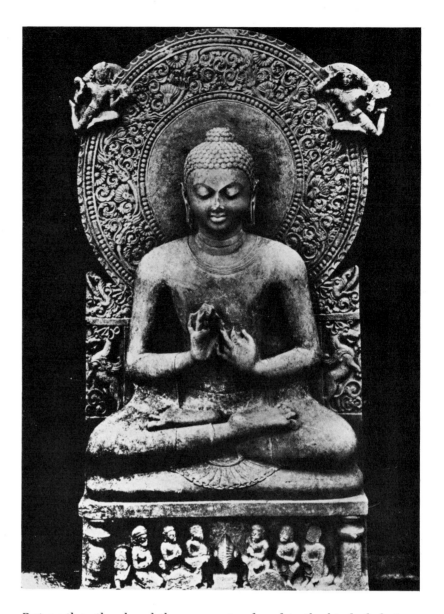

Buddha Preaching the First Sermon, from Sarnath, Gupta period. Sandstone, 1.57m. Archaeological Museum, Sarnath, India

But on the other hand they are not reduced to the kind of obvious uniformly curved geometric solids which the machine-conditioned sensibilities of so many modern designers and artists have not merely accepted but, unaccountably, eagerly embraced. The simplicity of the forms of these Indian sculptures is an organic, not a mechanical, simplicity; it arises not from a lack of formal content but from a concentration and compression of it. It is the simplicity of a fruit or stalk, not that of a billiard ball or bean can.

These volumes are contained within smooth, convex, and expansive surfaces which are unbroken by details of surface anatomy. The surfaces catch the light in ways that perfectly reveal the forms, while the contours, which correspond in their unbroken clarity and subtlety with the surfaces, are clearly

defined against their background by light and shade. Minor forms such as brows, eyes, and lips are clearly defined as patterns of light-and-shade-catching planes, and decorative details such as hair and jewellery are rendered by crisply textured patterns of light and dark.

Unbroken expansive surfaces are also a feature of the High Romanesque *Christ in Majesty* on the tympanum of the Portail Royal at Chartres. The conventionalized draperies of this figure are wrapped closely around its forms and stretched tightly across the spaces between the legs and between the arms and the body. This is done in a way that simplifies and unifies the surfaces into broad continuous planes. The space between the legs has become one large, taut, unbroken, concave plane reaching from the hips to the feet. There are no deep folds to trap shadow and no dark spaces between the lower legs. The whole surface is open to the

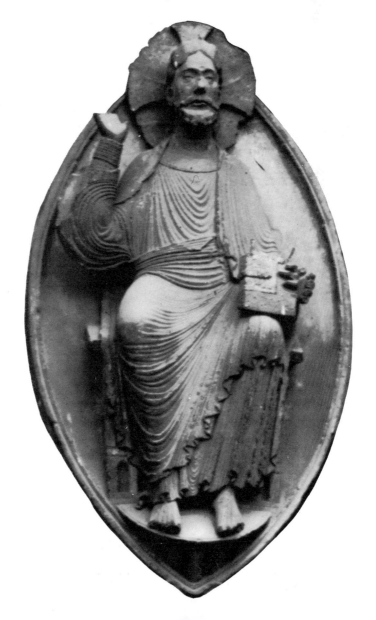

Detail of *Christ in Majesty*, Portail Royal, Chartres Cathedral. *See overleaf*

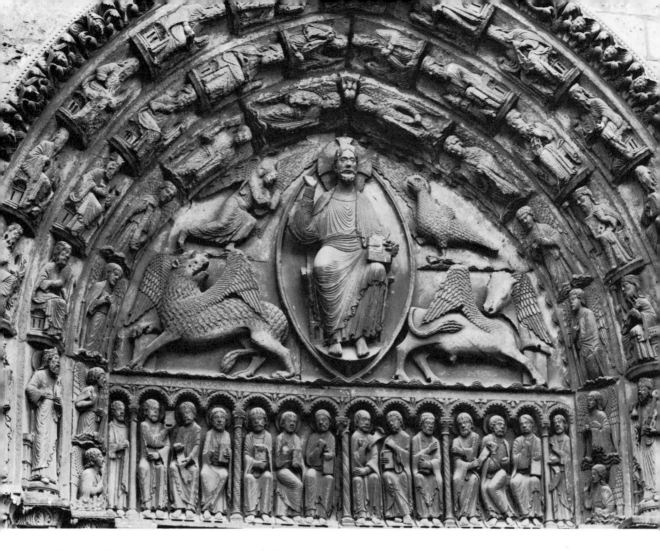

Christim Majesty, central tympanum of the Portail Royal, Chartres Cathedral, 1145–55. Stone. *Archives Photographiques*

light. All the shadow-creating complexities of form which tend to occur between the arms and the body are also eliminated, and the chest, arms, and shoulders are fused into one broad surface which sweeps up into the neck like the top half of an enormous pot. The folds are reduced to a pattern of lines which does not interrupt but rather defines the movements of the surfaces. They are so shallow that they nowhere interfere with the taut line of the contour. There are no shadows within the contours of the figure which are at all comparable in strength with those behind the boldly undercut contour itself. It is largely this which gives the figure its immediately graspable unity of form.

A similar breadth of treatment is apparent in the symbols of the evangelists. Their contours, too, are boldly defined by shadows cast on the background plane. And although their surfaces are diversified by texture, the scale of this has been carefully chosen so that it nowhere breaks up the modelling shadows and detracts from the strong positive breadth of the forms.

In this great Romanesque work light and shade are once more

the servants of form. The simplified outlines and interior surfaces modulate the light in such a way that we are given a perfectly clear idea of the main volumes, minor forms, and decorative details of the whole work. Nothing is left for us to guess at, nothing is merely suggested — everything is lucid and utterly explicit. This is not the emaciated terrifying spirtual being or stern judge of many of the earlier tympana but a truly majestic reassuring figure with all the serenity of a great Buddha. This mood is expressed not merely in the face and gestures but in the qualities of the forms themselves, and not the least in the way the forms are open to the light and without interior shadows. This is still a transcendent Christ although not a fearful one. We are reminded of the peace and love of a resplendent God not the gloom and horrors of Doomsday.

To summarize the tendencies we have been considering so far in this chapter we may say that the forms of these Classical figures (using the term in its broadest sense) are treated in a way that tends to make all their shadows modelling shadows. This makes us vividly aware of the tangibility, the solid substantiality, of the figures as three-dimensional entities each enclosed within its own boundary.

CHIAROSCURO There are other kinds of relief sculptures which do not aim to give us a clear idea of tangible three-dimensional form. The sculptor has not thought of light and shade primarily as a means of revealing form but as a visual component of the work which exists in its own right and directly contributes to the dramatic effect of a composition. In many instances it would be fair to say that the situation we have discussed in our previous examples is reversed and that the form subserves the effect of light and shade, which becomes itself a major instrument of expression. The surfaces may be modelled, cut into, and undercut mainly for the dramatic effect of the cast shadows they give rise to. The contours become broken and discontinuous and no longer function as boundaries which enclose the forms and clearly separate one figure from another or define it against its background. The forms themselves may be broken up in all sorts of ways. Drapery, for example, creates deep hollows and bold projections, or breaks up the surfaces into a mass of small intricate shapes which shatter the light that falls on them. Again, parts of the figures may project boldly at all angles and overlap and entwine in ways that defeat our attempts to grasp them clearly. They may also cast deep and visually confusing shadows. Even minor details of form such as locks of hair, eyes, and lips may be deeply undercut and drilled in order to create expressionistic or decorative shadow effects.

These tendencies become apparent for the first time in any marked way in Hellenistic and Roman sculpture. The use of light

and shade as a positive element in the composition of antique sculpture is sometimes called 'colourism' and the light and shade itself is often referred to somewhat confusingly as 'colour'. It may be a feature of the treatment of both individual forms and of compositions as a whole.

Shadows are used to intensify the expressions of pathos and agony in the features of the giants in the great frieze of the Altar of Pergamon. This enormous work represents the victories of the Pergamonians in mythological terms as a war of the gods with the giants, who symbolize the forces of darkness. In the heads of a number of giants the eye-sockets are deeply hollowed out behind the upper eyelids and even the eyelids themselves are undercut in order to create strong shadows. The hair and beards are deeply grooved and the massive locks are undercut and thrown up in powerful relief. The shadows caused by the undercutting of the hair are particularly strong where the hair falls over the forehead. The mouths are deeply set back beneath overhanging moustaches and the cavity between the open lips is deeply shadowed. The boldly modelled surfaces of many of the faces and the bulges and furrows of the foreheads are also exaggerated in order to intensify the shadows.

Chiaroscuro effects also play an important part in the larger scale design of the frieze. The high relief and deep undercutting of the main forms, the deep furrows of the draperies, the concavities of the insides of the shields, the exaggeratedly bunched muscles,

Detail showing *Athena Fighting the Giants* from the great frieze of the Pergamon Altar, *c.* 180–160 B.C. Marble, H. 7ft. 6in. *Staatliche Museum, Berlin*

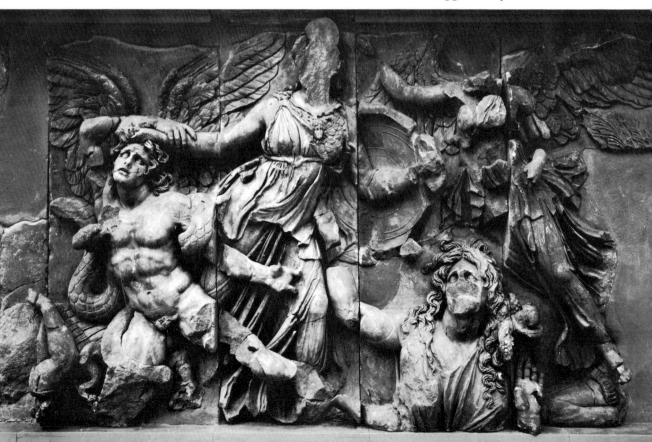

the deep spaces between the close-packed overlapping forms – all this creates a rich and varied pattern of light and shade across the whole composition which heightens the drama and helps to bind all the massive forms into a unified design. Yet in spite of this there is perhaps too much insistence on the weight and definition of each of the forms, a certain over-substantial quality and lumbering heaviness which slows up the rhythm so that the action seems to be taking place in slow motion. There is strength but not much energy. The Classical attitude to sculpture is still very much in evidence and the treatment of much of the form – for example, the long curves of the drapery and the clear, carefully defined pattern of the surface anatomy – is more suitable to a mood of harmony and permanence than to one of conflict and momentary action. Perhaps more angularity and less sweeping curves, more flatness and less insistence on the fullness of the volumes, more agitation and less fluidity in the draperies would have enhanced the feeling of violence and conflict. There are some moods, some types of expression, which are unsuited to the Classical treatment of form. The great frieze is a magnificent achievement and there are superb things in it, but it was left to later styles to find really successful ways of representing violence and agitated movement in sculpture. Pater wrote of the

special limitation of sculpture . . . [which] results from the material and other necessary conditions of all sculptured work, and consists in the tendency of such work to a hard realism, a one-sided presentment of mere form, that solid material frame which only motion can relieve, a thing of heavy shadows, and an individuality of expression pushed to caricature. Against this tendency of the hard presentment of mere form trying vainly to compete with the reality of nature itself, all noble sculpture constantly struggles; each great system of sculpture resisting in its own way, etherialising, spiritualising, relieving its stiffness, its heaviness, and death.[1]

I think it is fair to say that in most of the figures of the great frieze there is too much of the 'hard presentment of mere form' for the kind of feelings it aims to express and that more dissolving of the forms in the general mêlée, more use of light and shade to break down the independence of the figures, would have made the composition more vigorous and dynamic.

The role of chiaroscuro as an element in relief composition is much greater in some Roman reliefs. It reaches its peak in some of the relief decoration for sarcophagi. The treatment of relief on Roman sarcophagi was not based entirely on Hellenistic sources, which broadly speaking were still fundamentally Classical. It also owed much to Etruscan models, especially to the reliefs carved in soft materials such as tufa and alabaster on funerary urns. The

[1] 'Luca della Robbia', *The Renaissance*.

figures in these Etruscan works are in very high relief, deeply undercut, and extremely close-packed. Sometimes they are severely foreshortened and lean out of the relief. The effect of all this was to produce a background of strong shadow behind the forms, a background which is not an impenetrable spatial barrier, like the back plane of Classical reliefs, but is indefinite and suggestive of space.

Two of the best known Roman sarcophagi are carved with elaborate battle scenes. They are the Battle sarcophagus found near Portonaccio and the Ludovisi sarcophagus, both of which are 38 in the Museo delle Terme in Rome. The boldness and density of form in these reliefs are so great that the background ceases to function as a barrier setting limits to the depth of the relief and becomes a region of intense shadow out of which the figures emerge. The whole area of the field is covered with a scene in vertical perspective and the projection of the forms is limited by an implied front plane. In fact the reliefs are similar in many respects to the Amaravati roundel and the panels on Giovanni Pisano's pulpits. (It is certain that Giovanni Pisano must have looked hard at sarcophagi such as these, and the influence of Roman sculpture on Amaravati is widely acknowledged.) The overlapping of forms in the Roman battle scenes is carried to a point where the eye can hardly separate out the individual figures and dwell on them but is carried rapidly from one form to another over the whole surface of the relief. We are hardly aware of the

Battle sarcophagus found near Portonaccio, 190–200. Stone, H. 1.50m. Museo Nazionale delle Terme, Rome. *Mansell Collection*

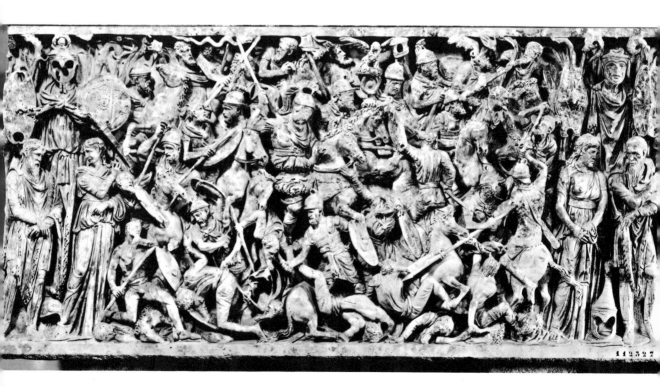

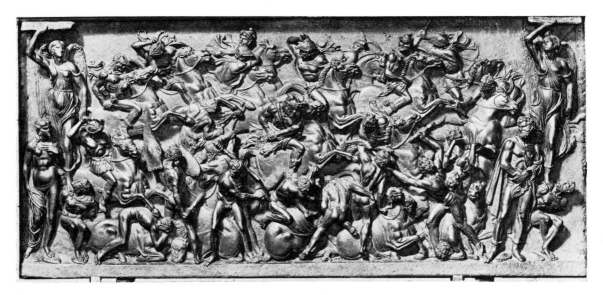

Battle of Horsemen, by
Bertoldo, *c.* 1492. Bronze,
43 × 99cm. Museo
Nazionale, Florence. *Mansell
Collection*

existence of contours because the whole scene is dissolved into a
patchwork of light and shade. It is the total effect which strikes
us most forcibly – the clashing rhythms, the sense of conflict,
the over-all pattern of bold light-catching projections and dark
spaces. There is a good deal of foreshortening in these works.
Figures and horses come straight out of and disappear into the
background and are no longer in the plane of the relief where they
might have at least a fairly continuous contour. It is worth noting

Battle of Centaurs, by
Michelangelo, 1490–4.
Marble, 4.5 × 90.5cm. Casa
Buonarotti, Florence.
Mansell Collection

that Bertoldo, who for a time was Michelangelo's master, produced a relief, *Battle of Horsemen*, which is based on a Roman sarcophagus relief, and that Michelangelo's *Battle of Centaurs*, one of his few reliefs, is based on Bertoldo's work.

The chiaroscuro effects of these battle scenes arise mainly from the congestion and superabundance of the forms rather than from the treatment of the surfaces of the forms themselves. The main shadows are trapped between and behind the forms but the forms themselves are fully modelled in bold relief; they are not cut up into a mass of facets or flattened artificially in order to produce lighting effects. This is not the case in the extraordinary *Lamentation over the Dead Christ* by Antonio Mantegazza. The extremely pictorial style of this fifteenth-century north Italian sculptor appears to contain elements which derive from the marble low relief style initiated by Donatello and elements from the art of Late Gothic sculptors on the other side of the Alps, while the treatment of drapery looks forward in some respects to that of Bernini and High Baroque. Ruskin's phrase, 'chisel painting', applies particularly well to the style of this work. In places the form is flat, even hollow, where in nature it would be convex, and the whole group of figures is broken up into a mass of flickering ridges, sharply cut concavities, and small angular planes. All this is as difficult for the eye to follow and to comprehend as the faceted surface of crumpled metal foil or the bottom of a pool of water whose surface has been disturbed. The style of this relief is usually said to be expressionistic, and it is certainly true that the harsh angularity and flatness of its forms and the broken, jagged rhythms of its light and shade are in keeping with the subject of the work and the feelings expressed in the faces of the figures. The light-shattering properties of the surfaces are not properties which could have been observed in real life. They have been imposed upon the subject by the artist in order to heighten its impact on our feelings.

But perhaps nowhere has form been carved more with an eye to its lighting effects than in the German Late Gothic wood carved altarpieces. The works of the numerous masters who were producing alterpieces around 1500 show considerable individual differences of style but they all exploit the dramatic effects of chiaroscuro. Some of the most celebrated of these carvers are Veit Stoss, Tilman Riemenschneider, Master H. L., and Michael Pacher, but so many altarpieces were produced during this period that it is possible to find first-class examples in most parts of Germany and Austria and in many other parts of northern Europe.

The drama of religious events enacted in these 'sacred theatres', as the altarpieces have been called, is everywhere enhanced by the drama of light and shade. One of the main causes of these

The Lamentation over the Dead Christ, by Antonio Mantegazza, 1490. Certosa, Pavia. Marble, 196 × 112cm. *Fratelli Alinari*

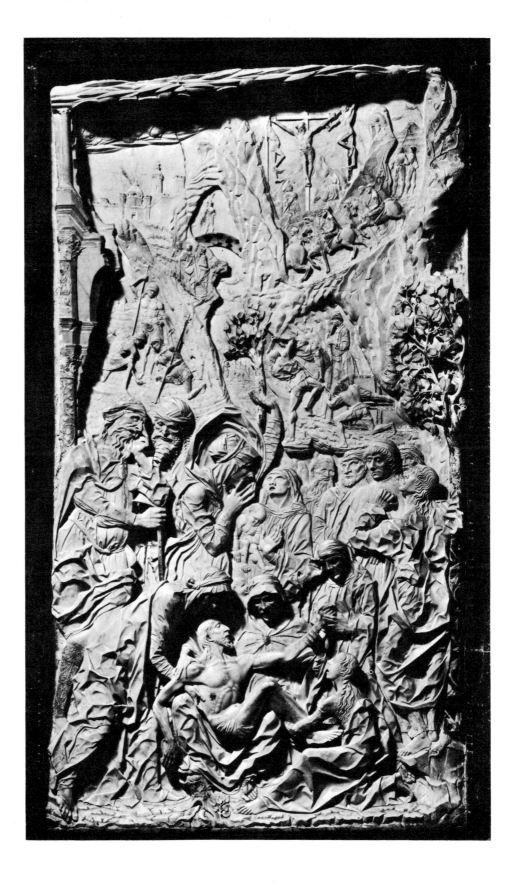

chiaroscuro effects is the manner in which the garments are treated. Draperies always make a major contribution to the expressiveness of Gothic sculpture, but towards the end of the Middle Ages they become the most important source of expressive sculptural form. One of the most noticeable features of the development of medieval sculpture is the progressive deepening of the modelling of the draperies and their tendency to assume a life of their own independently of the body which supports them. In most medieval sculpture the human body counts for little, although the hands and faces are often deeply expressive. (The hands in Veit Stoss's great altarpiece at Cracow are one of the high points of world sculpture.) Unlike the draperies of the Chartres *Christ in Majesty*, which wrap tightly round the forms of the body and provide clear uninterrupted external contours, the garments of the figures in most of these altarpieces are deeply undercut into heavy masses of folds which hang away from the body and conceal its shape. Sometimes they cascade to the floor and form masses of small folds or fly away from the figure to form complex shapes full of twisting planes and deep cavities.

But the rich effects of chiaroscuro in these works are not entirely due to the draperies. They are also due in part to the congestion

The High Altar, Church at St. Wolfgang, Austria, by M. Pacher, 1471–81. Polychromed wood. *Electa Editrice*

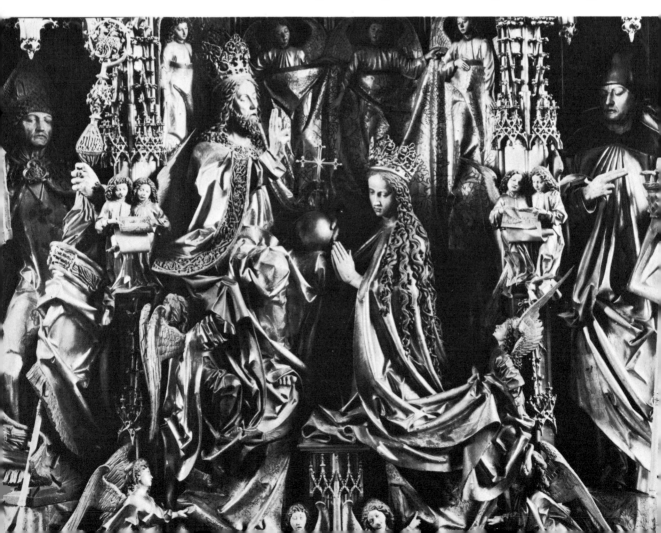

of forms, to the depth of the stage-like spaces into which the figures are crowded, and to the shade created by the overhanging canopies. The strong shadows created among the folds of the draperies merge with the shadows around and behind the figures, in the surrounding space. As a result the contours either disappear or become so broken that the eye cannot readily follow them and the figures and background fuse into a continuous composition of light and dark shapes. These shapes are indefinite and changeable and they do not coincide with the tangible outlines of the forms. In extreme cases the whole composition may become enveloped in an atmospheric chiaroscuro which merges figure with figure and figure with background and breaks down all the tangible boundaries of objects which the Classical approach so insistently preserves.

A special word must be said about the canopies, which are an extraordinary feature of many of these German altarpieces. They are made up of elaborate and fantastic architectural traceries or entwined botanical motifs which can reach an almost unbelievable luxuriance. Many British people cannot accept this Germanic complexity and see it as a meaningless exercise of skill. Roger Fry, for example, comments on these Late Gothic sculptures:

The worship of mere professional skill and undirected craftsmanship is there seen pushed to its last conclusions, and the tourist's wonder is prompted by the sight of stone carved into the shapes of twisted metal, and wood simulating the intricacies of confectionery, his admiration is canvassed by every possible perversion of technical dexterity. Not 'What a thing is done!' but, 'How difficult it must have been to do it!' is the exclamation demanded.[1]

A more sympathetic and balanced view is that of the German, Wölfflin. He writes:

The German imagination differs from the Italian not only because it grants the human figure no (such) predominance over the innumerable other phenomena of the world, but also because it is, above all, an imagination of the multitude and not of the single figure, of the host of forms and not of the isolated form. The interest in the single form is not absent, but the notion of formal complexes, the interaction of diverse existences, is primary. . . . For the Germans, the life of the tree is contained not only in the design of the crown, trunk, and roots, but also in the underbrush, the small growths that crowd about the trunk. Such things cannot be isolated. Nature does not bring forth single creatures but unburdens herself in a deluge of forms – an existence in large throngs, which may easily acquire a crowded jostling character.

Such a viewpoint naturally produced entirely different results in painting and ornament. We can understand how the tight interweaving of forms in, say, the superstructure of an altar – which appears so strange to the taste trained on Italian art – was felt in the North to be altogether natural.[2]

[1] *Vision and Design*, Pelican ed., 1961, pp. 158–9.

[2] H. Wölfflin, *The Sense of Form in Art*, New York, 1958 ed., p. 216.

Obviously the view we take of this aspect of German art is partly a matter of temperament and partly a matter of approaching it with the right expectations and attitude of mind. In any case it is certain that these elaborate canopies contribute a great deal to the over-all pattern of light and shade because they cast deep shadows into the space of the composition. Sometimes they are pierced so that they become lace-like patterns of light traceries against the dark background of the recess.

We must not forget that most of these altarpieces were not intended to be as gloomy and monochrome as many of them now are. They were brilliantly coloured and richly gilded. Many of the dark shadows in the draperies would have been filled with a magical glow reflected by the shining gold. Nevertheless the effect of colour and gold is not to cancel the effect of light and shade, although it does make the compositions somewhat less confusing than they may be in monochrome.

Not all of the altarpieces were coloured, however. In the Netherlands, in particular, they were often left with a natural wood finish. Riemenschneider occasionally left his carvings in this state. But it appears that his patrons or the public of Munnerstadt did not approve since some ten years after Riemenschneider had completed an unpainted altarpiece for them, Veit Stoss was commissioned to 'colour, paint, and gild' it.

Some Aspects of Composition

Some reliefs are entirely self-contained and independent works of art which may be considered as compositions in their own right without reference to anything outside them. Among these we may include reliefs on medallions and bronze plaques, portable religious icons, ivory panels, vessels such as the Portland vase, isolated wall panels, cameos, and Greek funeral stelae. And we may add to these the numerous reliefs produced in recent times which lead the same kind of detached, independent existence as easel pictures and are intended to be appreciated in isolation, for their own sake. The majority of reliefs, however, are not completely independent works of art, existing entirely in their own right, but are part of some larger, more complex structure into which they are more or less tightly or loosely integrated.

The central tympanum of the Portail Royal of Chartres 158 Cathedral, for example, is integrated both iconographically and compositionally with the sculptured voussoirs and lintel which surround it. Together they make up the superstructure of the central doorway. This superstructure ties up with the sculptured jamb columns beneath to form the whole central portal. The central portal, in its turn, is the dominant member of a symmetrical group of three sculptured doorways which are bound together within the larger compositional and iconographic unity of the whole Portail Royal. We may go further than this and consider the whole Portail Royal itself as an architectural unit within the context of the elevation of the west front, or even ultimately as one feature in the vast complex of the cathedral as a whole. If we do attempt to see the Portail Royal in this way, in relation to the rest of the architecture, we shall probably feel that the unity begins to break down since 'the *Portail Royal* differs in scale from the rest of the building. Conceived as an adjunct to an earlier cathedral, it has survived, together with the towers, as a detached and self-contained fragment, incorporated into a whole with which it has no organic structural connection.'[1]

While granting that the tympanum plays a key part in the larger composition of the whole central portal, we can and do regard it up to a point as a self-contained sculptural unit in both its subject-matter and its composition. For while whoever was responsible for its design has made this group of Christ and the four symbols of the evangelists into the dominating centrepiece of the whole trio of doorways, he has also carefully accommodated each of the major components of the group to the shape of the tympanum and bound them together into a tightly unified composition within it. The Portail Royal is a supreme example of

[1] P. Kidson and U. Pariser, *Sculpture at Chartres*, London, 1958, p. 4.

169

a type of composition, common in the Middle Ages, in which the component forms are ordered hierarchically. The figure of Christ is central not only to the tympanum or even to the main doorway. He is the centrepiece of the whole Portail Royal. (Some historians have seen in this hierarchic method of composition an artistic reflection or analogue of the structure of medieval society and of the theocentric universe of medieval theology.) To do such a composition justice it is necessary to appreciate its smaller compositional units both in their own right and as parts of a more complex formal structure and iconographic programme.

Other examples of reliefs which are parts of larger complexes are: the panels of the great pulpits of Nicola and Giovanni Pisano; the panels of bronze doors such as those of Andrea Pisano and Ghiberti; the metopes and friezes of Greek temples; the narrative scenes which are separately framed in medieval altarpieces and ivories; the lunettes, tondi, friezes, and panels of Renaissance wall tombs; the panels and roundels from the railings, gateways, drums, and domes of the great Buddhist stupas such as those at Sanchi, Bharhut, and Amaravati. All of these are units which may be considered both separately and as part of a larger complex.

The reliefs in some of these larger complexes are more independent and self-contained than that on the central tympanum of the Portail Royal. They are not part of a hierarchically ordered system but are juxtaposed to form a series in which each unit is of equal importance. The panels of Ghiberti's *Gates of Paradise* and the Pisani's pulpits, for instance, are completely unified compositions within themselves. As units of architectural structure they are, of course, completely interdependent and inseparable from the over-all design of the *Gates* and pulpits, but iconographically they are only loosely related, and compositionally each is quite self-contained.

If we move back far enough to see the whole of Ghiberti's *Gates* as a complete design, we cannot properly appreciate the panels as sculpture; they are meant to be looked at separately, one by one, and considered as compositions in their own right. When we look at them as part of the total complex we do not appreciate them as examples of relief sculpture but as parts of a door. We may then find ourselves coming to the conclusion — I am not suggesting that we should — that the *Gates*, as gates, are badly designed, or that the panels are wrongly proportioned or too fussy, even though as individual works of relief sculpture they are great masterpieces. Or, conversely, we may admire the *Gates* as an architectural feature but consider the reliefs to be bad sculpture. We can and do judge such things separately. If our interest is primarily in the relief sculpture itself, we may to some extent ignore its function within a larger composition and concern ourselves with its internal qualities and composition. In the case of the Amaravati reliefs and

The Gates of Paradise, by Ghiberti, finished 1452. The Baptistery, Florence. *Mansell Collection*

170

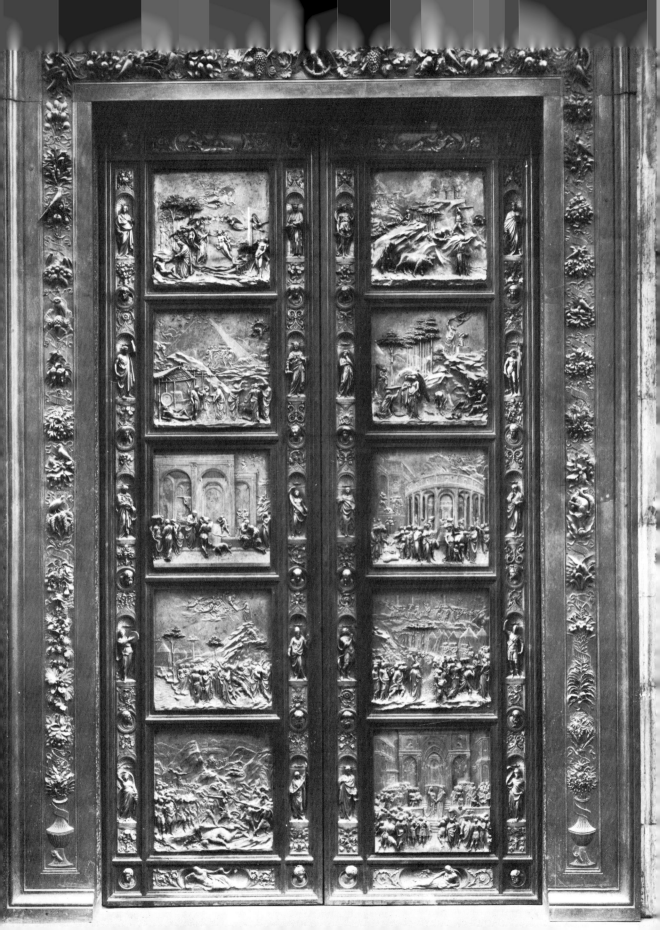

the metopes of the Parthenon we are obliged to do this, since they are divorced from the context of the building to which they belong.

Many of these larger complexes contain reliefs by more than one sculptor. It quite often happens that the over-all design of a composite work has been conceived by a single designer, who may also have determined the dimensions, materials, and subjects of the reliefs, while the actual reliefs themselves have been executed by a number of artists working independently in their own styles and interpreting the subject in their own individual ways. The font in the Baptistery at Sienna is a superb example of this kind of corporate workmanship. The history of the making of the font is perhaps unusually complicated but it will serve as an example of the way in which complex projects were often undertaken, particularly during the Renaissance in Italy. The following account is taken again from J. Pope-Hennessy's excellent and indispensable series of works on Italian sculpture.

The long history of the Font opens in May 1416, when the commission for the marble basin was entrusted to three sculptors, Sano di Matteo, Nanni di Jacopo da Lucca and Giacomo di Corso da Firenze. In July of this year Ghiberti was summoned to Siena in connection with the Font, and in December the Sienese sculptor Giovanni Turini visited him in Florence. In January 1417 Ghiberti again came to Siena, later despatching a specimen bronze cast from Florence for inspection by the Operaio. In March a representative from Siena again visited Ghiberti, and in April a model of the Font was prepared. It is clear from the documents relating to this phase of the construction of the Font that the decision to decorate the hexagonal basin with gilt bronze narrative reliefs was due in large part to Ghiberti. In April two of these reliefs were commissioned from the Sienese goldsmiths and sculptors Turino di Sano and Giovanni Turini . . . and two from Jacopo della Quercia. . . . In May Ghiberti, who again visited Siena, received the commission for the two remaining reliefs. . . . In 1423 the commission for one of the two reliefs allocated to Quercia . . . was transferred to Donatello. . . . At the corners of the basin are six niches containing gilt bronze statuettes of Virtues, of which the Hope and Faith are by Donatello . . . the Strength is by the goldsmith Goro di ser Neroccio . . . and the Charity, Justice, and Prudence are by Giovanni Turini[1]

The reliefs on medieval churches and Greek and Indian temples occupy fields provided by the structural or decorative parts of the buildings – walls, doorways, columns, friezes, and so on. The sculpture is in this respect subordinate to the architecture and the primary reasons for its existence are to enliven the surfaces of the building and to enhance its symbolic value. This is the most direct way in which architecture and relief sculpture have been associated. But they have also been very fruitfully associated in another way.

Architecture has provided many of the other arts, including sculpture, with a repertory of decorative forms which are derived

[1] *Italian Gothic Sculpture*, London, 1955, pp. 211–12.

from the components of buildings. Artifacts such as candlesticks, reliquaries, censers, picture and mirror frames, all kinds of furniture, musical instruments, and, in the early days of the Industrial Revolution, even steam engines and other kinds of machinery were conceived entirely or partly as architectural fantasies. Many complex works of art such as wall tombs, altars, tabernacles, fonts, and sarcophagi are combinations of architectural elements and figurative sculpture, including reliefs. When they come from the hands of a great sculptor these architectural and sculptural fantasies can be beautiful and highly imaginative. Some of the finest works of this kind were produced by Italian sculptors of the fifteenth century. The architectural components of these Renaissance works are of course Classical in origin. Some of the most outstanding works of this kind are by Donatello and

left
The Bruni Monument, by Bernardo Rossellino, begun 1444. Marble, 6.1 × 3.16m. S. Croce, Florence. *Mansell Collection*

right
The Marsuppini Monument, by Desiderio da Settignano, begun 1453. Marble, 6 × 3.58m. S. Croce, Florence. *Mansell Collection*

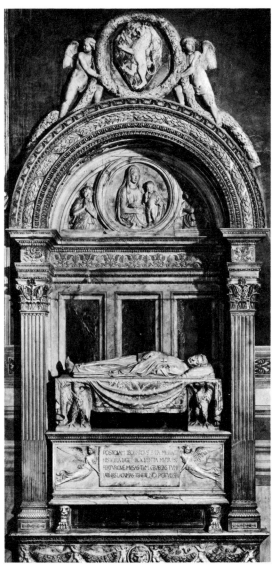

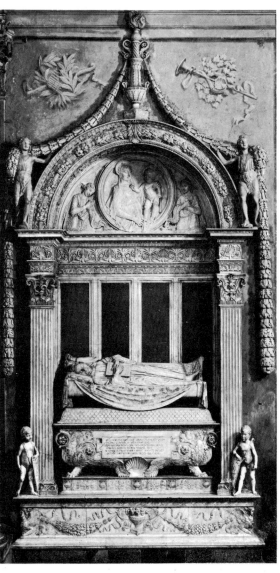

Michelozzo (the Brancacci Monument, S. Angelo a Nilo, Naples and the Monument of Pope John XXIII, Baptistery, Florence), Bernardo Rossellino (the Bruni Monument, S. Croce, Florence), Antonio Rossellino (the Tomb of the Cardinal of Portugal, S. Miniato, Florence), and Desiderio da Settignano (the Altar of the Sacrament, S. Lorenzo, Florence, and the Marsuppini Monument, S. Croce, Florence). In the proportions and arrangement of their architectural elements and the quality of their figurative and decorative sculpture, these are all beautiful and inventive works of art. Much may be gained by a comparison, part by part, of two basically similar works such as the Bruni and Marsuppini Monuments.

To pursue these larger aspects of relief composition any further would lead us into a discussion of the over-all design of an enormous range of complex works of art. Such an expansion of our subject could be most rewarding but it would divert too much attention from the central concern of this book, which is with the qualities of the relief sculpture itself. For the rest of this chapter, then, we shall discuss the internal organization, or composition, of the separable units of relief rather than their integration into larger structures. It is worth pointing out however that an interest in reliefs will almost certainly lead to an interest in the larger works of art with which they are associated.

PICTORIAL
COMPOSITION IN
RELIEFS

Because reliefs are presented in a plane, as pictures are, it is not surprising that almost every type of composition which exists in pictures exists also in reliefs and that throughout history the relations between the two arts has been very close, and their influence reciprocal. There is no important difference compositionally between the reliefs and paintings of Egypt. The drawings and paintings on Greek ceramics have a great deal in common with Greek reliefs. The composition of medieval miniatures and frescoes is closely paralleled in ivories, alabasters, tympana, altarpieces, and so on. The ordered plane-like character of Italian Renaissance art and the intricate recessive character of northern Renaissance art, which are so brilliantly discussed by Wölfflin,[1] are found alike in paintings and reliefs.

Pictorial composition is too vast a subject to discuss here in any detail. In the first place there are a great many widely different types, or categories, of composition. Then each of the individual works which falls within these larger categories has its own special compositional features. Moreover, each individual work is a complex structure which may be considered compositionally at a number of levels, from the larger-scale organization of its major divisions to the interrelationships among its minutest forms. The composition of great reliefs and pictures may be so rich and full

[1] Op. cit.

174

of subtleties that we perceive new relationships among their forms each time we look at them. This compositional richness is one of the reasons why we return again and again to certain masterpieces of painting and relief just as we return again and again to some of the complex masterpieces of symphonic or chamber music.

Many aspects of the pictorial composition of reliefs have already been touched upon in previous chapters. In particular we have discussed at some length the overriding necessity in figurative reliefs of presenting the subject clearly in the picture plane. We do not want to go over the same ground again. Nor do I wish to add to the copious literature about pictorial composition or to the vast numbers of analytical diagrams whose tangles of arrows and geometrical shapes make what is already complex enough appear even more so. All that I hope to do is to direct attention to the broad principles of organization which underlie some of the most common and historically important types of composition.

The shapes of the fields offered to the relief sculptor are greatly varied and sometimes they can be extremely awkward so that they tax the skill and ingenuity of the sculptor to the utmost. The problem of accommodating his design satisfactorily to the shape of the field is particularly acute when both the subject of the relief and the shape of the field are set. From the spectator's point of view it is fascinating to see how well and in what varied ways the problems of designing within a given shape have been solved by different sculptors. The fields offered by the capitals of medieval churches are often very similar or identical in shape and the subjects illustrated on them are often the same. As we become acquainted with more and more carved capitals we begin to make comparisons among the treatments of different artists. In this way we become more fully aware of the subtle ways in which the problems of designing within a set space have been solved. In a similar way we may compare the solutions of a number of sculptors to the problems of designing within the small circular field of a medal or a coin, or around the body of a pot or the drum of a font, or within such architectural fields as a lunette or a spandrel.

One of the most frequently remarked characteristics of a good composition is its 'inevitability'; the arrangement of its forms seems to be so 'right' that we cannot imagine how it could have been done in any other way. As a result of this we are likely to take the composition for granted, to accept it without scrutiny, and to rest content in our first impression of its unity of design and quality. But if we compare the solutions of various sculptors to the problems of designing within a similarly shaped field, we realize what differences are possible and we make ourselves more acutely aware of what has been achieved in each particular work.

We are often reminded nowadays, when generalizations of every kind are treated with suspicion, that each work of art is a unique individual. For some reason recognition of this fact has made some people distrust comparisons in art. It should not do so, since one of the main functions of such comparisons can be to bring out more strongly than before precisely what it is that constitutes the uniqueness of a particular work. The value of such comparisons as a means of increasing our awareness of composition, in particular, seems to me to be beyond question.

SYMMETRY AND ASYMMETRY

The human mind seems always to have been attracted to symmetry. Symmetrical arrangements appeal immediately and directly to our sense of order by uniting the parts of a composition in the most straightforward way so that their relationships may be easily grasped. They provide both the artist, while he is working, and the spectator, while he is looking, with an overriding principle of organization for the composition, a schematic framework within which its major parts and details fall into place.

The type of symmetry which is most widely used by artists and designers is bilateral symmetry, in which one side of a design is a reflection of the other. It is the type of symmetry which belongs to the human and most animal bodies and it is so familiar that in the minds of most people the term 'symmetry' is taken to mean bilateral symmetry. There are, however, other kinds of symmetry which are used in art and which occur in nature. The symmetry of the grid, or net, and radial symmetry are widely used, especially in decorative art.

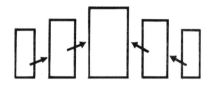

Fig. 22

While the human mind seems always to have had a craving for order and regularity it has also rejoiced in variation and diversity. Complete symmetry, the complete reflection or repetition of every element of a design, can be tiresome and is usually so static that it appears dead. This has been recognized by most artists, and few works of art are perfectly symmetrical. What we call a symmetrical composition is usually one in which the *over-all* organization of the main forms is governed by the principles of symmetry while many of the individual forms themselves and the details of their arrangement are not. The composition is only symmetrical generally, so to speak.

The tympana from Ely, Chartres, and Autun which are illus- 114, trated in this book are all compositions which are symmetrical 116 in fundamentally the same way. It is an arrangement which is widely used in hieratic works of art and it goes back at least 5000 years in the art of the Near East. Each of the three tympana is, however, symmetrical in a different degree.

In all three tympana the figure of Christ is the largest and most dominant part of the composition. It also occupies a central

position, is placed within the frame of a symmetrical mandorla, and is itself bi-symmetrical in its main forms. The bi-symmetry, however, does not extend to all its details and minor forms. The arrangement of the folds of drapery is different on the two halves of all three Christs, and the positions of the left and right arms are different in both the Ely and the Chartres Christs. Such strictly symmetrical arrangements of the major forms diversified by variations of superficial detail and minor forms are typical features of hieratic sculpture.

When we turn to the forms on either side of the mandorlas we notice that their degree of symmetry varies in all three compositions. The two angels supporting the mandorla at Ely are pretty well identical in every respect. The two pairs of symbols of the evangelists on either side of the Chartres tympanum are similar in many respects, but far from identical. The two lower symbols are similar in size and pose, but there the resemblance stops. They have the characters of different animals, their heads are differently posed, one has texture on its body while the other has not, and so on. The two upper symbols are similar in size and in the general direction of their forms, but they differ in almost every other respect. In the Autun tympanum the conformity of one side with the other is limited to the general scale and arrangement of the groups of figures. Much of the liveliness of the composition of this tympanum is due to the variety of its smaller forms.

What we call asymmetry is in many compositions not so much a total absence of symmetry as a departure from it. Oriental pottery, for example, is often praised for its asymmetry, but this does not mean that it is completely irregular like a flint. It implies rather a relaxed attitude towards symmetry. The pots are basically symmetrical but not rigidly so. In many reliefs the arrangement of forms is in principle symmetrical in the sense that an underlying symmetrical scaffolding is implied. The artist has had a bi-symmetrical schema in mind while working but has allowed his composition to develop away from it in the direction of asymmetry. If we take a fundamentally symmetrical composition like any of the tympana we have just been discussing and introduce more and more irregularity into its forms and their arrangement, we shall eventually arrive at a point at which we will say that the composition is asymmetrical rather than symmetrical. Such asymmetry is a matter of degree.

The composition of Riccio's panel *The Sickness of Della Torre* 178 goes a long way towards asymmetry but we can still sense that the fundamental scheme of the composition is a symmetrical one. The concept of bilateral symmetry, of equally weighted and similarly disposed elements arranged on either side of a central axis, controls the over-all organization of the composition. There

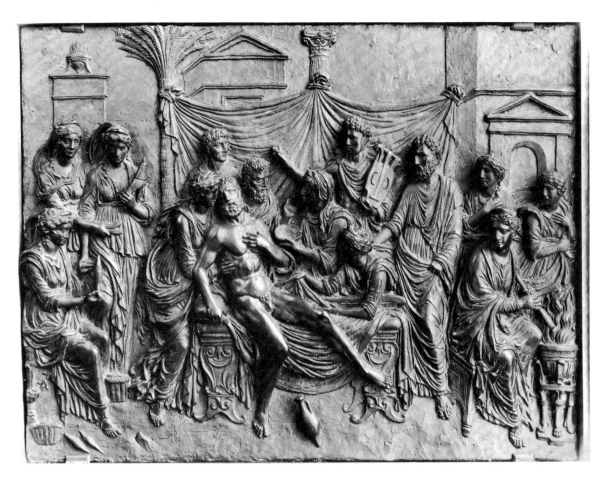

The Sickness of Della Torre, by Riccio, 1516–21. Bronze, 37 × 49cm. The Louvre

are three major divisions in the composition. First there is the main central group of figures gathered around the figure of Della Torre. This group is placed within the frame of a rectangle largely defined by the strange curtain which hangs between the tree on the left and the building on the right. This central group is flanked by two groups of three figures, in the wings so to speak, turned towards the centre. Each of these side groups is made up of two standing and one seated figure, but the poses of the corresponding figures on either side are quite different. Although the most important central group of figures is contained within a rectangular symmetrical frame, it is not in itself at all symmetrical. The psychological centre of the relief, the figure of Della Torre, is well to the left and all the action and interest is concentrated towards him.

The character of this composition of Riccio's may be brought out more strongly if we compare it with one of Ghiberti's panels. The composition of Ghiberti's *King Solomon and the Queen of Sheba* 53 is almost completely symmetrical, especially in the arrangement of its architectural background and the grouping of its figures. The departures from symmetry occur in the details. The buildings

178

on the extreme left and right and the individual figures which make up the more or less symmetrically disposed main groups on either side of the relief are far from identical. There are many features common to the two reliefs, and there are important differences. Much may be gained by comparing them closely. There is of course a much greater degree of asymmetry in Riccio's composition.

There is another kind of asymmetry which is not a matter of degree but is absolute. The idea of symmetry has never entered into it and it is asymmetrical in principle, from the beginning. Unlike the Solomon panel, which is rather exceptional, most of Ghiberti's reliefs for the *Gates of Paradise* are like this. Such reliefs are not disordered or lacking in unity. They are organized and unified by principles other than the principles of symmetry.

OVER-ALL COMPOSITIONS

Fig. 23

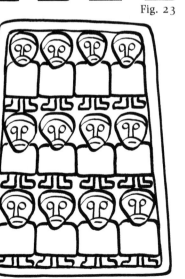

Fig. 24

One of the most common ways of organizing the forms of a relief within the shape of its field is to spread them more or less evenly over the whole area. This may be done in several different ways. One is to organize the forms in a strictly disciplined manner to make a regular and repetitive pattern, as in the delightful panel of the Twelve Apostles on the great Irish Cross of Moone, and the rather less strictly organized panel from San Domingo. Or the forms may be densely packed together into an irregular space-filling mass, as in many of the panels from the stupas of Sanchi and Amaravati, some of the panels of the Pisani's pulpits, and the violently agitated Roman Battle sarcophagi. Or they may be loosely but more or less evenly scattered over the whole area, as in many Egyptian and Assyrian compositions.

At a time when every kind of art outside the Graeco-Roman and post-medieval Western traditions was regarded by cultured people in the West as primitive, the tendency to occupy every part of a surface with forms was often ascribed to 'horror vacui', a fear of empty space, which was believed to be part of the psychological make-up of primitive peoples. I would think it more probable that these over-all space-filling types of composition have their roots in something far more positive – the impulse to decorate. They can certainly be extremely decorative. If we ignore the representational significance of most of them, we may see them as all-over patterns of line and texture, or light and shade, or hollows and bosses. By filling the whole area of the field with pattern they emphasize its shape and enhance its value as a decorative unit. Many purely ornamental, non-figurative reliefs have this over-all quality. But it can also be combined with movement and used with great dramatic power, as in G. Pisano's marvellous panel of *The Massacre of the Innocents*.

30

29

Another basic scheme for relief compositions which has been widely used through history is that of serial repetition. In reliefs of this kind a single compositional unit or motif is repeated a number of times, usually with minor variations, to form a rhythmical series. Henri Focillon gave the name *l'homme arcade* to one of the most important and widespread of these compositional schemes. The basic unit of *l'homme arcade* is a figure occupying an aedicule, or niche, that is an enclosed space between columns or pilasters which is roofed by an entablature, arch, or pediment. A linked series of these units becomes a continuous colonnade or arcade with figures between the columns. The scheme is an example of the association of architectural motifs and figures which we discussed a few pages ago.

This method of dividing up the field of a relief is first encountered in a Greek sarcophagus from the middle of the fourth century B.C., known as the sarcophagus of the Mourning Women. It is an example of what Panofsky[1] has called a 'domatomorphic'

Fig. 25

Fig. 26

Fig. 27 From the sarcophagus of the Mourning Women, *c.* 350 B.C. Marble, H. 71 in. From Sidon. In the Archaeological Museum, Istanbul

(house-shaped) sarcophagus – a miniature building which is a dwelling for the dead. In this instance the sarcophagus is a scaled-down model of a Greek architectural monument such as the Tomb of the Nereids. The basic unit of its relief decoration is a draped female mourning figure in an intercolumnar space. This motif is repeated eighteen times round the sarcophagus. The danger of monotony has been avoided by variations in the poses and attitudes of grief of the figures. Some of them are standing, others are half seated on the parapet that runs along behind them; some turn to the right, others to the left; and the position of the arms, the fall of the drapery, the set of the head, and many other features are different in each figure. Here again, as in so many compositions,

[1] E. Panofsky, *Tomb Sculpture*, London, 1964.

The sarcophagus of Melfi,
c. 170. Marble, 1.66 × 1.24m.
*Istituto Archaeologico
Germanico, Rome*

we find the principle of an underlying similarity with variations of detail. This type of composition:

was ultimately to develop into the truly spectacular scheme known as the 'Asiatic' or (after the two splendid specimens preserved respectively in the town hall of a small South Italian city and the Museum at Constantinople) the 'Melfi' or 'Sidamara' type, where six colonnettes organize the front wall, after the fashion of a *scaenae frons*, into a rhythmical succession of five units: a niche framed by an arched aedicula on either side, and two flat, lintelled spaces in between.[1]

In later Roman, especially Early Christian, sarcophagi this basic type of composition was developed in a number of directions. In some instances a second row of figures and columns was superimposed on the first, giving a two-tiered composition. In others the isolation of the figures in the intercolumnar spaces was broken down by causing the columns to retreat into the background and linking the figures into a more frieze-like continuous composition. In others again the single figures of the earlier sarcophagi were replaced by groups and the space was converted into a small stage setting for the enactment of scenes from the Bible.

Because the unit motif of *l'homme arcade* may be repeated any number of times it is an extremely adaptable form of relief decoration. It lends itself particularly well to the decoration of long

[1] Ibid., pp. 25–6.

181

horizontal rectangular fields such as altar fronts, lintels, and, of course, sarcophagi. And it is ideal for decorating drum-shaped objects such as fonts, capitals, *situlae* (ritual buckets), and other vessels. *L'homme arcade* is used in many Early Christian ivories, including several of the most well known, such as the front panels of the Throne of Maximian and the beautiful Carolingian ivory book-covers from the Lorsch Gospels. It is also found in the East, in the reliefs of Gandhara. During the Middle Ages it was one of the most widely used of all compositional schemes.

Ivory cover from the Lorsch Gospels, 1st half of 9th century. 0.38 × 0.27m. *Victoria and Albert Museum, London: Crown Copyright*

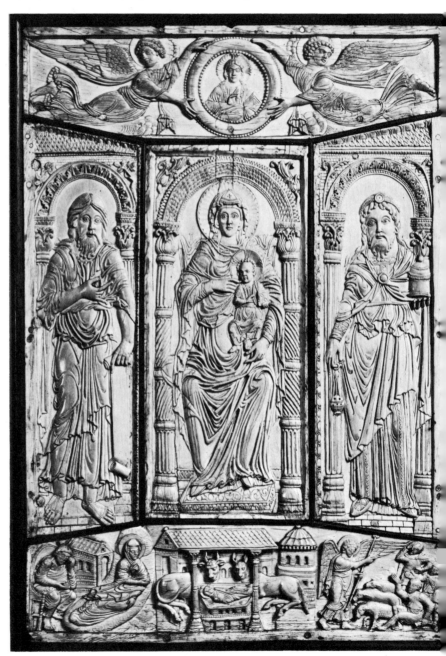

The unity of composition in a relief panel, as in a picture, may
depend primarily on either the stability and balance or the move-
ment of its forms. Both movement and stability are essential in
some degree to all compositions. They are interdependent, like
the rigidity of the skeleton and the mobility of the flesh of the
human body. The metaphor which speaks of the *bones* of a com-
position is apt even if it has become somewhat blunted through
over use. Some styles of art push one or other of these aspects of
composition to the limit. The restless interlacings of Barbaric
ornament, creeping like a jungle growth over the whole surface
of an object, and the lifeless rigidity of some ancient Near Eastern
hieratic reliefs, probably represent the two extremes.

There are a number of features which may contribute to the
stability of a relief composition – the presence of vertical and
horizontal lines and forms, for example – but here we shall be
concerned with only one of them, although it is perhaps the most
important: the balance of masses.

The masses in symmetrical compositions are balanced in the
simplest and most obvious way, by making one side of the com-
position the same, or nearly the same, as the other. Asymmetrical
compositions aim at something more subtle and difficult to achieve
or appreciate, namely a balanced arrangement of unequal masses.

Most people have a feeling for visual weight and balance which
enables them to go beyond strict symmetry and to appreciate and
create arrangements of things which are balanced without being
symmetrical. It is this feeling which makes us satisfied or dis-
satisfied with the positioning of windows and doors within the
shape of the elevation of a building, or with the layout of illustra-
tions and type within the pages of a book, or with the arrange-
ment of pictures on a wall or ornaments on a shelf. The weight
of one mass in relation to another, the positioning of the main
masses within the shape of the field, the distance between one
mass and another and between the masses and the edges of the
frame or support, are all important features of composition in
both pictures and relief panels. The balancing of masses is not
quite the same in a relief panel, however, as it is in a picture. It
is not just a matter of relationships on a picture surface or in a
notional picture space; there is the actual third dimension, the
actual projection and weight of the forms, to be taken into account
as well. The composition of a relief may be easily upset if the pro-
jection of its forms in different areas of the field is not carefully
considered. One area may loom out at us and throw the com-
position off balance, or it may become overweighted by shadows
which are darker than those in other parts of the composition.
For we must bear in mind that the composition of a relief as we
see it is not entirely the work of the artist in quite the same way
as the composition of a painting. It may be greatly affected by

lighting. As we have already seen, there are many aspects of the lighting of reliefs which the sculptor may predetermine by his treatment of the forms; but his control is limited. The forms themselves may be constant but the visual effect of a relief composition may change greatly in different intensities and directions of lighting. This is something which everyone who has ever tried to photograph a relief will be vividly aware of.

We say that a composition is full of movement when its forms keep our attention on the move by directing it from one part of the composition to another. Creating movement in a composition is not simply a matter of representing things which are moving — dancing satyrs, windswept draperies, galloping horses, and so on — although this may be an important part of what the artist is trying to do. Of course a picture or a relief cannot really depict movement as such; it can only show us one image of a thing in motion, one moment in a continuing process. And this alone will not necessarily convey a vivid feeling or impression of movement. The forms must not only represent something moving but must also be made to *express* movement. They may do this through their own expressive character or through their expressive relations with other forms in the composition.

We attribute mobility to shapes and lines independently of what they represent. Spirals and undulating ogival curves, for example, are dynamic forms in themselves; they express movement in their own character whether they represent anything or not. And when an artist does represent something which is moving — dancing satyrs, flying angels, galloping horses, etc. — he usually reinforces any idea of movement that comes from the subject by also expressing mobility in the character of the shapes and lines themselves.

It is possible to arrange the forms of a relief in such a way that they link up with each other and create elaborate movements within the composition. These linkages are of two main kinds. First, they may be purely two-dimensional connections across the picture plane which bear no relation to any represented or actual links between forms in three-dimensional space. Such connections keep our attention moving over the plane of a relief just as in a picture they keep it moving over the picture surface. On the other hand there may be connections in depth which in some instances may even add up to continuous chain-like movements which keep our attention moving in three-dimensional space. In low reliefs such movements take place in what is primarily a notional picture space, but in high reliefs they may be actually three-dimensional.

Our attention is directed around a composition by lines — outlines and interior lines — and by the surfaces and the axial movement of forms. The quality of movement may be swirling, as in many Baroque reliefs; or angular and jagged, full of abrupt

Fig. 28

God Calls Adam to Account, by Bishop Bernward, 1015. $21\frac{1}{2} \times 37\frac{1}{2}$in. A panel from the bronze doors of Hildesheim Cathedral. *Bildarchiv Foto Marburg*

184

changes of direction, as in many Late Gothic reliefs; or smooth and continuous, with long slow curves; or complex and knotted. Sometimes these movements add up to a complex system of rhythms and counter-rhythms, sometimes the whole composition is caught up in one great rhythmic surge which runs through all its forms.

Movement may be created in a composition by psychological as well as formal means. We have an almost irresistible urge to follow the direction of somebody's glance or gaze, and if a figure in a composition is looking in a certain direction we naturally follow and look the same way. Gestures like pointing are similarly compelling. Both looks and gestures can carry our attention over large spaces and establish links between widely disconnected parts of a composition. A particularly powerful and direct example of this occurs in the dramatic panel, *God Calls Adam to Account*, from Bishop Bernward's bronze doors at Hildesheim, the first pair of medieval bronze doors to be decorated with figurative reliefs. The angry accusing figure of God is looking intently and pointing towards a cringing, shamefaced Adam, who cannot look God in the face and is pointing to Eve and passing the blame to her. She in her turn is looking back at God and pointing to the serpent. The effect of these looks and gestures is to carry our attention back and forth across large empty areas which then become a field of action charged with dramatic tensions. This psychological effect is reinforced by the directional character of the forms themselves: the strong diagonal that connects God's head via Adam's to Eve's (*a* in Fig. 29); the arrow-like bends in the bodies of Adam and Eve (*b* and *c*) and the subsidiary angles of Adam's

Fig. 29

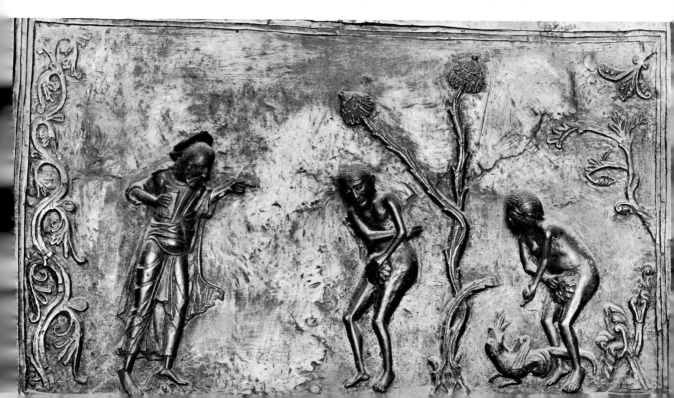

left arm (*d*) and the tree branch (*e*); the drawing away of these bent forms from the taut, straight, advancing figure of God; and many other features which the reader will no doubt discover for himself.

Fig. 30

Sepulchral monument of
Hegeso, late 5th century B.C.
Marble, 149 × 95cm.
National Museum, Athens.
Hirmer Fotoarchiv München

Dramatic and narrative compositions usually have a point of focus in their representational meaning which also becomes a point of focus for the movement and arrangement of their forms. The organization of forms and the organization of meaning coincide, so to speak. This unity of form and meaning is essential to most representational works of art and its existence invalidates all attempts to consider representational works as though they were abstract ones, that is as though their content did not matter. Compositions with a strong centre of interest may lead us to explore them in many directions but our attention is constantly brought back by various psychological and formal means to their centre. It should go without saying that the centre of interest need not be the geometric or even the optical centre of a composition, although it sometimes is.

The composition of the Hegeso stele is strongly centred on the hands of Hegeso, who is holding a necklace which she has just taken from the casket held by her maidservant. The necklace itself, which was painted, has long since disappeared. As in most Greek relief compositions, the two figures are turned away from the frame towards the centre, and they are arranged in such a way that they create a large space in the middle of the upper half of the panel. The centre of interest is at the bottom of this space, in the geometrical centre of the whole relief. Both halves of the composition are linked together by a powerful 'U'-shaped movement which runs along the arms of both figures and across the casket. This is reinforced by the movement of surfaces and lines in the upper parts of the two bodies and is echoed by the lines of the other arms and the drapery, which are carved in shallow relief on the back plane. All this creates a large cup-shaped hollow in the top half of the panel which surrounds and contains the centre of interest. We are constantly brought back to this centre by the movement of lines, surfaces, and forms, but the most powerful effect on us is produced by the heads. They terminate the upward movement of the two figures and redirect our attention forcibly across the central space towards the necklace at which the two young women are looking. What more gently human reminder of the tragedy of young death could there be than this quiet, sadly beautiful scene of everyday life?

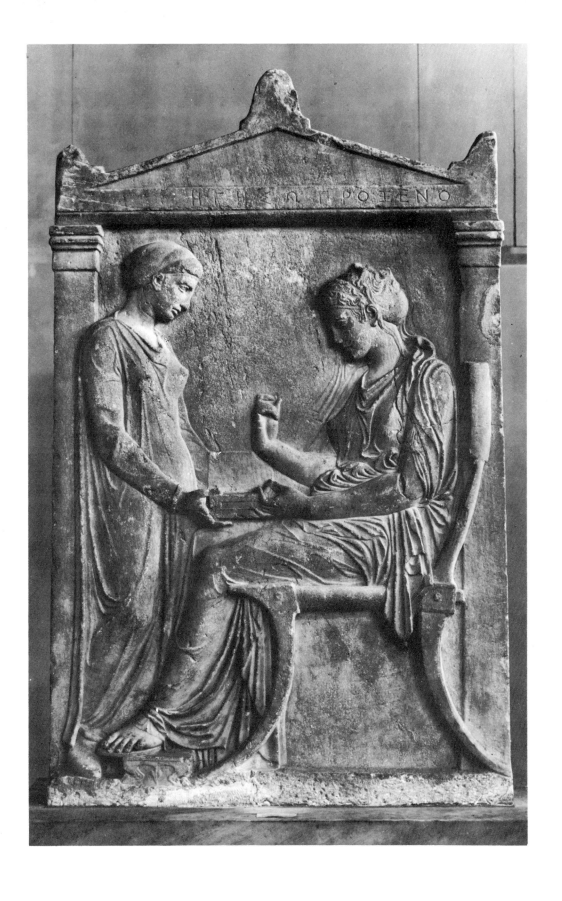

CHAPTER 9 Coins and Medals

COINS Perhaps the most familiar of all works of art are the miniature two-sided reliefs which everyone carries in his pocket or purse. Reproduced as they are in their millions, the designs on coins have a circulation which no other kind of artwork can begin to rival. Yet although we all handle them several times a day, how many people ever pause to consider them as examples of relief modelling or to wonder why they are designed as they are or what their history is?

The first coins as we know them were produced in Asia Minor in the seventh or eighth century B.C. From there the practice of coining spread to the rest of the Greek world, then to Rome and the whole of the Roman empire, and then to the medieval world. Nowadays coins are the accepted medium of exchange in all civilized parts of the world. Their variety is enormous.

Coins form a special study in themselves. Together with medals they constitute the subject-matter of the science of numismatics. For the historian they are of inestimable value. They provide evidence for the spread of cultures and empires and for the dates of important events, they provide portraits of historically important people whose features would otherwise be completely unknown, and they are a valuable record of the development of artistic styles. We are, of course, primarily concerned with coins as examples of the art of relief sculpture on a miniature scale.

A coin usually has a design in relief on both sides. The numismatic term for the sides of a coin are: the *obverse*, which is the side bearing the principal design, usually a head; and the *reverse*, which is the back or 'tail'. The relief designs themselves are referred to as *types*. The first coins were stamped with a device or figure on only one side, but somewhere around 566 B.C. the ruler of Athens, Peisistratus, had coins produced with a type on both sides. On the reverse he put an owl, the symbol of Athens, and on the obverse he put a head of Athene, the patron goddess of Athens. In doing this he started a practice which has lasted some two and a half thousand years, for pretty well every coin which has been produced since then has been imprinted with the head of a god, a ruler, or other important person on its obverse and with a symbolic device of some kind related to the city or state on its reverse. Greeks in other cities put representations of other gods – Dionysus, Apollo, Aphrodite, Hermes, etc. – on the obverses of their coins. It was only a matter of time before the value of coins as an instrument of political propaganda was realized and the obverse was stamped with a portrait of the ruler and the reverse with a device and legend of political significance. This aspect of

Coin from Athens under Peisistratus, *c.* 566. 4dr., reverse, an owl; obverse, Athene. *The Trustees of the British Museum, London*

188

coins, as one might expect, was fully exploited by the Romans.

In order to appreciate the coins of both the past and the present it is necessary to know something about the ways in which they were and are made and something of the constraints which are imposed on the coin artist by the process of manufacture and the functions which coins are required to fulfil.

The process of producing coins by striking has not changed in principle since they were first made. It is true a few coins have been produced by casting, that is by pouring molten metal into a mould, and by other processes, but these were nowhere near as successful as *striking*, and we may ignore them. For striking a coin two main things are required: a plain metal disk, known as a *blank* or a *flan*, and a pair of dies, one for the obverse and one for the reverse, into which the coin types have been carved in intaglio. The blank, heated to make it more plastic, is placed between the two dies. Then by means of a hammer blow on the upper die, or by some kind of mechanical pressure, the metal of the blank is squeezed into the intaglio designs on the dies. Thus both sides of the coin are stamped with designs in relief. Nowadays of course this is all done at a high speed by minting machinery, but it used to be done entirely by hand.

The process of striking imposes severe limitations on the kind of relief which can be achieved. First of all it limits the degree of projection of the forms. To attempt to force the metal into a too deeply hollowed-out die would be to court failure, particularly in hammered coins. And secondly, because the die has to be withdrawn from the imprinted coin there can be no undercutting. The forms of the relief must meet the background at an open angle and all the contours of the relief must be on the plane of the background.

One of the main requirements of modern coinage is that every coin in an issue should be identical in shape, size, and weight. When coins were first made in precious metals it was most important for them to be identical in weight, since this affected their real value. The blanks were therefore carefully adjusted to the right weight. Size and shape, however, which were very difficult to control, were not as critical as weight and they varied a good deal. Striking coins by hand was a somewhat hit and miss procedure. The coin blank was not to start with a perfect shape and the punch into which the upper die was cut would often not be placed in the centre of the blank when it was struck with the hammer. Moreover the blank would spread out unevenly under the force of the blow. As a result of all this ancient coins are much more irregular than modern ones.

Another important requirement of modern coins is that they should stack easily into neat, secure piles. This is one reason why they have a raised border of even height all round their perimeter

and why their relief designs are flat, even and level with the border. We should not forget too that the coins of today have to suffer the indignity of being put into slot machines, which is another reason why they must be perfectly alike and of an even thickness. No such requirements restricted the modelling on ancient coins and the relief on them tends to be somewhat bolder, more rounded, and altogether more irregular.

From an aesthetic point of view the most important aspect of coinage is the design and execution of the reliefs on its two sides. Until recent times these designs were carved in intaglio directly into the face of a metal die by a coin engraver. This was difficult work. Not only is the material hard and intractable and the scale of work almost impossibly small, but the whole design has to be cut as a negative form and in reverse. Even with a positive model as a pattern and the possibility of taking pressings constantly in some plastic material as a check on the progress of the work, it still calls for a high degree of skill.

The majority of coin engravers were simply craftsmen who more or less competently produced something which was merely useful; but some were artists of the first quality who were able to use the processes of coining as a means of producing superb miniature works of relief sculpture. Fine coins have been produced in many parts of the world but it seems to be universally acknowledged by those who are interested in coins as works of art that not only did the ancient Greek world invent coinage as we know it but it also produced coins whose beauty has never been equalled, let alone surpassed. Some of these Greek coin artists even signed their work, thus enabling us to assign a few masterpieces of coinage to such artists as Cimon, Euainetos, Theodotos, Myron, Polykrates, Herakleidas, and Eukleidas.

Coin types are a rather special category of reliefs and there are a number of special features which may be looked for and admired in both their design and execution.

Perhaps the most obvious of these is the adaptation of the head and lettering, if there is any, on the obverse, and the heraldic device or other symbol and lettering on the reverse, so that they create a satisfactory composition within a circular field.

Secondly we may notice the suitability of the treatment of the forms of the relief to the small scale of the coin. Reducing the complex planes and details of a human head or the complexities of a chariot drawn by four horses so that they fit into a circle which is less than one and a half inches in diameter is a difficult exercise in simplification. It is not just a matter of deciding what to leave out but also one of breadth of modelling, of the fusion of detail and small planes into a bold and expressive image. A comparison of the treatment of the relief in the Syracusan coins I have chosen for illustration, two by unknown masters and

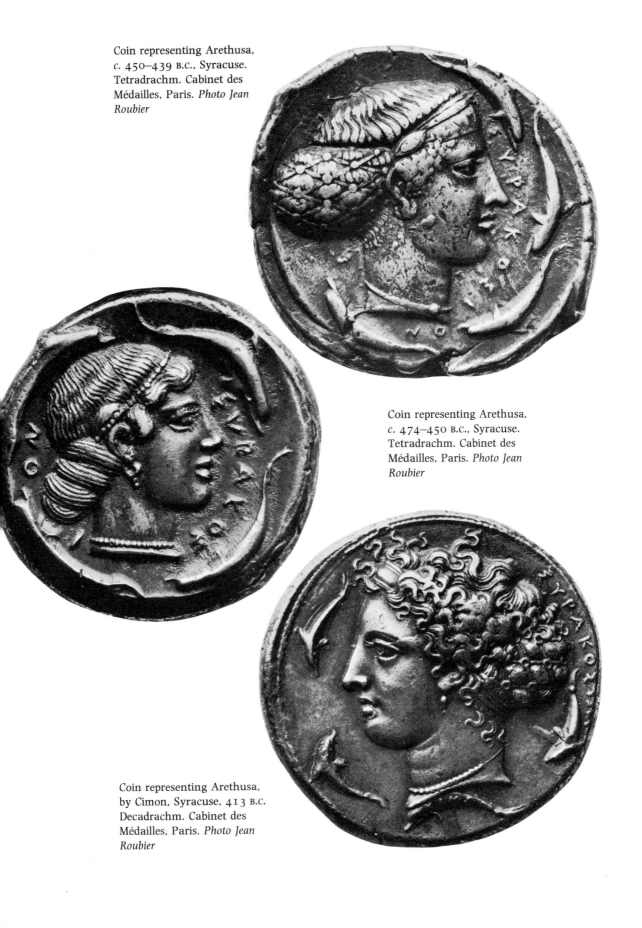

Coin representing Arethusa,
c. 450–439 B.C., Syracuse.
Tetradrachm. Cabinet des
Médailles, Paris. *Photo Jean
Roubier*

Coin representing Arethusa,
c. 474–450 B.C., Syracuse.
Tetradrachm. Cabinet des
Médailles, Paris. *Photo Jean
Roubier*

Coin representing Arethusa,
by Cimon, Syracuse, 413 B.C.
Decadrachm. Cabinet des
Médailles, Paris. *Photo Jean
Roubier*

one by Cimon, gives a fascinating insight into the range of form and expression which may be achieved in a coin-sized relief. These Syracusan coins are among the most beautiful ever produced in the whole history of coining.

Breadth of modelling is seldom found in modern mechanically produced coins. There are many reasons for this but the main one is that the coin types are no longer cut directly into the dies. They are modelled several times larger than the coin will be and are then cast and reduced by means of a machine working on the principle of the pantograph. The dies themselves are then produced from this reduced version of the original model. While such a process avoids the strain of working on a minute scale, it tends to encourage the inclusion of detailed modelling and a lack of breadth which is not appropriate to the small scale of the finished coin. One of the last coin types to be directly engraved was the famous *St. George and the Dragon* by Pistrucci. It first appeared in 1817 and was used repeatedly on British coinage for over a hundred years. It is a fine relief, full of energy, highly plastic, and perfectly adapted to a circular field.

The quality of the modelling of the relief itself is an outstanding feature of many coins. It is amazing what richly tactile and organic forms some coin artists have been able to create within

St. George and the Dragon, design for British coinage by Pistrucci, 1817. *The Trustees of the British Museum, London*

such a shallow depth of relief, especially when we bear in mind that this was done by carving directly into a metal die.

The tactility of coins may be enhanced by age. Coins are not works of art which are put in a frame or on a pedestal to be merely looked at. They are carried about in purses and pockets where they rub against each other, and they are handled and slid across table tops and counters with the result that the high points of their surfaces, their sharp edges and ridges and other prominences are softened and then rubbed smooth. Ultimately of course the whole type can disappear. Moreover, with age the surfaces of most coins change their colour in ways that are an improvement on their freshly minted appearance. The uppermost layers are polished bright while the areas around the outlines of the forms and the hollower parts of the relief become dull and oxided. The effects of this are particularly attractive on copper coins. The rich black-brown at the recessed surfaces and the shining bright copper high points on a Victorian penny are a well known instance of this. Old silver coins, too, acquire a certain softness of surface and subtle colour differences. These are of course features not only of coins but of many other metal objects. One of the most delightful characteristics of sculptural bronzes and old silver are the polished highlights and oxidized depths which they acquire through repeated polishing over many years. Within certain limits this kind of ageing and wear can greatly improve the visual appearance and tactual qualities of coins, although of course most collectors prefer to have a coin which is in 'mint condition'.

We have already said that the heads on many coins are portraits. If so, then the head may be considered as an example of the art of portraiture and we may look at it as we would look at any portrait to see whether it conveys a convincing and lively impression of the character of a living individual person. Many Roman and Hellenistic coins do this brilliantly. We feel that the heads are not merely stereotypes of imperial power but that they catch something of the human (or inhuman!) qualities of their subject, and are really taken from life. Usually, however, the portraits of rulers on coins are more idealized than other official portraits. The symbolic and propaganda functions of coins required this.

There are hardly any mechanically produced coins which deserve consideration in a book of this kind. This is not so much owing to the inadequacy of the artists as to the way in which they are required to work in order to satisfy the requirements of modern methods of production and the standards of precision and mechanical perfection which are now, alas, universal. In the circumstances it is surprising that some artists can produce even reasonably good work.

The principal difference between coins and medals is a functional one: whereas coins are intended to be used as currency, with all that that entails in the way of handling, stacking, and so forth, medals are made in order to commemorate a person or an event, or to serve as an award for bravery, service, or the like. We shall be concerned here only with commemorative medals, since it is among these that the outstanding works of medallic art are to be found.

There are some ancient coins which have a commemorative function as well as monetary value. The demareteions of Syracuse, for example, were struck in order to commemorate the victory of Syracuse over the Carthaginians. These and other ancient medal-like objects, together with some medieval medals which are of no great artistic value, are precursors of the great Renaissance medals, but the history of the medal as a work of art in its own right begins in the Italy of the early Renaissance with the work of one man, Antonio Pisano, usually known as Pisanello. Besides being 'the greatest medallist of this or any age' this extraordinarily imaginative artist was also a great painter and draughtsman. His work, like that of some of his contemporaries, including Ghiberti, bridges the gap between the medieval and Renaissance worlds. His paintings display a richly glowing poetic fantasy which is characteristic of a great deal of late medieval courtly painting and he is usually regarded as a leading exponent of the international Gothic style. His portrait medals, however, with their emphasis on the individual character of the sitter and their Classical and humanist overtones, were the first in a genre which is one of the most characteristic manifestations of the Italian Renaissance spirit. He cast his first medal in 1439 to commemorate the visit to Italy of the Byzantine emperor John VIII Palaeologus. It was an immediate success and was followed during the next ten years of Pisanello's life by numerous others. These were not only the first of their kind but, in the opinion of all who care about medals as works of art, they are also the finest ever produced.

Because medals are not used in the ways that coins are, but are intended primarily to be looked at, they are not subject to the same restrictions in their design. They may be more freely and boldly modelled than coins and are usually larger. Pisanello's medals, for example, have diameters which range between about $2\frac{1}{2}$ and $4\frac{1}{4}$ inches; Pilon's are larger than this. (The term 'medallion' is sometimes used in place of 'medal' for these extra large works.) Nevertheless, medals are reproduced in quantities from the same mould, as coins are, and this affects the nature of their relief much as it does the relief on coins. They must be modelled without undercutting and with all their receding surfaces at an angle which enables them to be easily withdrawn from the mould. A profile portrait, for instance, cannot be modelled beyond the median

Cecilia Gonzaga medal, by
Pisanello, 1447. Obverse and
reverse. Metal, 88mm.
Museo Nazionale, Florence.
Mansell Collection

plane of the head and all external contours must meet the background at an open angle. The interior modelling of the features of the face and of drapery and hair is also affected in a characteristic way. Undercut folds and deeply hollowed-out spaces between locks of hair are out of the question and the design of the ear, nose, and eye must be carefully thought out so that there is superposition of planes but no undercutting. The hollows and receding surfaces of the ruff which Pilon's Catherine de Medici is 91 wearing have been brilliantly adapted to suit the process of medal casting. If we consider what a fabric ruff is really like and then look carefully at Pilon's rhythmically alternating convex and concave curved surfaces, we may appreciate the difficulties involved and the artistry of his solution.

It is the necessity of accommodating the design of the relief to the process of manufacture which gives medals and coins their characteristic continuity of surface and compactness of modelling. Receding surfaces which step down from one plane of modelling to another are always visible, always, so to speak, out in the open; we never lose sight of any part of the surface and our eye passes from one part of the relief to another without any interruption and without being led round behind the forms or into gaps between them.

Pisanello's medals and those of most of his followers were not engraved directly into metal dies and then reproduced by striking, as coins are, but were made by one of the standard methods of producing sculptural bronzes. The essential stages in this process are: the modelling of the medal in wax, the making of a heat-proof mould from this model, and the casting of the

final metal version in the mould. The use of a plastic material for the first model encourages a softness and plasticity in the forms. Pisanello exploited this quality superbly. The modelling of the dream-like allegorical scene on the reverse of his Cecilia Gonzaga medal has a fluent plasticity and softness which is ideally suited to the reflective properties of the metal surface. It bathes the forms in atmospheric light. The drapery, flesh, and hair of the lovely remote female figure, the barren rocky landscape, and the shaggy unicorn are all differentiated by the treatment of their modelling but they are all blended into a plastically continuous, almost painterly surface. The features, hair, and costume of Cecilia herself on the obverse have a similar softness and plasticity but here the surfaces are more broadly modelled, less rippling and larger than those on the reverse, and line is of paramount importance. I have already stressed the importance of drawing as a component of low reliefs and it is no mere coincidence that Pisanello was a draughtsman of the first rank as well as a great medallist. The linear design of the portrait of Cecilia, with its taut straight lines and subtle balance of convex and concave curved lines could only be achieved by a master draughtsman.

It is interesting to compare the treatment that Pisanello has used to interpret the character of this young girl with his treatment of some of his male sitters, for example Lionello d'Este and Filippo Maria Visconti, or with the harder, more detailed, more literal, and less poetic modelling of Pilon's Catherine de Medici.

Many other outstanding medallists followed Pisanello in Italy, among them Mateo de Pasti and Sperandio, and the art of medal making spread from Italy to the rest of Europe. Between 1439 and the end of the sixteenth century an enormous wealth of medals was produced and most large museums contain a collection of some kind. Germany in particular produced some excellent medallists.

RELIEF AS ORNAMENT

Relief is a fundamental technique of ornament which has been used in every age, in most parts of the world, and at every level of civilization. As we saw earlier, there are only three ways in which a figure or decoration may be related to a ground: it may be sunk below it (intaglio), lie flat on it (painting, drawing, etc.), or be raised above it (relief). Relief ornament is usually incorporated into the structure of the object it decorates, so that it becomes an intrinsic part of its material and form. It is thus a natural extension of the craft of the mason, silversmith, bronzeworker, or wood-worker; an elaboration of the object which can become part of the process of fashioning the object itself, rather than an after-thought. Moreover, it is an extremely durable kind of decoration.

The source of the decorativeness of relief ornament is the reaction of light to the projection and recession of surfaces. This creates highlights and shadows and intermediary gradations of tone which may be valuable in themselves as patterns and may also reveal the rhythmic movements and interplay in three dimensions of surfaces and solid forms.

It is not possible to draw a hard and fast line between ornamental and other kinds of relief. Dichotomies such as decorative or ornamental relief, on the one hand, and representational, figurative, or fine art reliefs, on the other, are by no means clear cut. In the first place reliefs are not so single-purposed as to be simply either decorative or something else. Almost all reliefs serve a decorative function. They enhance the appearance of a building, implement, utensil, or the like, and may thus be regarded as decorative in some sense, whatever else they may be. From an architect's point of view the sculpture of Chartres and Autun is part of the decoration of the cathedrals. Nor can we distinguish on the grounds of representation. There are a great many reliefs which are both highly decorative and representational, even naturalistic. The leaves, flowers, birds, and animals of a good deal of Gothic ornament, for example, are extremely naturalistic. Then again we cannot base a distinction solely on the presence or lack of human figures in a relief. The human figure has served as a subject for decoration in the same way as plants and animals. What could be more decorative than the treatment and arrange-ment of figures on such magnificent Irish stone crosses as the Cross of Muiredach and the Cross of Moone?

All we can say is that there are some reliefs whose primary or sole function is to decorate. If human figures or other subjects taken from nature appear in them, then they do so primarily as components of a pattern. In contrast to these there are other

kinds of reliefs which are mainly figurative and which, in spite of any decorative function they may serve, aim at more ambitious levels of symbolization, expressiveness, and formal organization. But having said this we must bear in mind that many reliefs which we would unhesitatingly consider as examples of fine art are of poor quality, and that some reliefs which are undoubtedly works of decorative art manage to transcend their decorative function

Book cover, French, 11th century. Ivory, 22 × 13.5cm. *Victoria and Albert Museum, London: Crown Copyright*

Rail pillar from Amaravati, inner face, with detail showing lotus. 2nd century. Stone, 8ft. $10\frac{1}{2}$in. × 2ft. $10\frac{1}{4}$in. *The Trustees of the British Museum, London*

and achieve higher levels of symbolization, expressiveness, and formal organization than are usual in ornamental art. Examples of the latter include some of the foliage sculpture of the great French Gothic cathedrals and those marvels of botanical ornament, the leaves of Southwell Minster. As embodiments of the medieval 'respect for the loveliness of created nature', the leaves of Southwell Minster are considered by Nikolaus Pevsner to be 'one of the purest symbols surviving in Britain of Western thought, our thought, in its loftiest mood'.[1]

The field of relief ornament is vast. Its form and character are extremely varied and it exists in a wide range of media and on an enormous range of different kinds of objects. Sometimes it is used on its own and sometimes it is used in conjunction with other kinds of reliefs, combining with them to form a complete decorative and symbolic scheme. Often the decoration plays a secondary role, serving merely as a frame for a narrative scene or the like. But even as a frame ornament can begin to assert itself. In the eleventh-century French ivory plaque each little scene is enclosed in a broad band of decorative foliage which in scale and depth of carving is at least equal in strength to the figurative reliefs. The sculptural decoration on the rail pillars and cross bars of the Amaravati stupa is organized on different principles. Like the carving on the Christian ivory, it is a combination of floral decoration and narrative scenes, only this time the scenes are based on incidents in the life of Buddha and stories of his previous existences, and the floral decoration is mostly based on the lotus.

[1] *The Leaves of Southwell*, London and New York, 1945, p. 67.

199

But the ornamental relief does not in this instance merely frame and set off the figurative reliefs. It occupies the same shaped fields as the figurative relief. The roundels may be filled either with a narrative scene or with a large conventionalized lotus. In both the small ivory and the large stone rail pillars the over-all effect is a result of the interplay of two kinds of relief work.

The character of the relief used in ornament varies in much the same ways as that of figurative compositions, and much of what we have said in previous chapters about the different ways of treating the forms of the human figure in relief applies also to relief ornament. A great deal of relief ornament is closely bound to the surface it decorates and may be regarded as a raised two-dimensional pattern, or a pattern in two planes. The greater part of Islamic relief decoration is like this; so is much of the linear abstract ornament of the Irish stone crosses.

In contrast to work of this kind is relief ornament which really uses the third dimension and exploits the sculptural possibilities of the relief medium more fully. These more plastic types of relief ornament vary in the degree of their projection from their backgrounds. Some are in very high relief and stand free from the background, others are in medium or low relief. Their forms move backwards and forwards in depth within the available relief space and different parts of the decoration may exist in different planes of relief. Foreshortening is not uncommon in some styles, as when a leaf turns out of the plane of the relief towards the viewer. Often the forms of these reliefs twist and turn within the limited space of the relief in ways that are related to the rotation of the forms of the figure about its axis.

MOTIFS A motif is a unit which is repeated or a subject or theme which is developed in ornamental art. The first requirement for a useful ornamental motif is adaptability. It has to have the kind of form which may be developed and varied in order to fit it into differently shaped fields. The main categories of ornamental motifs are: abstract (geometrical), botanical, and zoomorphic. Abstract forms are, of course, completely free and adaptable. They are subject to no external limitations, apart from tradition, and may proliferate and vary according to the inventiveness of the artist. Plant forms are also extremely flexible because their shapes and growth patterns are variable and may be adapted and multiplied to fit into any kind of space. They may run along a moulding, wind round a column, fill a large rectangle, cluster round a corbel, boss or capital, and so on. The acanthus and anthemion motifs in the West and the lotus in the East are excellent examples of this kind of adaptability. Animal and human forms are rather more determinate than plant forms. Animals and human beings do not

grow and multiply in the same way as plants; they do not repeat themselves over and over in leaf, tendril, bud, flower, and fruit. In short, they do not have the same natural potential as ornament that most plants have. If animal and human forms are to be used freely in ornament, then the artist himself must be the source of that freedom. He must have the inventiveness and the will to indulge in creative play with the forms of nature, stretching and compressing them, varying their proportions, simplifying them, decomposing and reassembling them in a different order, inverting them, combining them with other forms, and so on. If an artist has the right attitude and enough imagination, then he will be able to treat any kind of form, whether derived from nature or not, with the freedom necessary to make it serve as ornament. The animal styles of pre-Christian northern Europe are an outstanding example of this.

Each civilization and cultural period has its own characteristic forms of ornamental art, its own preferences for certain kinds of motifs and ways of treating them. The motifs in these various styles of ornament have been exhaustively catalogued and named, and their occurrence in the arts of different peoples and times has been carefully noted by historians, for whom they are a valuable guide to the interpenetration of cultures. We need only mention a few of the more common types of motif to remind ourselves of their diversity. Most of the names are descriptive: frets, interlacings, plaitwork, knotwork, spirals, scrolls, inhabited scrolls, rosettes, lotus, anthemion, acanthus, egg and dart, bead and reel, sawtooth, lozenge, festoons, palmettes, and so on.

Throughout history there has been an enormous traffic in ornamental motifs from one country to another. A motif perfected by the Greeks, and possibly adapted by them from a Mesopotamian or Egyptian original, may turn up on an early Indian temple alongside purely Oriental motifs, in a medieval Scandinavian wood carved relief (perhaps as a border round a panel of completely northern draconite ornament), on a portal of a French or Spanish Romanesque church, on an Italian Renaissance tomb, on a nineteenth-century public building in Manchester or North America, and finally, in its ultimately degraded form, as a spray-painted plastic moulding on sale at so-many pence a yard in a present day 'house beautiful' supermarket.

Tradition is of the utmost importance in ornamental art. Each generation of artists does not start all over again from scratch and invent its own forms of ornament. Once a motif is invented it takes on a life of its own and its development comes about as the result of the work of numerous artists and craftsmen over a long period. Thus a motif may become a theme which successive generations may develop in their own ways. It becomes in a sense independent. If it started as a fairly straightforward and easily recognized representation of a specific animal or plant it may be developed by

generations of craftsmen independently of its source until it bears little or no relationship to its natural prototype. It may even end up as a completely abstract geometricized motif.

The abstract geometrical schemes of the intellect and the living forms perceived in the objective world are the two poles between which ornamental art varies. Sometimes the abstractions are clothed with the forms of life and sometimes the forms of life are disciplined to fit into the geometrical schemes. There are thus two dangers to which ornament is constantly open. On the one hand it may degenerate into an unconsidered naturalism which attempts to reproduce the forms of nature in a completely imitative way; on the other hand it may become formalized to the point of emptiness and sterility. But what can be a danger if pushed to extremes is also a source of the vitality and variety of ornamental art. Between these two extremes there are many degrees and kinds of naturalism, conventionalization or stylization, and abstraction. Many societies have shown a clear preference either for abstract and highly stylized or for naturalistic ornament; others have produced work in which the geometrical and the organic are about evenly balanced, or have allowed the two tendencies to exist side by side and produced a mixed style.

NATURALISM Naturalism is the predominant tendency in Hellenistic and Roman ornamental relief and in the Renaissance and post-Renaissance styles which to a considerable extent stem from them. The exquisite delicate naturalism of the relief ornament on the Ara Pacis Augustae exploits the medium of relief with great subtlety. The serpentine movements of the acanthus relief on the dado, and the arrangement of its scrolls, leaves, and flowers are beautiful in themselves as sheer pattern but they also have an unobtrusive and refined plasticity. The main movements of the forms take place in the plane of the relief but the modelling of the details makes subtle use of the limited depth space: petals and leaves curl backwards and forwards at their extremities, leaves grow out from behind the stalks, and tendrils wind round the stalks and emphasize their three-dimensionality. The swag of fruit and foliage suspended 204 between two ox skulls and tied with ribbons contains corn ears, fir cones, ivy, pomegranates, quinces, grapes, olives, and oak. Again, the relief is extended mainly in the plane of the surface it decorates and it is not spatially aggressive, but it varies considerably in the degree of its projection, and its forms, although small in scale, are fully rounded and full of movement in depth.

The supreme achievements in the translation of botanical forms into sculptural relief are the foliage sculptures of Gothic churches. Largely, no doubt, because they are carved in softer stones than the hard dense marble of the Ara Pacis, these Gothic foliage sculptures

Ara Pacis Augustae, Rome. 13–9 B.C. Detail of acanthus relief on dado. *Mansell Collection*

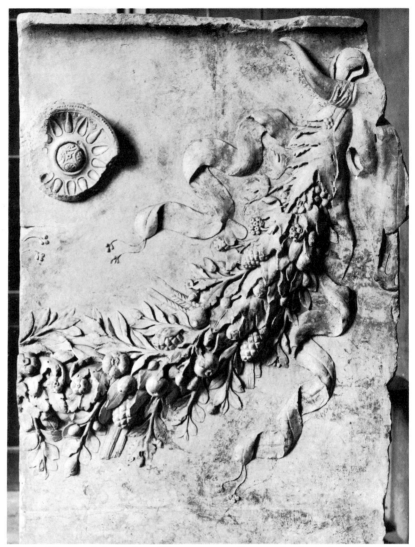

are bolder and broader. Their naturalism, which is based on the closest study of natural models, gives the lie to the often repeated statement that medieval Christianity was not concerned with the natural world. Nobody has written with greater eloquence and insight of this aspect of medieval sculpture than Émile Mâle. Opposing the idea that every animal and plant in medieval sculpture should be interpreted in a symbolic sense he writes:

The impartial student of the decorative fauna and flora of the thirteenth century finds it purely a work of art, the expression of a deep and tender love of nature. Left to himself the medieval sculptor did not trouble about symbols, but was simply one of the people, looking at the world with the wondering eyes of a child. Watch him creating the magnificent flora that came to life under his hand. He does not try to read the mystery of the Fall or the Redemption into the budding flowers of April. On the first day of spring he goes into some forest of the Ile-de-France, where humble plants are beginning to push through the earth. The fern tightly rolled

like a powerful spring still has its downy covering, but by the side of the streams the arum is almost ready to open. He gathers the buds and the opening leaves, and gazes at them with the tender and passionate interest felt by all men in early youth, and which is the artist's birthright through life. The vigorous lines of these young plants which stretch upwards and aspire to be, seem to him full of strength and grandeur by their suggestion of concentrated energy. With an opening bud he makes the ornament which terminates a pinnacle, and with shoots pushing through the earth he decorates the cushion of a capital. The capitals of Notre Dame at Paris, especially the earlier ones, are made of these young leaves, which swelling with the rising sap seem to thrust up abacus and arch as they grow.[1]

There are a number of fine examples of foliage sculpture in the medieval churches of Britain but the most abundant, most outstanding, and best loved are those in the Chapter House of Southwell Minster. These, like all similar naturalistic Gothic leaf sculpture in other parts of Europe, owe their inspiration to the work of French sculptors. The leaves of Southwell preserve a balance between the natural form and vitality of the actual living plants, the nature of

[1] *The Gothic Image*, London, 1961 ed., pp. 51–2.

Capitals on the right of the door to the Chapter House, Southwell Minster, end of 13th century. Stone.
A. F. Kersting

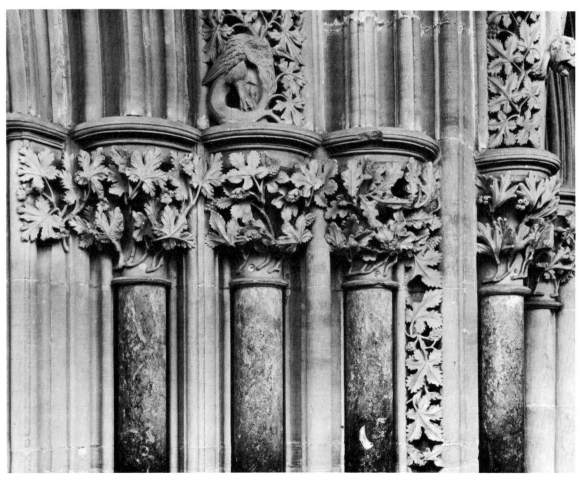

stone as a material in its own right, and the demands of the underlying architectural structure. Although they are based on a close observation of living models and show consummate skill in the craft of stone carving, they do not torture the stone into complex forms which display the craftsman's virtuosity rather than the artist's sensibility. The leaves are not merely copied in stone, but are translated. They are deeply undercut and in very high relief so that they show up light against the spaces between and behind them. In these spaces we can still see, or at least sense, the shape of the capital continuing under them. The sprays of leaves are attached by their stems to the base of the capital and they widen out to follow the upward expansion of the capital. There is a great deal of movement in the surfaces of the individual leaves but they cluster round the capital in a fairly compact cup shape with their surfaces generally following the curvature of the column. The ends of the stems and the terminal points at the top of the leaves form lines which follow the lower and upper mouldings of the capital.

Decoration is usually most successful when it serves to articulate and enhance rather than conceal and destroy the form or structure which it decorates. That basically is its function. But if relief decoration is to have a character of its own and not to be completely subjugated to the underlying form, it must in some way be complementary to the structure and play around it without slavishly following it. This is a precarious business, especially when the decoration is in bold relief. The temptation to play safe and conform tightly to the architecture or to cut loose and allow the carving to run riot over it must be considerable. At Southwell the balance is preserved with superb artistry.

CONVENTIONALIZATION

Beautiful and expressive examples of conventionalized natural form may be found in the ornamental arts of many countries. The Greeks in particular developed some conventionalized plant ornament of great refinement and beauty which has been admired and used repeatedly ever since. Greek architects included some of these botanical motifs along with abstract and figural relief work in the decoration of their greater buildings. Perhaps the best known and most widely copied and adapted of all Greek examples of this kind of work are the Corinthian capitals, which are based on the acanthus. Another striking example, which became a permanent part of the repertory of Western ornament, is the anthemion motif. It is used along with other superb ornamental relief on the Erechtheum at Athens. The anthemion is a continuous pattern made up of a combination of a horizontal progression of scrolls and alternating vertical palmettes and lotuses. The scrolls and the petals of the palmette and lotus on the example illustrated are fluted so that they break the light which falls on them and look less heavy

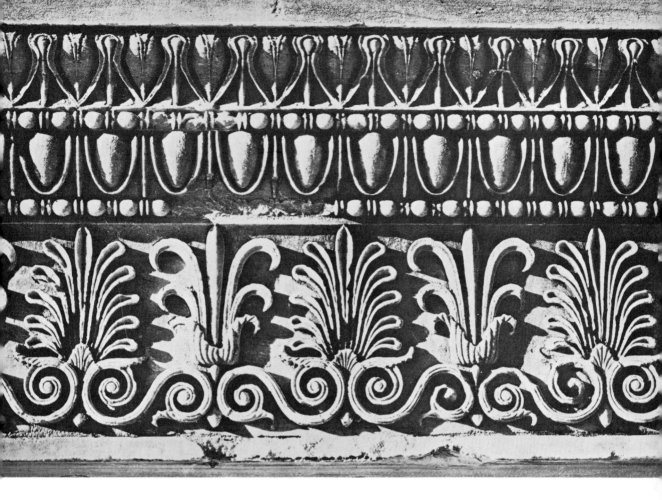

Anthemion motif, from the Erectheum, Athens, 5th century B.C. Marble. British Museum, London. *Mansell Collection*

than they would otherwise do. The alternation of flaring palmettes and drooping lotus petals is particularly effective. The suitability of the bi-symmetrical floral forms to the corners of the building is noteworthy too.

Our main example of conventionalized plant ornament is much less familiar to Western eyes than anything Greek. It is part of the sculptural decoration of the Amaravati stupa, which we have already referred to several times. The major part of the stone rail which surrounded the stupa consisted of alternating vertical pillars and groups of three superimposed circular cross bars. These were topped by a deep coping. Each of the pillars was decorated with a full lotus roundel at its centre and a half lotus at either end. Each cross bar was filled with a full lotus. In all there were 136 pillars, 348 cross bars, and 800 feet of coping 2 feet 8 inches deep. Pillars, cross bars, and coping were all carved on both their inner and outer faces and, as we have already seen, many of the lotus roundels were filled with figurative relief carvings. The carving of this vast amount of relief decoration was spread over a long period, and as a result there are differences of style and some variation in quality, although the standard is generally very high. The lotuses, on the

199

whole, are superb examples of conventionalized plant ornament, an ideal marriage of abstract geometry and living plant form, in which the discipline and order of the one and the vitality and organic rhythms of the other reach one kind of balanced perfection. They are carved in low relief and consist fundamentally of a central flat boss projecting within a fluted hollow cup, a number of concentric rows of petals increasing in size from the centre outwards and separated by thin bands of decoration, and a surrounding peripheral band of low relief decoration. This basic scheme may be subtly varied by including three, four, or five rows of petals; by making the innermost one or two rows turn inwards; by filling the surrounding band with different kinds of relief decoration, which in some instances is refined naturalistic ornament of the highest quality; and in many other ways.

The two fundamental principles on which the design of the lotuses is based are concentricity and radiation. These are evident in the purely two-dimensional linear pattern but they are also emphasized by the design of the relief projection of the surfaces and the play of light and shade which this gives rise to. The circle of the central boss shows up bright against the dark hollow around it. Then the curvature of the modelling of the rows of petals as they spread outwards from the centre creates a series of expanding movements like the circular ripples caused by a stone falling into a pond. It is the rhythm of this movement which is varied so effectively by turning the innermost rows of petals towards the centre. The radial aspects of the design are strengthened by the play of light over the surface of the petals. The contrast of light and shade on the two halves of each petal stresses their central lines and thus contributes to the spoke-like, radial aspect of the design.

ABSTRACTION As we have already mentioned, some societies have exhibited as strong a preference for abstraction in their art as others have for naturalism, and a number of different kinds of predominantly abstract or near-abstract styles of decorative relief have flourished in the past in various parts of the world. Various theories have been advanced in explanation of the predilection that certain peoples have had for either abstract or naturalistic styles of art. These include theories which attribute it to innate racial differences, to the effects of climate or topography, to differences in the level of civilization reached by a community or in its types of social organization. None of these alone carries complete conviction and few historians today would seek or expect to find such an all-embracing explanation. The only thing which seems certain is that the causes are complex and need to be separately traced for each style, if indeed they can be traced at all. Fortunately our ability to appreciate works of art is independent of all such explanations and

I mention them here only to warn the reader, since the field of ornamental art seems to provide the kind of soil in which theories of this nature flourish more abundantly than anywhere else. Such, indeed, is the power of 'scientific' theories over the modern mind that we may easily be misled into believing that explanations of this sort can actually illuminate the objects themselves in a way that enables us to appreciate them more fully as works of art.

The most aesthetically interesting art works of the Celtic peoples of Iron Age Europe are metal artifacts in the La Tène style of the last four centuries B.C. These include such things as body ornaments, utensils, shields, swords, helmets, and horse trappings, many of which are decorated with relief. Animal motifs abound in this art but its general tendency is towards a refined abstract style of a predominantly curvilinear character, with an abundance of crescents, circles, ovals, spirals, whorls, and curved trumpet-like forms. Much of the relief work makes excellently composed, dynamic two-dimensional patterns, which are often involved and structurally ingenious, and it is this aspect of La Tène art which is often rightly admired. But it is also an extremely subtle three-dimensional art, the beauty of which may be easily overlooked if we pay too much attention to its beguiling linear and areal patterns. Its forms are often highly plastic and sculptural, and their dynamism is not one merely of lines or flat shapes moving in a single plane. The reliefs are made up not of flat areas or strips raised from a background but of surfaces which move freely in depth, change the quality of their curvature, and fade into each other. They exploit the contrast between convex and concave surfaces, sharp and softened edges, lines and masses. They swell out into rich, boldly protruding bosses, which are often covered with shallow relief, and they contract into delicate wire-like linear forms; their surfaces rise and fall and curve and twist in all three dimensions. These qualities are abundantly present in the superb English shields from Battersea and the river Witham and in work from other parts of Europe in what, on account of its rich modelling, is usually referred to as the Plastic style.

The most powerful abstract architectural decorative relief is that of the façades of buildings in the ancient Mexican cities of the Yucatan region. One of its most common forms is sometimes known as the mosaic style because it consists of independent and interchangeable blocks of stone, each carved with a separate design in relief, which are assembled to make a decorative façade. The method has been likened to typographic design, and it is really rather more like assembling units of type, each of which bears a symbol in relief, than building up a picture or pattern from the flat tesserae of mosaics. Some of the most notable examples of this kind of decoration are on the Governor's House and the Nunnery at Uxmal and the Nunnery at Chichen Itza. Whole areas of the façades of these

209

Stone 'mosaic' wall from
Uxmal, Mexico, *c.* 1000.
Eugen Kusch

buildings are carved in relief decoration in the form of lattices, key
patterns, and highly abstracted masks and serpents.

The character of this Mayan decorative relief makes a vivid
contrast with the graceful symmetry of the Greek anthemion and
the refined curvilinearity of the La Tène shields. It is primarily
rectilinear, staccato, bold to the point of brutality, and full of
powerful contrasts of light and shade caused by the deep hollowing
and bold projection of the stone. It is ideally suited to the massive,
rooted, rectilinear architecture and is disciplined into areas in the
structure of the buildings where it creates an all-over pattern whose
strength matches the strength of the architecture itself. In many
areas the distinction between figure and ground no longer applies
because it is the masonry of the wall itself which projects and
recedes and not something which exists on the wall and stands out
from it.

An extremely refined form of abstract stone relief, based appar-
ently on weaving patterns, decorates the buildings of the ancient

Mexican city of Mitla. It consists of about one hundred and fifty panels of fret patterns framed by boldly projecting mouldings. Their designs, which are completely abstract, draw upon a 'vocabulary of eight typical forms, all elaborated upon primary key fret and spiral fret patterns'.[1] These repeating patterns are translated into flat two-plane reliefs. The vertical side walls of the relief are deep in relation to the scale of the forward-facing areas and the forms are predominantly angular with an abundance of zig-zags. The designs show up as boldly contrasting patterns of ungraduated light and shadow which are both powerful and elegant.

The art of Islam, more than the art of any other cultural tradition, exploited the expressive possibilities of all-over repeating patterns. They cover the surfaces of Islamic metalwork, glass, ceramics, furniture, textiles, carpets, and buildings in unbelievable variety and profusion. Some authorities see a connection between this dominance of the all-over repeating pattern and the special character of the Islamic religion:[2] 'In making visible only part of a pattern that exists in its complete form only in infinity, the Islamic artist relates the static, limited, seemingly definite object to infinity itself.' One effect of the infinite pattern is said to be the 'dissolution of matter':

The ornamentation of surfaces of any kind in any medium with the infinite pattern serves the same purpose – to disguise and 'dissolve' the matter, whether it be monumental architecture or a small metal box. . . . Solid walls are disguised behind plaster and tile decoration, vaults and arches are covered with floral and epigraphic ornament that dissolve their structural strength and function, and domes are filled with radiating designs of infinite patterns, bursting suns, or fantastic floating canopies of a multitude of mukkarnas, that banish the solidity of stone and masonry and give them a peculiarly ephemeral quality as if the crystallisation of the design is their only reality.[3]

While the over-all character of so much Islamic relief decoration may disguise and dissolve the matter from which an object is made, it seldom disguises its form. In fact one of the outstanding characteristics of Islamic relief ornament, which is especially noticeable in the architecture, is its preservation of clear, unbroken outlines and surfaces in the volumes it decorates. It does not give rise to the kind of recessions and protrusions which break into the surfaces and profiles of Hindu, Gothic, and Mexican and Mayan architecture. It is a kind of relief ornament which lies at the opposite extreme from the plastic exuberance which characterizes Baroque forms, wherever they are found. The cylinders, drums, cuboids, cones, domes, and other primary forms of which the architecture is composed may be completely covered with relief but their purity of

[1] G. Kubler, *The Art and Architecture of Ancient America*, p. 97.
[2] E. J. Gruber, *The World of Islam*, London, 1966.
[3] Ibid., p. 11.

The dome of the Tomb
Mosque of Qait Bey, Cairo, in
the eastern cemetery,
1463–96. *A. F. Kersting*

outline is hardly ever disturbed or their articulation obscured. And
on a different level this is also true of the decoration of such small
objects as the well known ivory caskets from Cordoba. The main
reasons for this are, first, the nature of the relief itself and, second,
its scale. Islamic relief, whether in stone, brick, stucco, terracotta,
or ivory, is almost invariably shallow, flat and spread out with its
outermost surfaces all in the same plane, and it is small in propor-
tion to the object it decorates. The total effect is delicate and intri-
cate, like lace. In the bright clear light of the Islamic countries, it
covers the wall panels, or the drum below a dome, or the chimney-
like column of a minaret, with a crisp pattern of light and shade
which from a distance reads more as texture than relief.

Western relief is based almost entirely on the plasticity of the
human figure and its movement in relation to a background.
Figurative friezes and even abstract and botanical ornament seem

212

to be applied as additions to a surface which functions as a background and exists separately from them. Islamic relief decoration is typically quite different from this. It is itself an integral part of the surface. Its forms do not move in relation to an underlying background and exist against it, apart from it, as do the swags and acanthus scrolls of the Ara Pacis, for example. They are all in a plane and it is the top surfaces of the relief forms themselves which constitute the outer defining surface of the building or other object. Such reliefs are in fact an extreme example of the kind of relief we discussed on p. 80.

The main sources of Islamic ornament are geometry, Arabic writing, and vegetable forms, all of which lend themselves readily to an over-all treatment. Animals and birds are also frequently found, especially outside the field of architectural relief, and human figures are not as rare as is often supposed. The decorative use of writing is a special and beautiful characteristic of Islamic ornament. Arabic scripts, which are basically highly decorative, were developed and elaborated in the most delightful ways and are found everywhere, from Spain to India, as an important element in schemes of decoration. They are even adapted for use in brick reliefs.

Casket made in the workshop of Khalaf at Madimat az-Zahra, *c.* 965–70. Ivory. *Courtesy of the Hispanic Society of America*

CHAPTER II Relief in the Twentieth Century

In previous chapters we have ranged far and wide over the history
of relief sculpture but we have not said much about recent work.
This has been deliberate. There are many developments of relief
in the twentieth century which it would be confusing to discuss in
the kind of terms which we are able to use of the reliefs of the past.
It is true there are some artists who are working in ways that
broadly speaking could be regarded as traditional, or at least as
developments out of traditional ways of working. The superb
reliefs of Giacomo Manzù and Emilio Greco, for example, are un-
doubtedly works which belong to the present time but there is
nothing in their treatment for which a reader who has pondered
many of the great works of the past will be unprepared. But the
works which receive the greatest attention today and which many
people find the most puzzling seem to have little connection, either
direct or indirect, with the work of the past.

Any attempt to discuss present-day reliefs immediately raises
problems of definition in their most acute form. Which of the art
works of the last few decades should we include under the term
'relief'? Indeed, can the categories of sculpture in the round, sculp-
ture in relief, and pictorial art be meaningfully applied to much of
the art of our own time? When one artist, say Donald Judd, attaches
a set of boxes to a wall and another artist, say Robert Morris, places
a similar set of boxes on the floor, is there any sense in regarding
the first as a relief and the second as a sculpture in the round?
When Schwitters, Picasso, and Rauschenberg attach buttons,
pieces of rope, or stuffed birds to their pictures does this change
them into reliefs? The twentieth century has invented new terms
for its art forms, referring to them as collages, assemblages, com-
bines, constructions, object paintings, ready-mades, environments,
and so on, and this is probably a good idea. Many of the artists who
produce the work insist that they have broken with the traditional
categories of art, and although they may not always be as radically
novel in their approach as they might like to think, there is little
point in shoe-horning their work into the older categories if it does
not readily fit them.

Nevertheless, although a more specialized vocabulary is useful
for making finer distinctions, especially among hybrid art forms and
border-line cases, I still think that what I said in my introductory
chapter is true, that relief is one of the fundamental spatial modes
of art and that much of what is being produced today may, without
any undue stretching of the term, be regarded as relief. There is a
vast amount of varied work which depends for its effect, either
entirely or in part, on the projection and recession of forms in

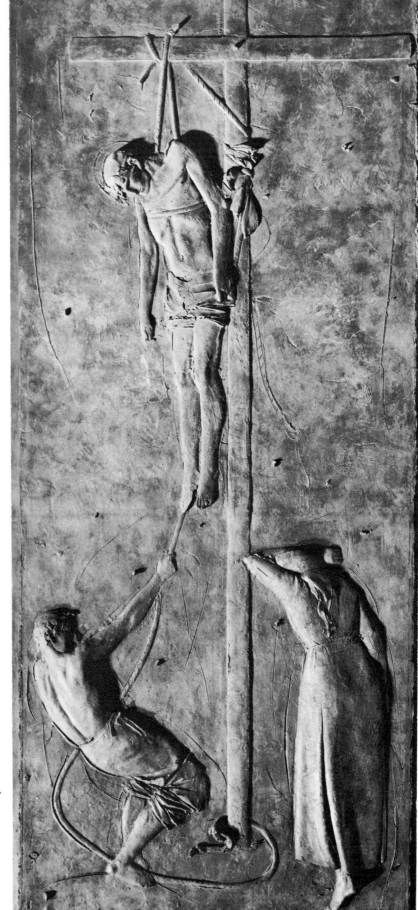

The Death of Christ, by
G. Manzù, from the Door of
Death, St. Peter's, the Vatican,
1964. Bronze, 9ft. 10in. ×
4ft. 1¼in. *Gallerie Welz,
Salzburg*

relation to a plane and on a combination of extension in a two-dimensional plane with extension in depth. Almost every major art movement since the early part of the century has produced works which could be regarded as reliefs. Certainly Cubism, Neo-plasticism, Suprematism, Constructivism, Surrealism, Kinetic art, Optical art, Pop art, and Minimal art have done so. There is so much that all I can hope to do in this short final chapter is to give a few general pointers which may help the reader to follow what is happening to the art of relief in our own day by putting him in a suitable frame of mind for approaching it. For information and discussion of a more particular kind it is necessary to refer to books which deal with individual artists and movements in some detail. There is certainly no lack of books about twentieth-century art.

Without doubt the most outstanding feature of twentieth-century art has been the development of numerous kinds of abstract or non-objective art. All the visual arts, including relief, have been caught up in this general movement, which is certainly the most discussed aspect of the art of our time and still for some people the most puzzling.

The term 'non-objective' means simply that the work does not take its point of departure from the things which we see in the world around us; it does not represent anything directly nor is it an abstraction derived from anything which has been observed. The work is a pure invention, a result of the human mind operating with the visual elements of colour, line, shape, spatial relations, volume, and so on. The theorists of non-objective art have always made great use of the analogy with music. It should be possible, they argue, to make use of expressive visual forms in the way that music uses expressive sounds to create configurations or compositions which are expressive or beautiful in themselves without the need for any reference either direct or indirect to the objective world. 'Non-objective' is probably a better term to use of this kind of work than 'abstract', which has wider connotations and is used of images which are derived from nature and which may still retain representational features.

One major effect of the abandonment of representation in reliefs is a change in the nature of relief space. The space of non-objective reliefs no longer has any notional, represented aspects. Pictorial, represented space disappears along with other represented features. The non-objective artist is no longer interested in the problem which preoccupied so many relief sculptors in the past, namely the problem of finding a satisfactory way of representing the space and form of the real world in the limited space and form of relief. You cannot say that the space and form of a relief are compressed or condensed unless you relate them to the space and form of the everyday world. A narrow space and a thin form in a non-objective relief are simply a narrow space and a thin form. They are not a

narrowed-down or attenuated version of real space or a real object. Thus the interplay between the space and form of the relief itself and the space and form which are represented by the relief, an interplay which in figurative reliefs can be such a rich source of aesthetic interest and such a marvellous field for the exercise and development of imagination and technical skill, no longer plays a part in the work. A non-objective relief exists, so to speak, on only one level – it is what it is and nothing more.

Nevertheless, although the forms of non-objective art do not represent any particular objects or classes of objects which we may observe in the world, they do have expressive and structural properties which are the same as those possessed by all other visual forms. Thus although their forms do not refer directly to the objective visual world, they do relate to our general visual experience, to the knowledge of and feeling for visual forms which we have acquired in our contact with the visual world since childhood. This brings me to the most important point I wish to make about the appreciation of non-objective reliefs (and non-objective art in general): if we are to see these works as anything more than mere geometrical exercises or meaningless conglomerations of shapes and to learn to discriminate among them and to pick out works of value, then we must develop our capacity for responding to the expressive qualities of visual forms for their own sake. As we have said in previous chapters, our ability to respond to expressive visual form is the most fundamental aspect of appreciation of all kinds of visual art. In non-objective art these qualities exist for their own sakes and do not interpret, express or expand a subject-matter which is also meaningful on another level. The richer and more varied our experience of form is the more likely we are to appreciate sculpture of all kinds. The point has been well made by Ben Nicholson, one of the earliest and most subtle artists to produce non-objective reliefs: 'The solution to an understanding of abstract art is really a very simple matter and is the same as the solution to understanding, for example, Chinese: if we learn the language we shall understand how bad and how good are some of the things it says.'[1]

Every kind of expressive form which is capable of being constructed in relief is open to the non-objective relief artist. Thus, as one might expect in an age which attaches such importance to individualism, there are wide differences of character in the works produced. Each sculptor or school of sculptors has a preferred range of forms and types of composition: organic, geometrical, curvilinear, rectilinear, highly organized and controlled, sketchy and largely accidental, bold, delicate, simple, complex, harsh, spiky, angular, soft, slack, tense, dynamic, static, symmetrical, balanced,

[1]Quoted in M. de Sausmarez (ed.), *Ben Nicholson*, Studio International Special, 1969.

asymmetrical, etc. The forms of these reliefs and the ways in which they are put together are either capable of sustaining our interest and moving us in various ways or they are not. There is no way of appreciating them other than through our growing familiarity with the world of visual forms, a developing sensitivity to proportions, formal relationships, and expressive qualities.

The question whether non-objective art has become impoverished by abandoning the representational element has been discussed at great length by artists, critics, and philosophers of art and the differences of opinion among experts are extreme. The answer we give to this question is perhaps best deferred until we have become familiar with and developed our responses to both kinds of work. Perhaps then the answer we give to it will not have to be argued at the theoretical level but will be a matter of straightforward experience. Above all we should avoid taking too seriously the extravagant theories which are sometimes put forward in support of non-objective art, and which claim, for example, that it is purer or higher in some Platonic metaphysical sense than other forms of art, or that it is more spiritual or intellectual or even more real than representational art, or that it is the great culmination towards which the visual arts have been evolving over the centuries.

The more one thinks about non-objective reliefs the clearer it becomes that although they explore certain areas of sensibility in a new way, they are not as radically new as they may at first seem to be. One of the reasons why they appear to be so different from anything produced in the past is that we tend to think of them as an alternative to or replacement of figurative reliefs and our clear view of them is obscured by the smoke of ideological conflicts. Moreover they are usually presented as independent, self-sufficient art objects made by people who are generally recognized as artists and they invite the kind of consideration that we give to the panels and pictures which we see in museums and art galleries. But if we forget all about the manner in which they are presented and think more carefully about what it is that is being presented, we shall see that many of these reliefs may be regarded as a continuation of, or at least as a relative of, certain kinds of work which have been going on for a long time alongside figurative reliefs. They may in some respects be more subtle and varied, but many of the reliefs are *in principle* concerned with the same problems of non-objective relief composition as are resolved in the projections and recessions of an architectural façade or in the panelling of a room, a door, or a ceiling, in the design of a shop-front or a piece of furniture, or in the layout of fittings and other items on the interior walls of buildings. Again, others are not different in principle from the abstract decorative relief panels on pre-Columbian and Islamic buildings, or the abstract ornament on Romanesque churches and Greek

temples, or Celtic ornament. But the aspect of relief sculpture on which so many of the artists of the past have been able to work with a freedom comparable with that of the modern non-objective artist is drapery. A study of the treatment of drapery in Archaic and Classical Greek and Hellenistic sculpture, in medieval sculpture, from Romanesque to Late German Gothic, in the work of Renaissance sculptors such as Donatello, Agostino di Duccio, and Claus Sluter, and in Baroque sculpture, especially that of Bernini, will reveal a range of expressive forms conceived in a spirit of almost complete freedom.[1] These observations are not intended to depreciate modern non-objective reliefs in any way or to detract from what is new in them. The point of showing such connections is to demonstrate that we are not dealing with an entirely new area of human sensibility but with what is at its best a subtle, complex, and refined application of well established principles of relief in a new area or context.

Many non-objective relief artists limit themselves to a range of forms which is far more restrictive than that available to the figure sculptor. It is not easy for an artist to exist in an atmosphere of complete freedom and sculptors who have escaped the 'tyranny' of the human figure have often embraced the far more rigid tyranny of a narrow geometry. The influence of Mondrian and possibly of some of the less imaginative architecture of our century has led

White Relief, by Ben Nicholson, 1935. Oil on carved mahogany. 101.5 × 166cm. *Tate Gallery, London*

[1] For fuller discussion of this see my *Sculpture*, London, 1969.

many artists to restrict themselves to a vocabulary of straight lines, squares, and rectangles, all either perpendicular or parallel to the relief plane. Others have gone slightly beyond this and admitted a few more forms such as oblique lines and planes, and circles. Such works, if they are to succeed at all, must depend for their effect on the subtlety and perfection of the relations among their components. Only a concern with the utmost refinement of proportion and spatial relationships could justify the self-imposed restrictions under which the artists work. This kind of concern is apparent in the works of Ben Nicholson.

Many of these precise geometrical reliefs, including many of Nicholson's, are either largely or entirely white. White surfaces respond ideally to lighting: the planes of the reliefs are clearly distinguished, their edges show up as crisp lines, and their cast shadows, because they are clearly defined, play a more positive role in the composition of the reliefs than is usual. Ben Nicholson's large white relief in the Tate Gallery was carved in mahogany and then painted white. It shows clearly how effective the play of light on intensely white surfaces can be. The counterchange of reflected lights and cast shadows inside the recessed circles, the reflected halo around the illuminated edges and the varying depth of shadow created by the changes of depth of the relief are characteristic features.

In the 1960s Nicholson produced a number of magnificent reliefs in which his skill as a painter and as a relief artist are perfectly combined. The subtleties of colour and surface texture which have always been characteristic of his paintings, and his use of the effects of projection and recession to create a play of light around the planes of the reliefs, make these some of the most poetic of all non-objective works of art. Their particular range of expressiveness links them with whole areas of our visual experience. Their apparent austerity is seen on closer acquaintance to be a rich and in its way romantic evocation of space, light, form, and atmosphere, of just those qualities for which landscape paintings have always been admired. They do not depict a particular landscape but are a distillation into the expressive forms of art of some of the aspects of landscape which move us most deeply. If anyone doubts that personal expression of a high order is possible in non-representational art, these later works of Nicholson's must surely convince him that it is. In many ways they form a link between traditional and new forms of art, and for the viewer who finds it hard to cross the gap between representational and non-representational art, these reliefs may serve as a stepping stone. After experiencing some of them he is likely to find some of the more uncompromising forms of non-objective art easier to approach.

Nicholson's reliefs are very much an extension of painting. They are low reliefs which project only slightly into the third dimension

and they rely greatly on surface qualities and the suggestion of space. In this respect they are like many of the reliefs of the past which approach closely to the art of painting in their own day. In contrast there are many non-objective relief artists whose work may be said to be in high relief because it fully exploits the third dimension and depends for much of its effect on the use of actual space.

The use of actual space as a positive element in the reliefs of the past has been severely restricted. Even in high reliefs in which air does circulate all round some of the figures we feel that the space exists primarily as an environment for the solids. But in many twentieth-century reliefs the thin rods, wafer-like sheets and open frames exist primarily for the sake of the spaces which they define. They project and hover in front of the ground plane and in front of each other, sometimes in several separated overlapping layers, and they enclose or outline volumes of empty space. This emphasis on the void is connected with architecture rather than traditional sculpture, which has always given precedence to solid form, but it also, of course, reflects the preoccupation with space of many present-day sculptors. Such uses of space are possible only in a constructed relief which is made up of assembled components. It cannot readily be achieved through the traditional processes of carving and modelling.

Symptomatic of this interest in space is the use of transparency as a feature of many constructed reliefs. Panes of glass, or more usually of perspex, are used to establish planes of relief which cut the relief space into layers which can be seen one behind another. When opaque components are fixed between these transparent sheets or are made to project in front of or behind them, their position in depth can be clearly assessed in relation to the transparent planes, but at the same time they appear to be freely suspended, as though floating. The connection of this tendency in reliefs with the work of such architects as Mies van der Rohe and Philip Johnson is obvious. The suggestion has in fact been made that a great deal of modern relief is like architecture projecting from a vertical instead of a horizontal surface.

Another tendency in twentieth-century reliefs, which contrasts with the architectonic compositional developments we have just discussed, has been towards new kinds of patterned reliefs based on the repetition of identical or similar elements. Some interesting work of this kind has been produced by the Hungarian-born artist Zoltan Kemeny. He avoids mechanically regular repetition in his work and his small metal units change in size and are unevenly distributed so that they coalesce and separate to form clusters. As in many natural and artistic structures, it is the interplay of an implied regular principle of organization with an overlying irregularity and variety of detail which gives the work much of its interest. With

Suburb of Angels, by
Z. Kemeny, 1957. Metal,
$26\frac{1}{2} \times 37\frac{3}{4}$ in. *Tate Gallery,*
London

Kemeny, as with Nicholson, it is the artist's sensibility rather than
a preconceived formula which determines the final form of the
work, making it complex, expressive, and evocative of many
aspects of visual experience. Plant structures and the structures of
urban landscapes are two of the things which Kemeny's work
calls chiefly to mind, but the kind of cellular structures which
interest him recur in many areas of our visual experience.

There are many non-objective relief artists who, like Kemeny,
prefer to work freely and organically and their reliefs exploit the
qualities of their materials and the effects which can be produced
by the processes of working them. While most formalist, Con-
structivist artists attempt to eliminate all signs of personal handi-
work and to achieve an anonymous perfection in their work, these
other artists create works which are in many respects akin to the
freely modelled bronzes of traditional sculpture. This aspect of
twentieth-century sculpture may be illustrated by the metal reliefs
of Arnaldo Pomodoro. Pomodoro's reliefs are essentially impressed
or hollowed-out. They stress the negative effects of recession into a
surface rather than the more usual relief effects of protrusion from
a surface, and they could perhaps be more accurately regarded
as intaglios.

Most experimental and new developments in relief are

222

Omaggio al Cosmonauta No. 2,
by Arnaldo Pomodoro, 1962.
Bronze. 80 × 80 × 14cm.
Marlborough Gallery, Rome

uncommissioned works, carried out privately at the artist's expense. But as the decorative and expressive possibilities of non-objective art are becoming more widely appreciated an increasing number of relief artists are being given the opportunity to produce large-scale commissioned public works. Two major problems of public sculpture, especially if it is sited out of doors, are durability and the high cost of labour and materials. These problems have been largely overcome by new developments in the use of concrete and

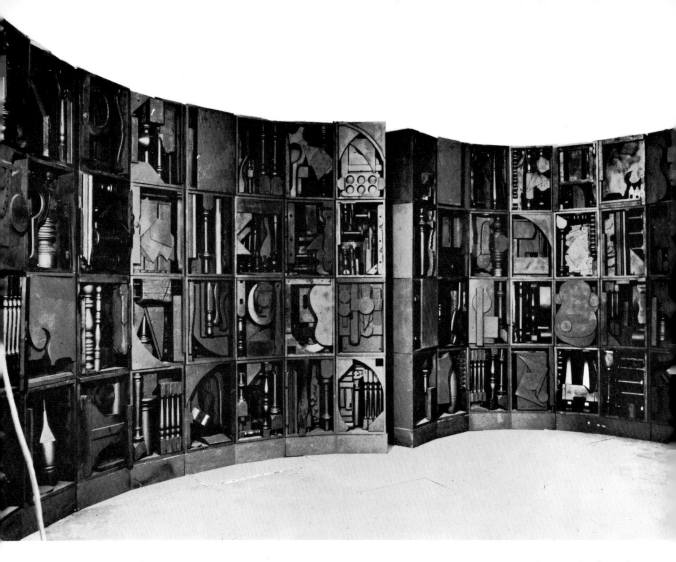

Homage to 6,000,000, I, by Louise Nevelson, 1964. Wood, 108 × 216in. The Jewish Museum, New York. Courtesy of Mr. and Mrs. Albert A. List

plastics as sculptural media and in new simple methods of casting and working metals. These new materials and methods have enabled relief artists to create large murals without the kind of labour which would be involved in stone carving or the more orthodox methods of producing metal sculpture. The concrete, glass fibre, aluminium, or constructed wood mural relief is becoming a common feature on new public and industrial buildings. Almost every large town containing new blocks of flats, factories, schools, universities, or government buildings will afford some examples.

The art of assemblage is, like non-objective art, a major new tendency in the art of the twentieth century. It too has retreated from the age-old preoccupation of the visual arts with representation, but it has moved in the opposite direction from non-objective art. Instead of cutting out all reference to the objective world, to what artists used to call 'nature', the assemblage artist has imported into his work actual objects or fragments of objects. We

could put the matter in somewhat old-fashioned but still useful terms by saying that if representational art is essentially a fusion of form and content, then non-objective art approaches the condition of an art of pure form while assemblage tends to become an art of pure content. I say 'approaches' and 'tends' because it is not really possible to reach either condition. It is odd, since the two forms of art are moving in opposite directions, that the claim is often made that both non-objective art and the art of assemblage have forsaken a world of illusion in order to achieve a greater reality. This contrast of 'illusion' (meaning representation) and 'reality' is typical of the persuasive language used nowadays by the ad-men and public relations officers of the art world. It is something we should be always on guard against since it is liable to distort our view of what is actually involved.

At first, in the work of Picasso, Schwitters, Ernst, and others 'found' objects were incorporated into works of art which also included more or less straightforward painting. But before long relief-like works made up entirely of assembled objects were being produced. This juxtaposition of fragments of the real world, sensitively controlled as it is in the work of Louise Nevelson and the boxes of Joseph Cornell, can surprise and delight us in many ways. It can do so by heightening our awareness of the visual qualities of the objects themselves by setting them apart, so that we experience them out of their normal context; by bringing together objects whose forms relate unexpectedly to create exciting compositions; and by playing upon the feelings which the objects themselves may evoke in us through their own inherent expressive qualities and their associations.

There has never been a time when differences of character among works of art have been as great as they are at the present day. The range of form and expression covered by twentieth-century reliefs from, say, Manzù's doors at Salzburg and the

City, by L. R. Rogers, 1966. Concrete, 41 × 12½in.

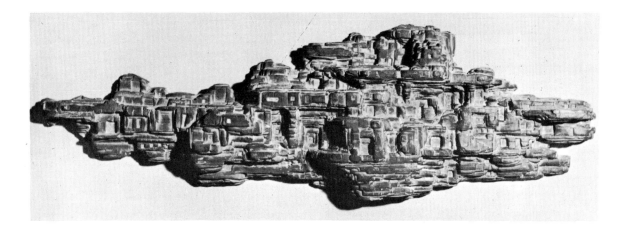

Vatican to the Structurist reliefs of Charles Bierderman and his followers, or from the stark forms of Minimal art to some of the more emotionally extravagant products of assemblage, has probably reached the limits of possibility. In our gloomier moments, when we see contemporary history as the 'immense panorama of futility and anarchy' that T. S. Eliot thought it was in 1923, we may look enviously at the art of past civilizations and regret the absence in the twentieth century of a concerted, cumulative effort to develop a coherent and socially acceptable tradition. But whatever we have lost in this way is perhaps made up for by the immense variety of work that there is for us to look at and by the opportunities that artists have to choose the ways in which they work. It is difficult to see how an individualistic democratic age could produce any kind of continuous artistic tradition. It is the emphasis on personal expression, on individual creativity, which is the paramount feature of present-day art and it is possibly the variety itself rather than any of the styles included in it which most truly reflects our deepest beliefs and attitudes.

Index